This book is a gold mine for the commercial
artist, the designer, the teacher, and a
fine aquisition for any publisher, or anyone
who utilizes graphics in publicity.

These pages contain over 3,000 pictures
in the public domain. Any picture in this
book may be used without fee, and
without permission.

THE GREAT GIANT SWIPE FILE

Over 3,000 pictures which can be used without fee or permission.

Compiled by Harold H. Hart

Designed by Hima Pamoedjo

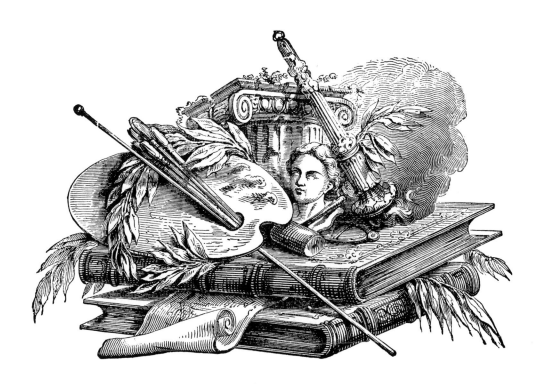

Hart Publishing Company, Inc. • New York City

COPYRIGHT © 1978 HART PUBLISHING COMPANY, INC.
NEW YORK, NEW YORK 10003

ISBN NO. 08055-0383-8
LIBRARY OF CONGRESS CATALOG CARD NO. 78-71357

MANUFACTURED IN THE UNITED STATES OF AMERICA

CONTENTS

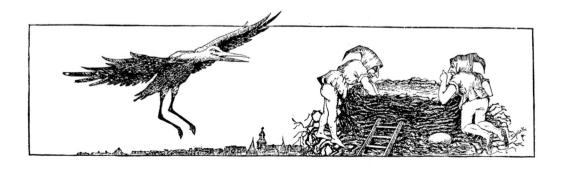

THE GREAT GIANT SWIPE FILE

ACTORS & PERFORMERS

11

AGRICULTURAL WORKERS

AGRICULTURAL WORKERS (continued)

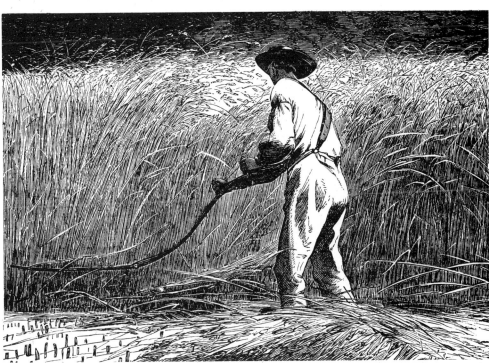

AIRCRAFT

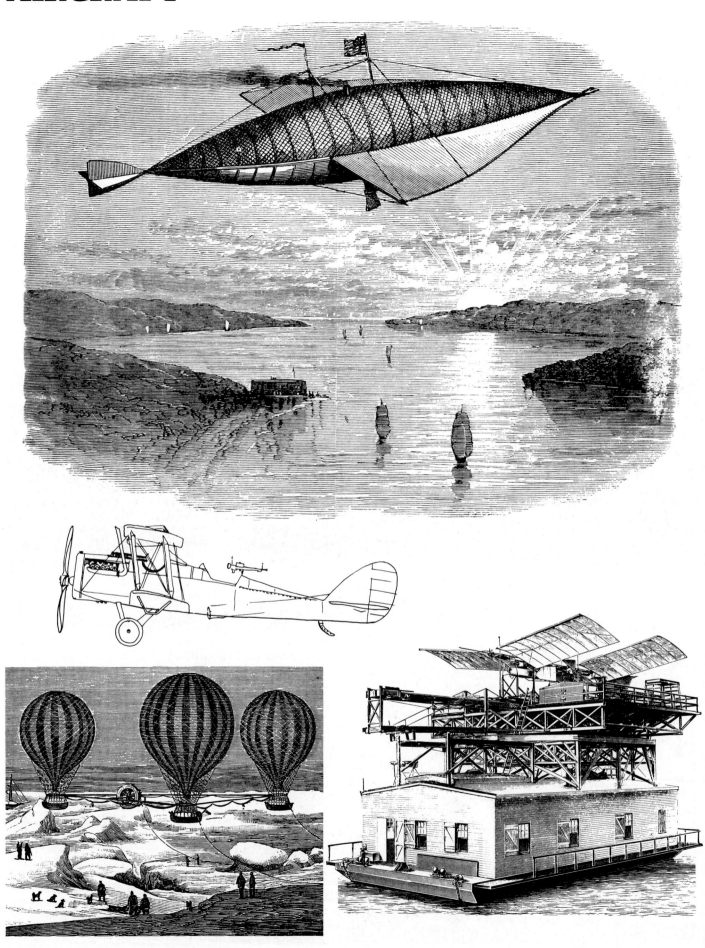

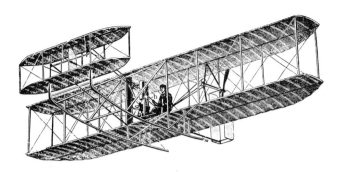

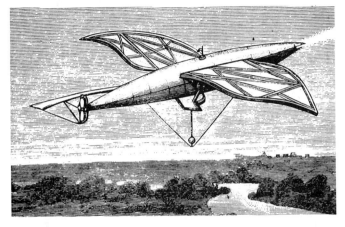

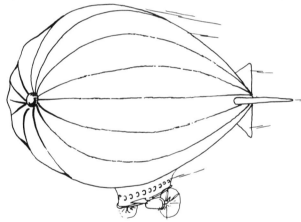

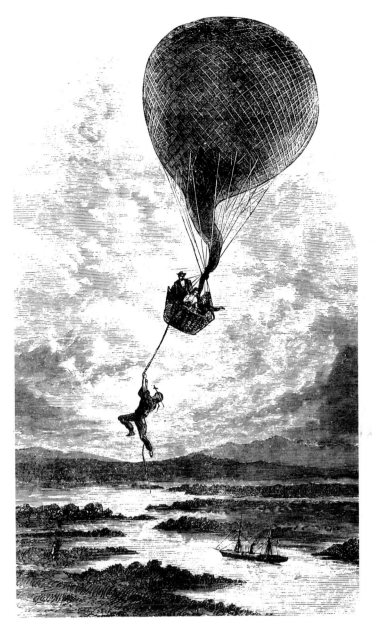

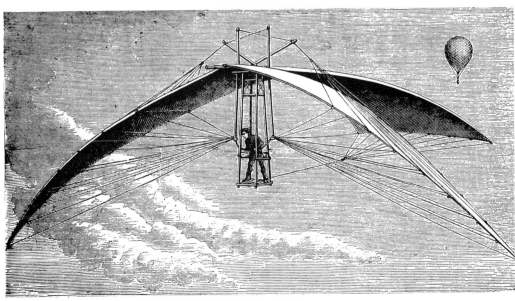

ALLIGATORS & CROCODILES

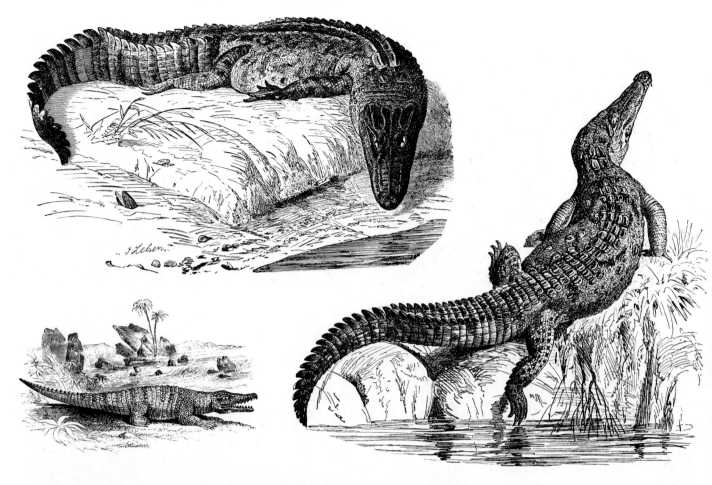

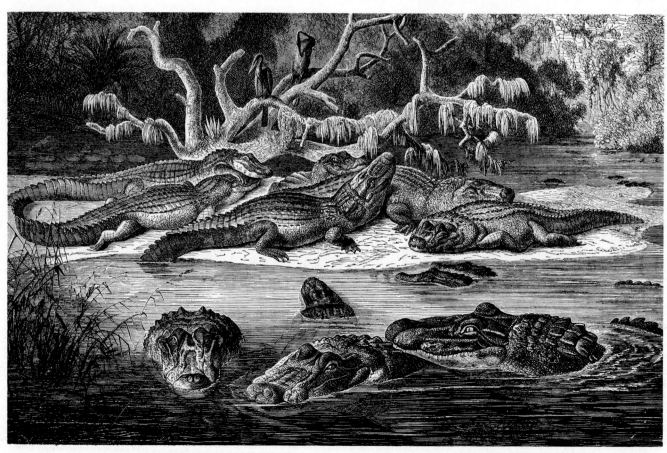

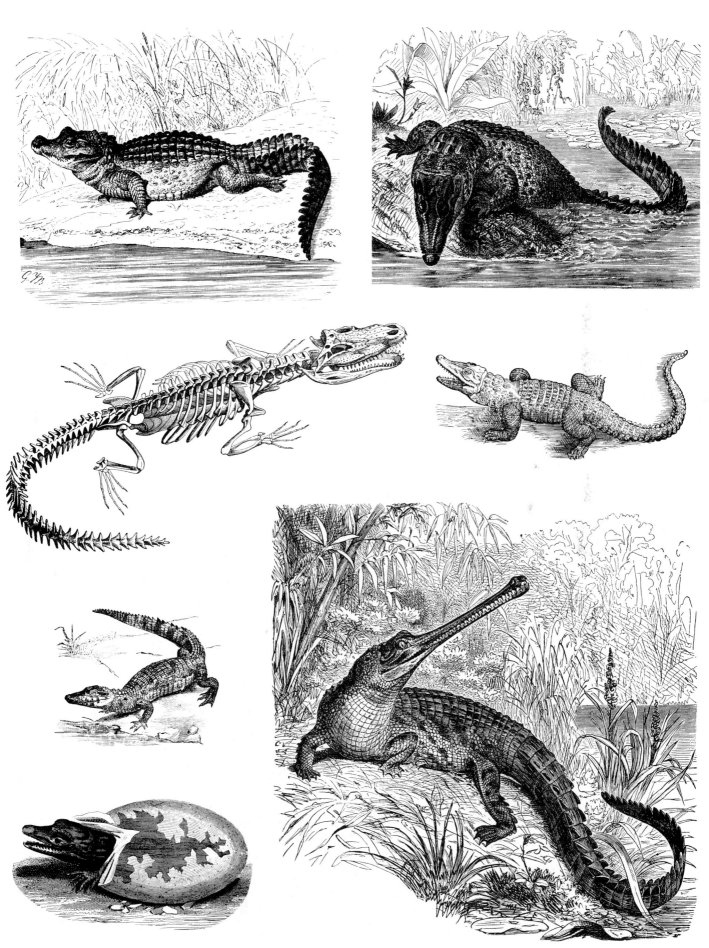

AMPHIBIANS

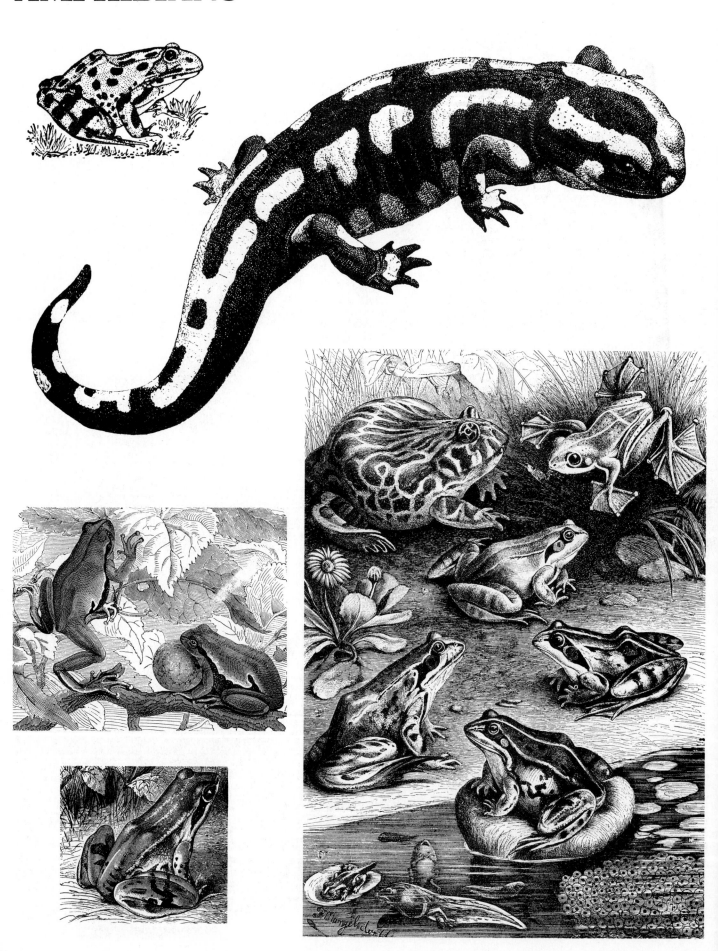

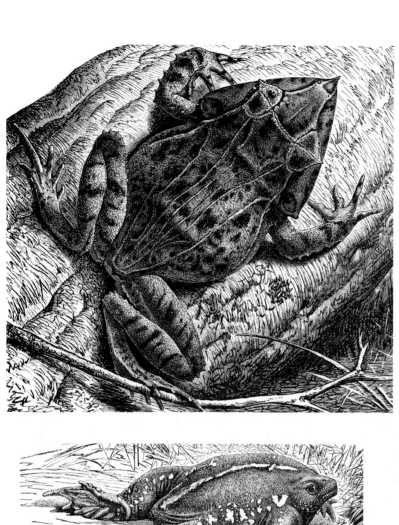

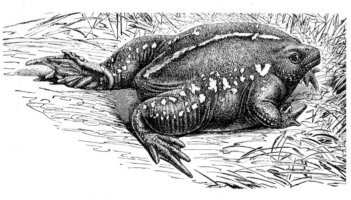

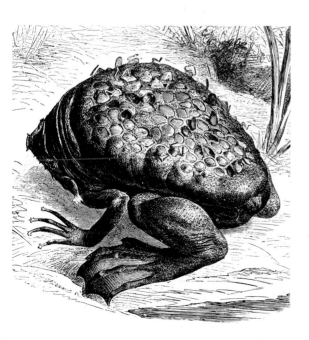

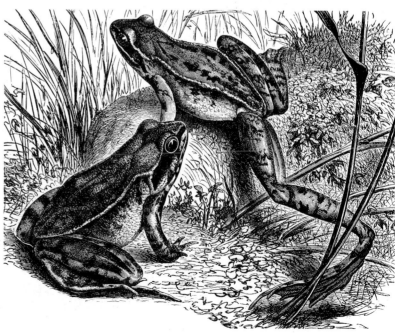

ANTLERED ANIMALS

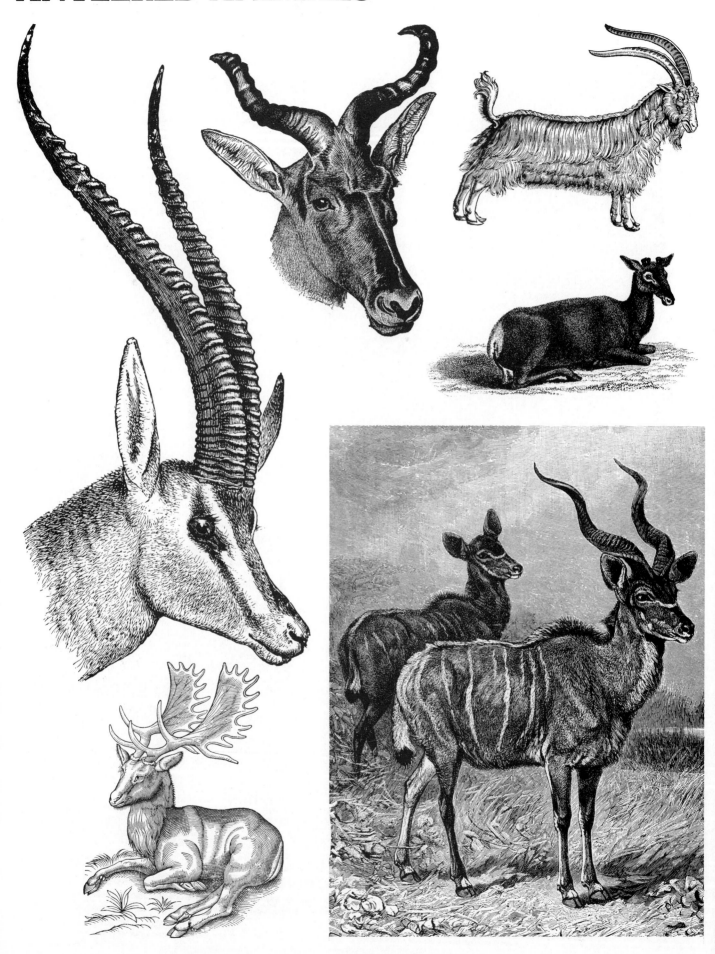

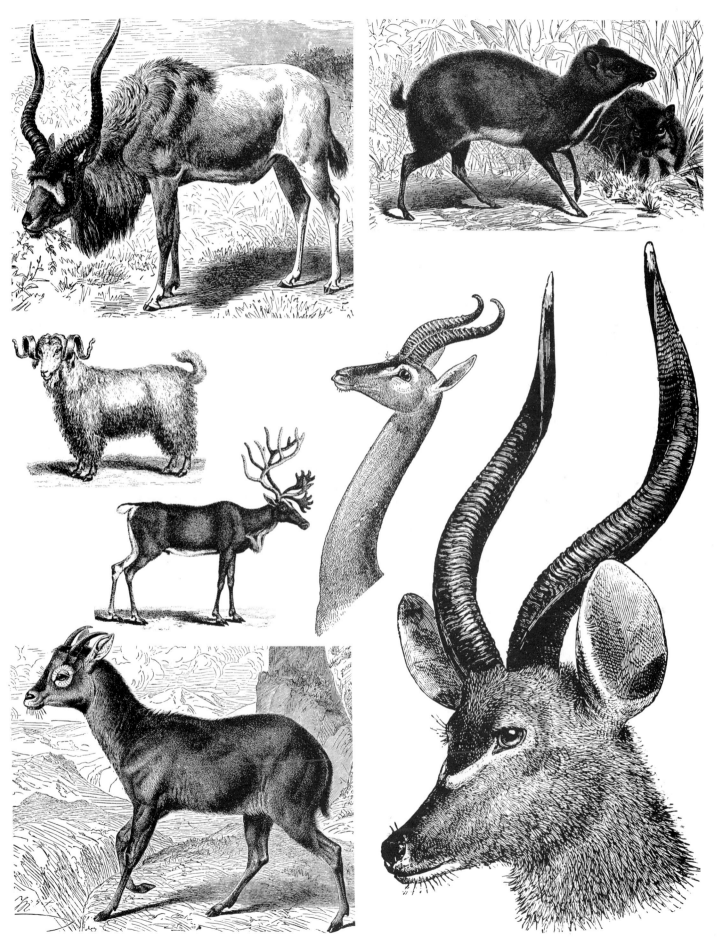

APES

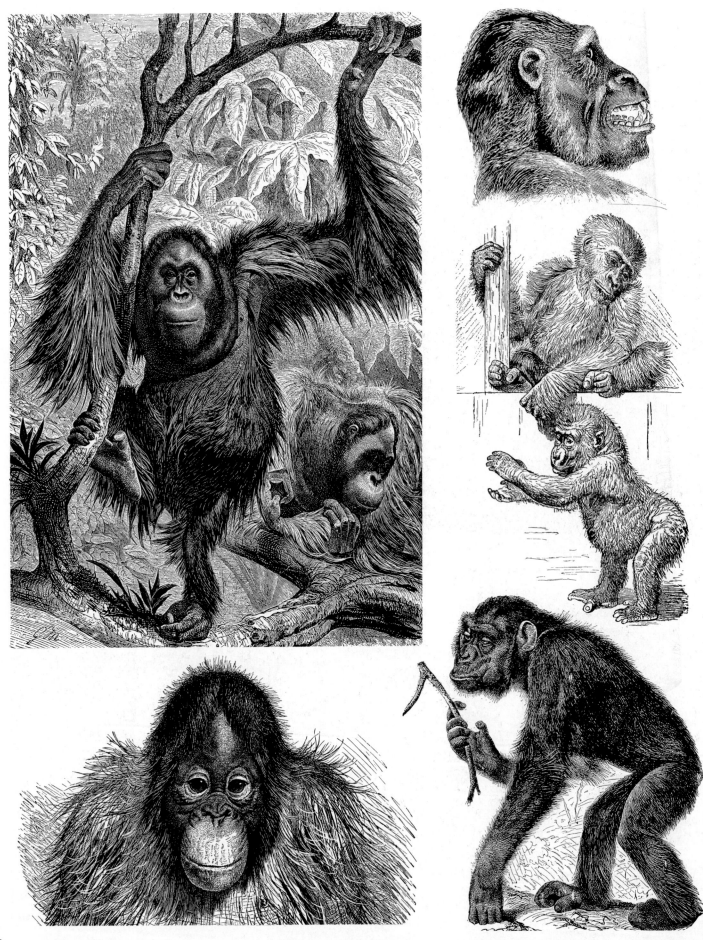

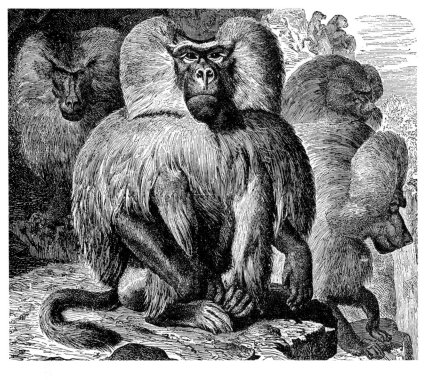

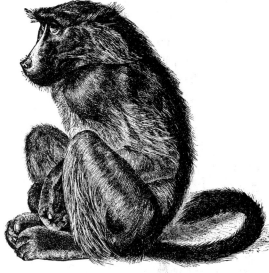

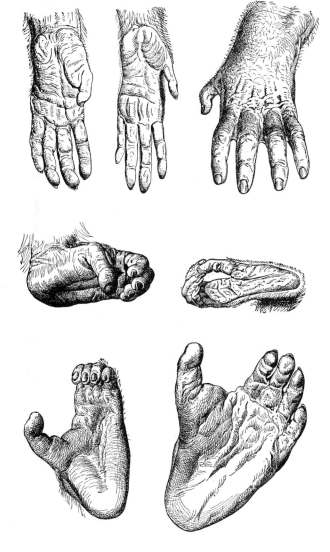

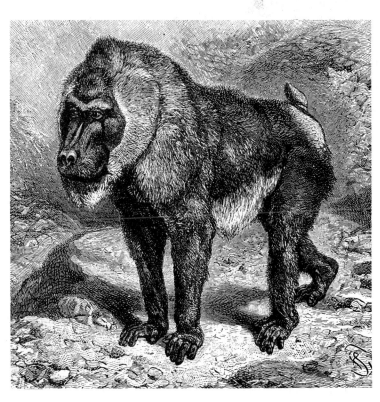

ARCHITECTURAL ELEMENTS

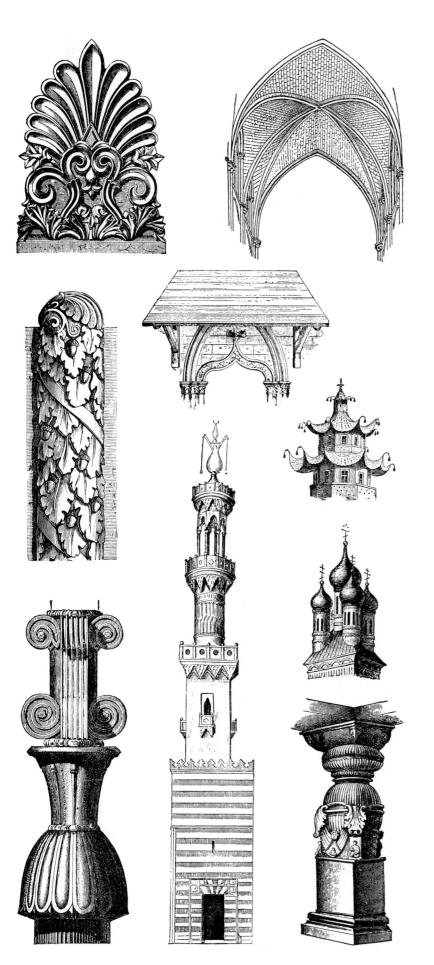

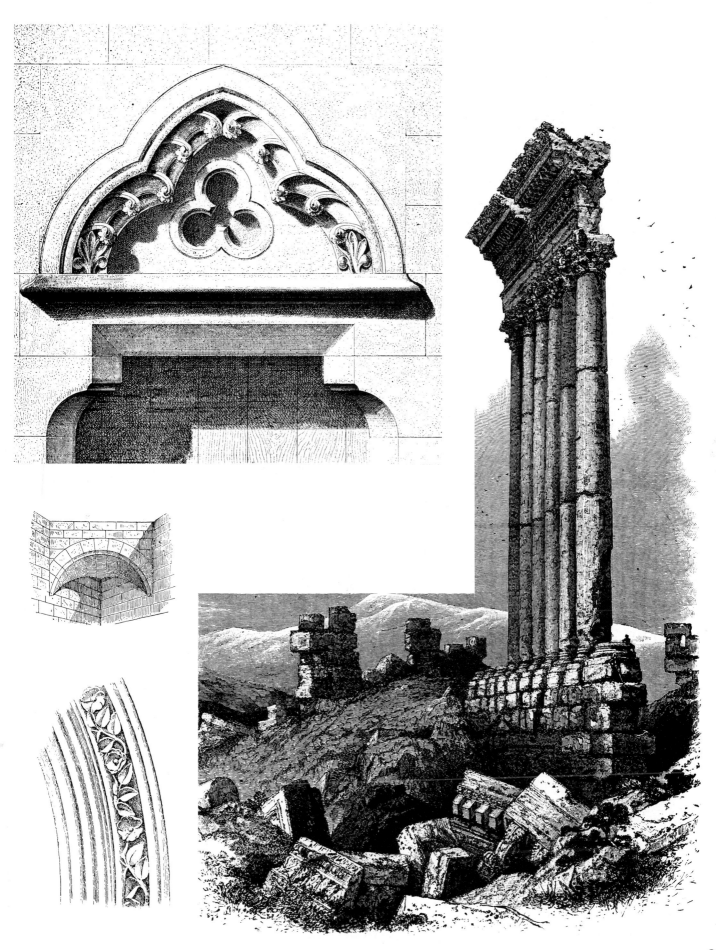

ARMADILLOS & PANGOLINS

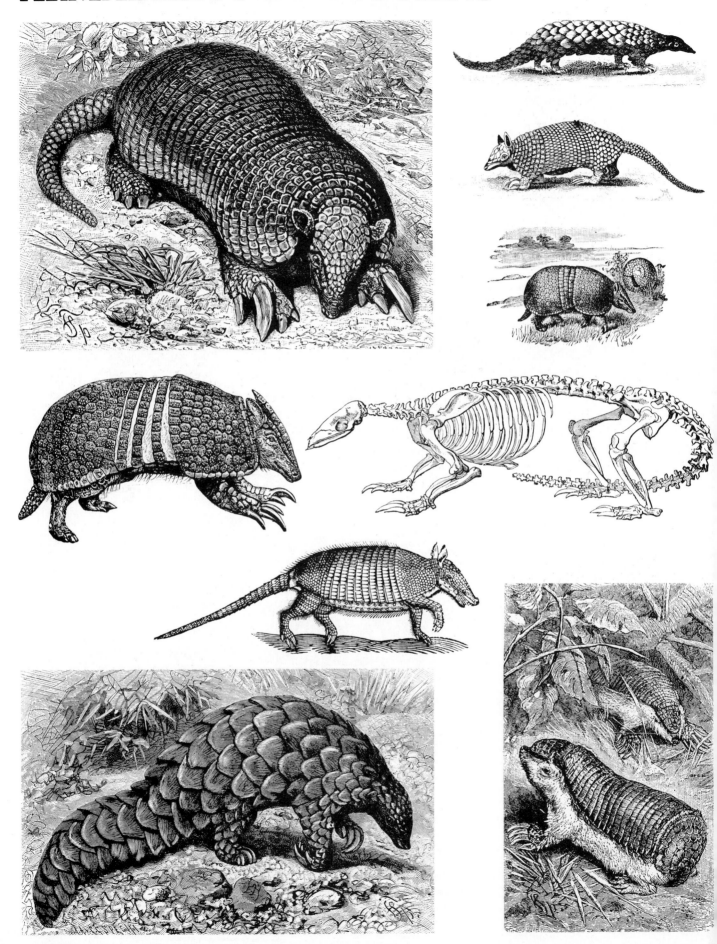

ARMS & ARMOR

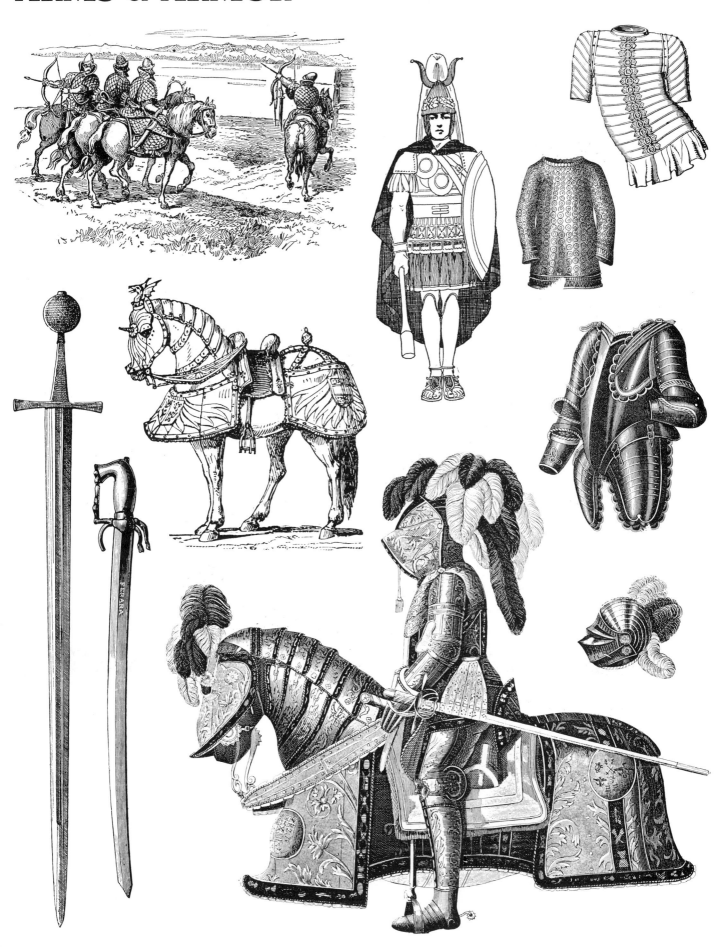

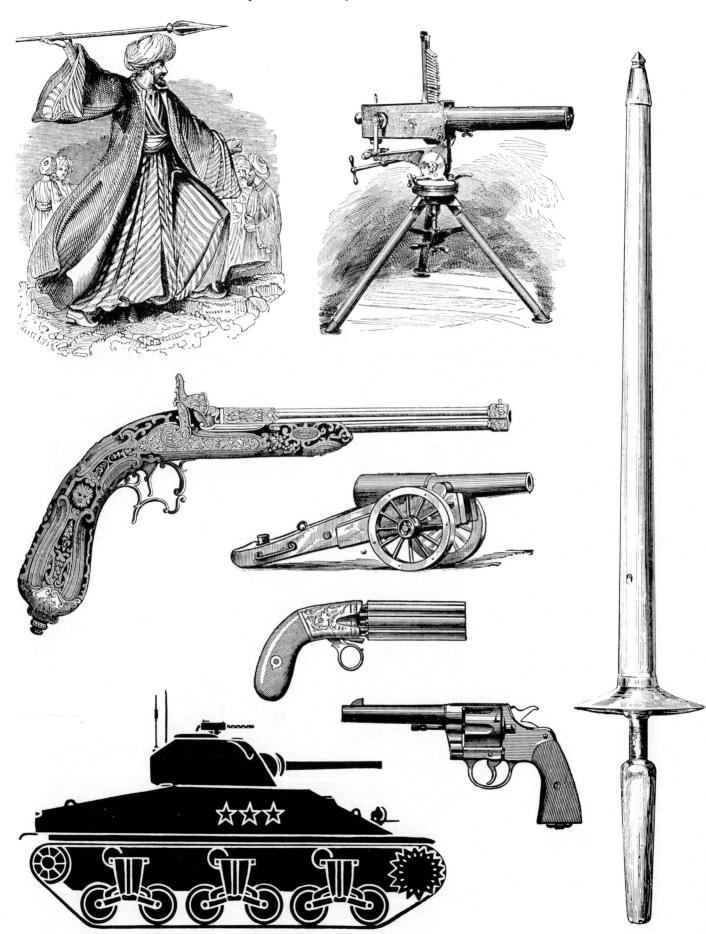

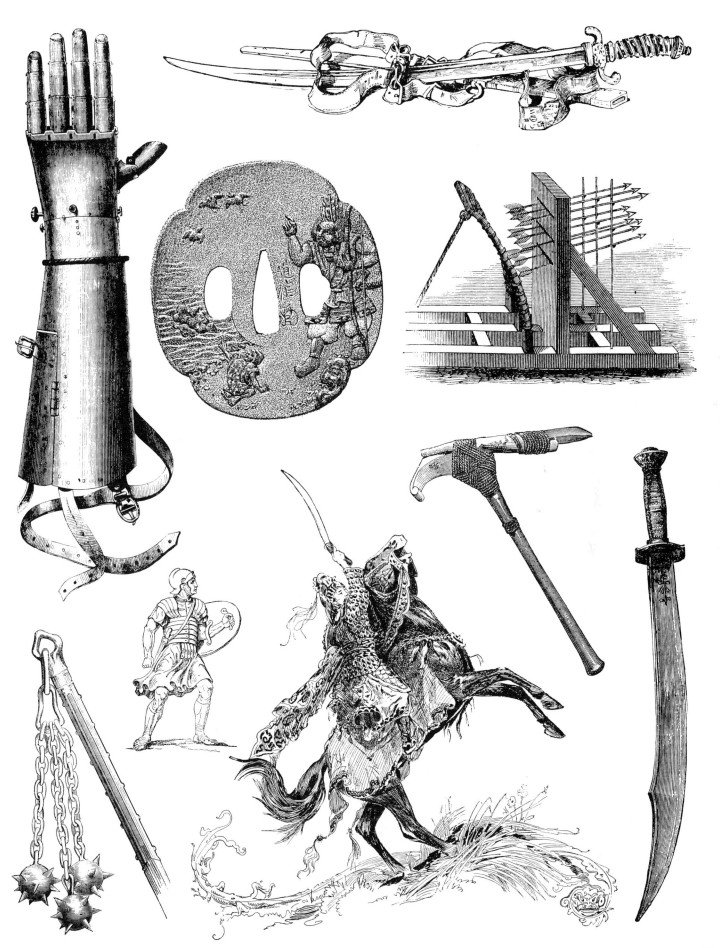

ARMS & ARMOR (continued)

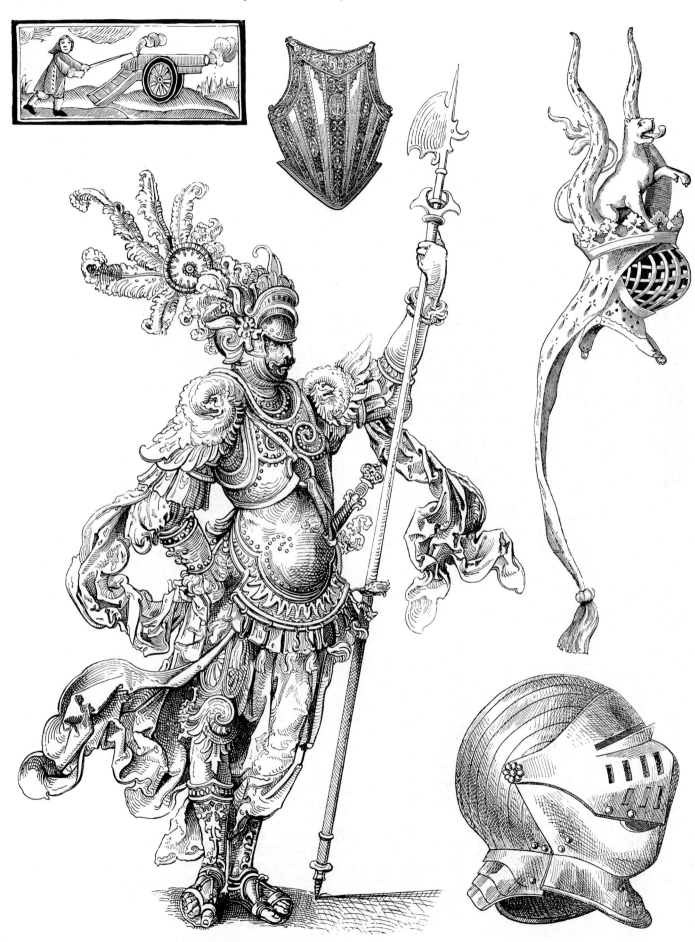

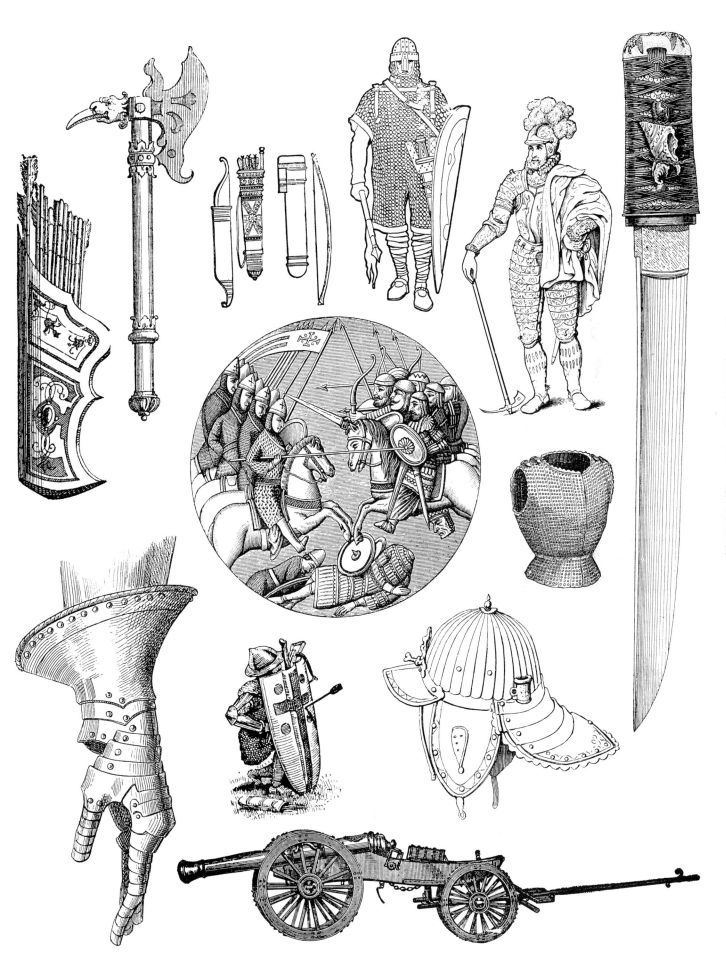

ARMS & ARMOR (continued)

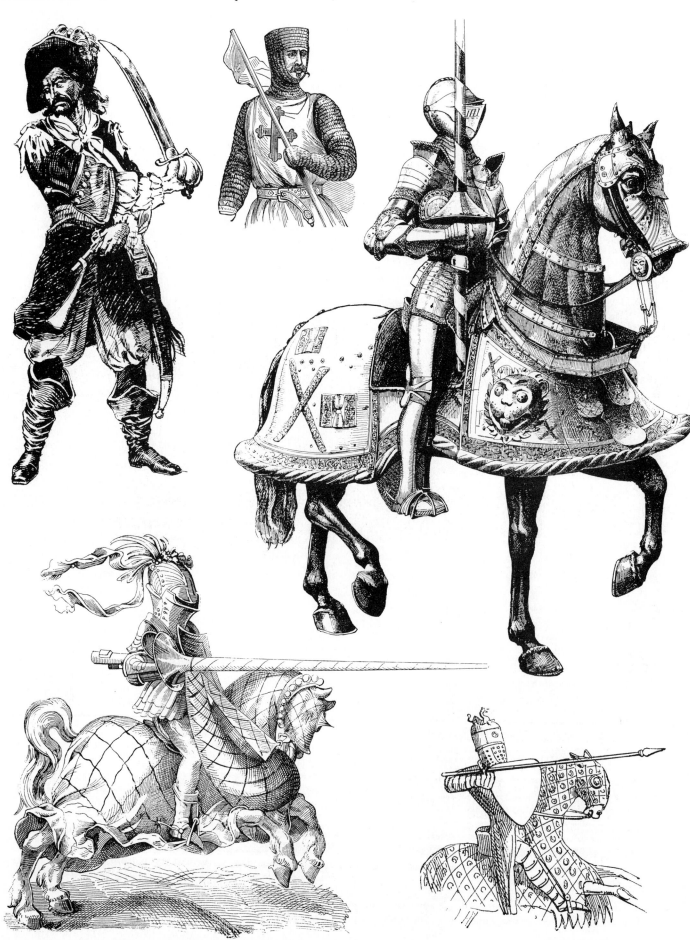

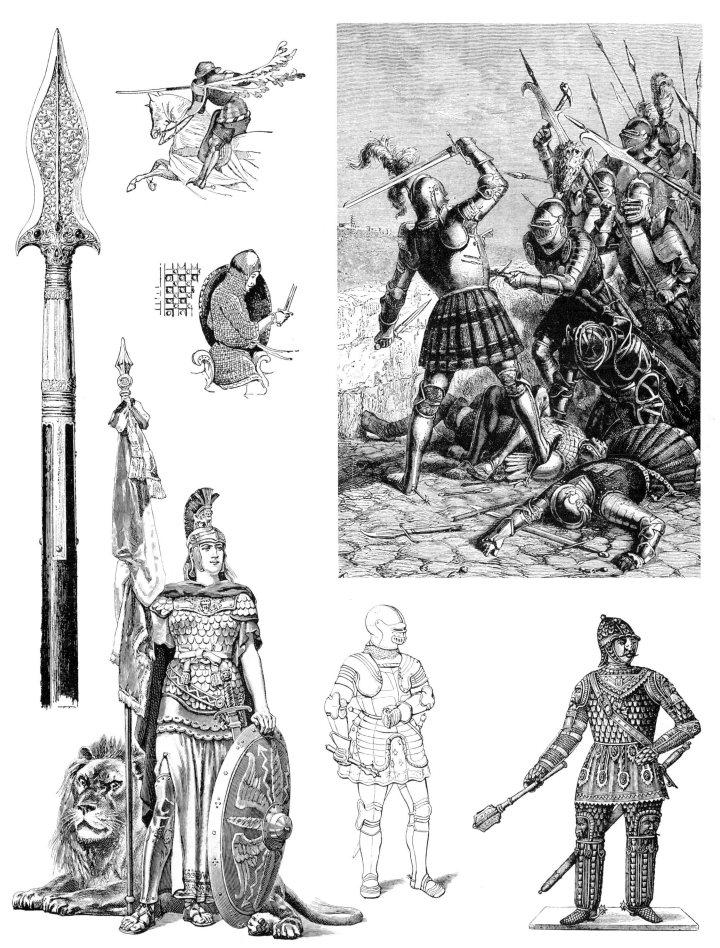

ART & DRAFTING SUPPLIES

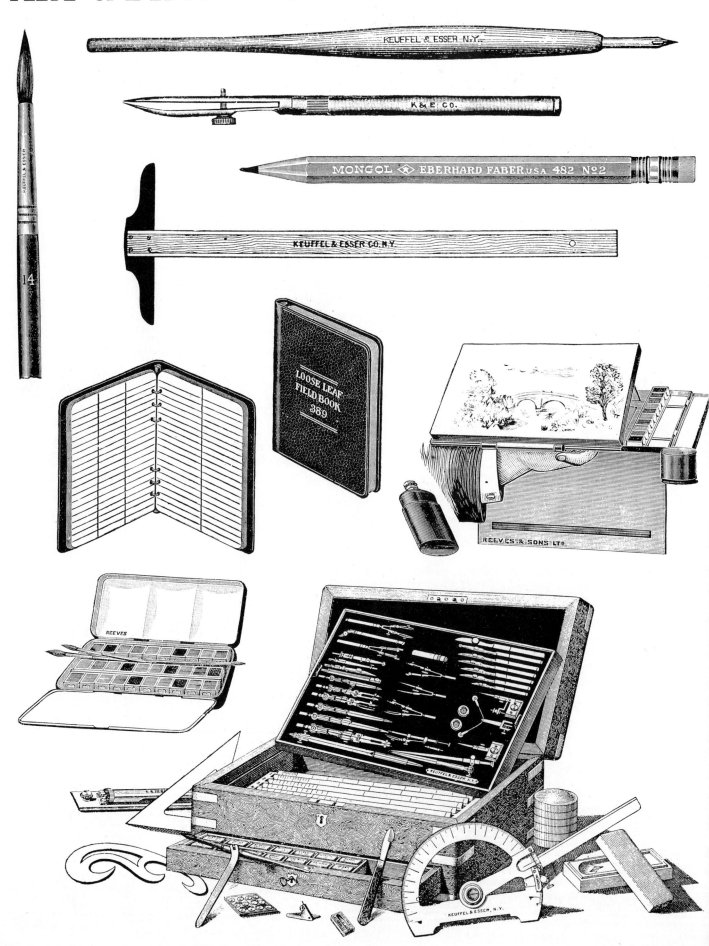

ARTISTS

BATS

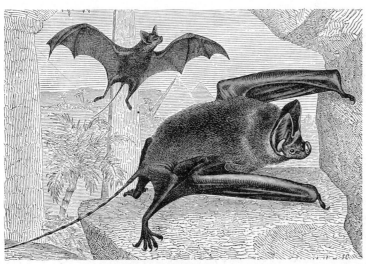

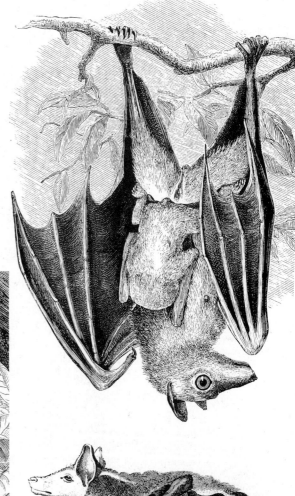

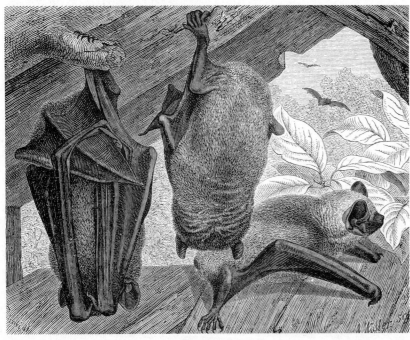

BEARS

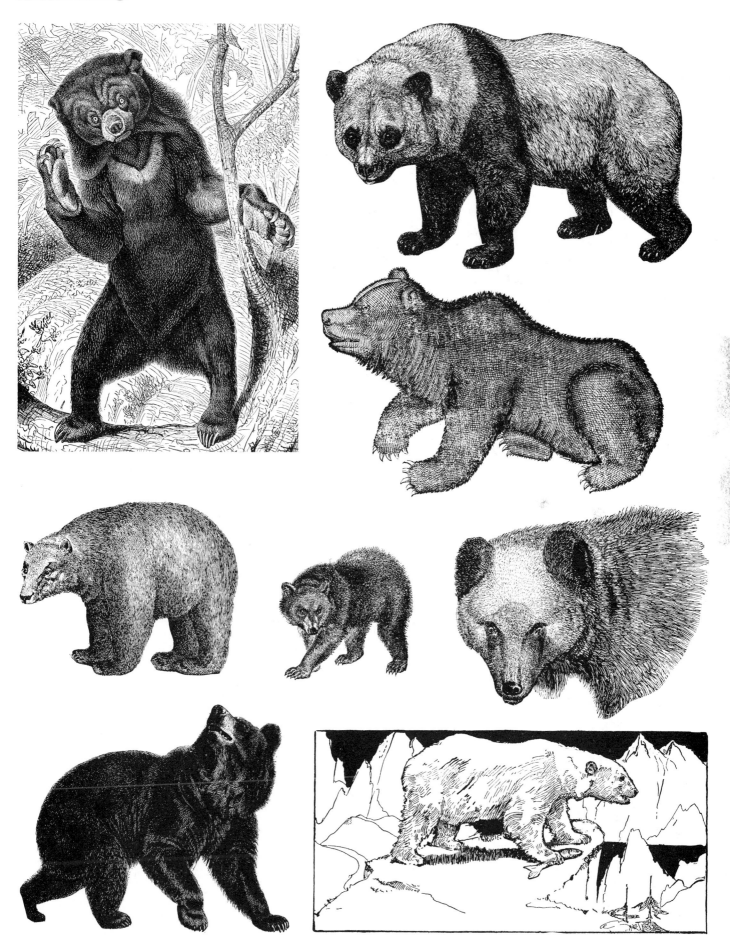

BEAUTIES

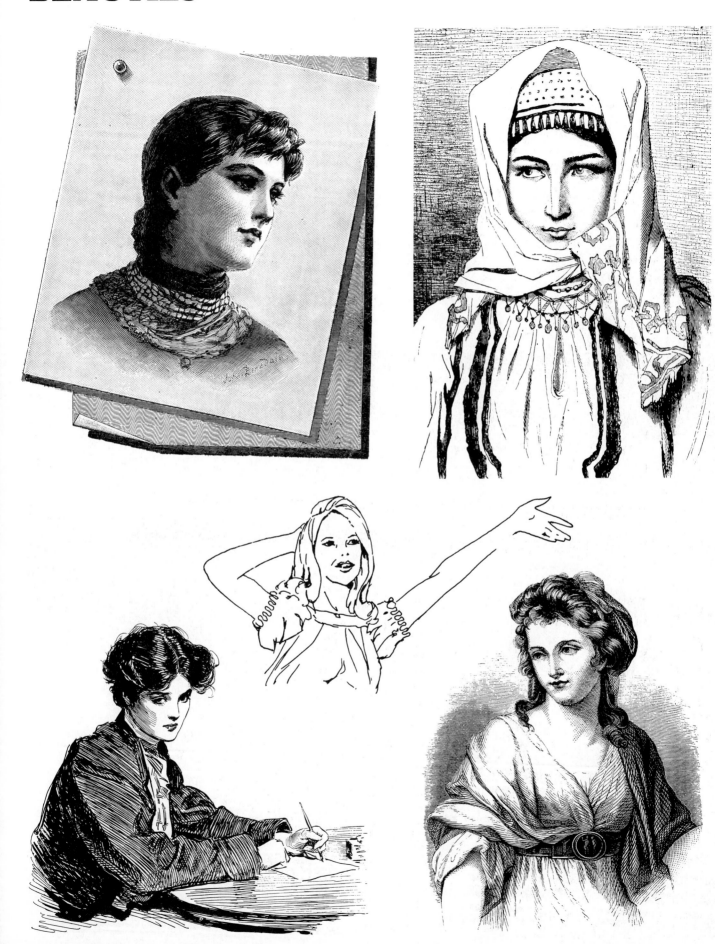

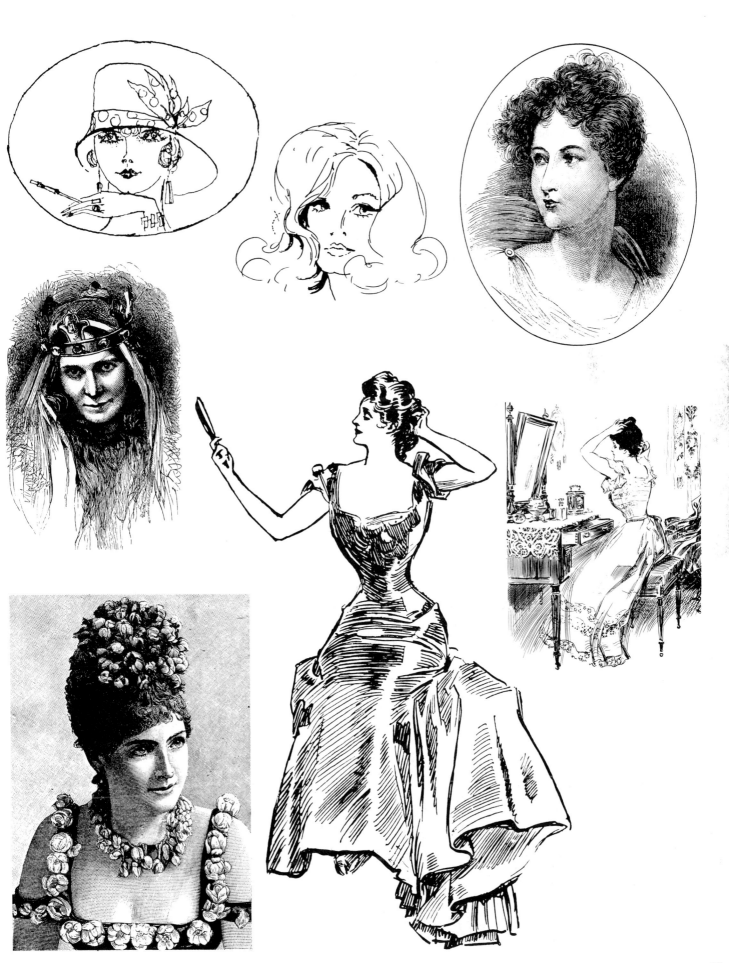

BICYCLES

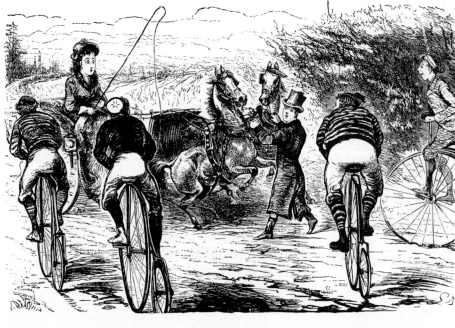

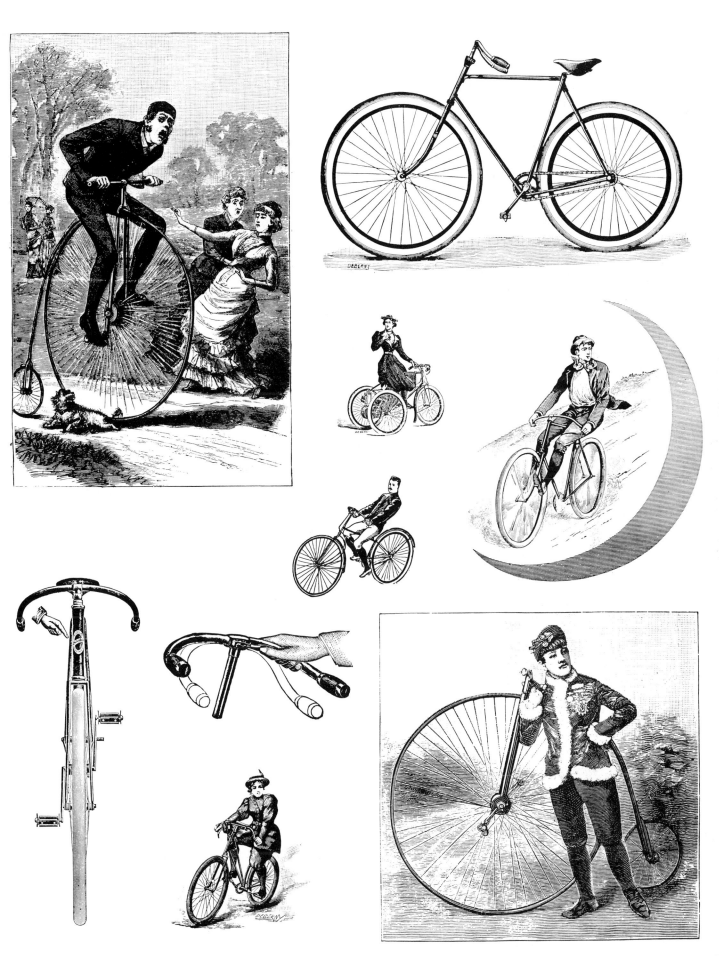

BIRDS

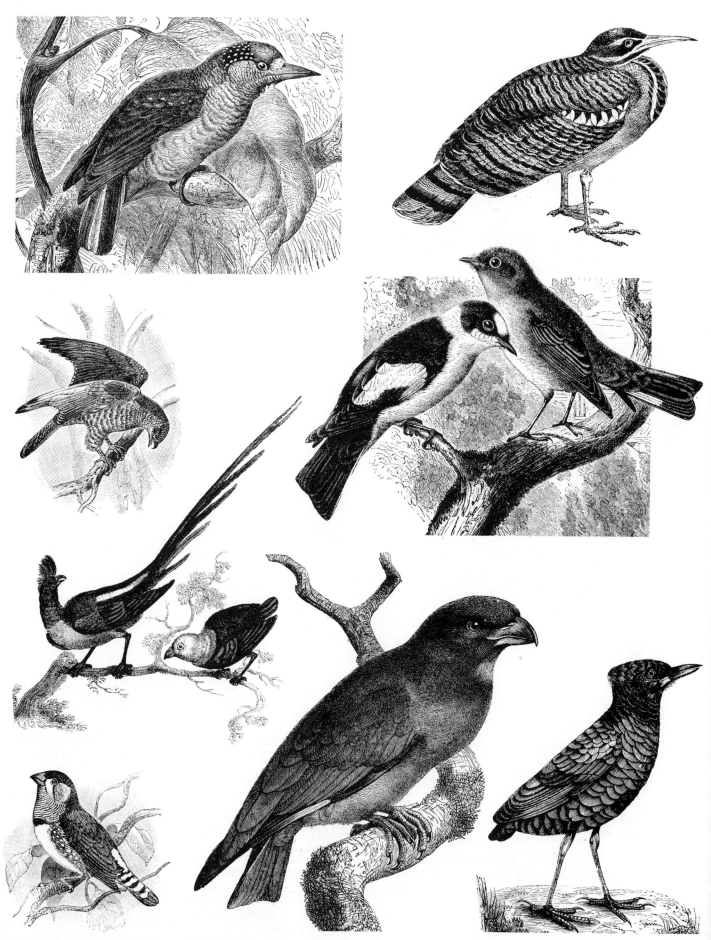

BORDERS & FRAMES

BORDERS & FRAMES (continued)

FIAT LUX

BORDERS & FRAMES (continued)

61

BRACELETS

BRACELETS (continued)

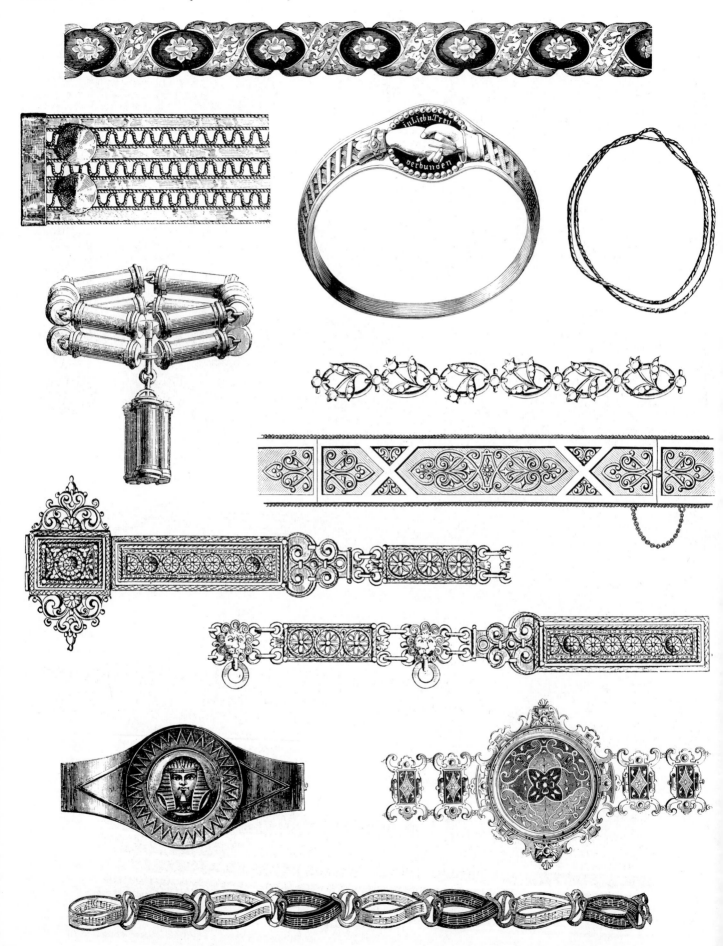

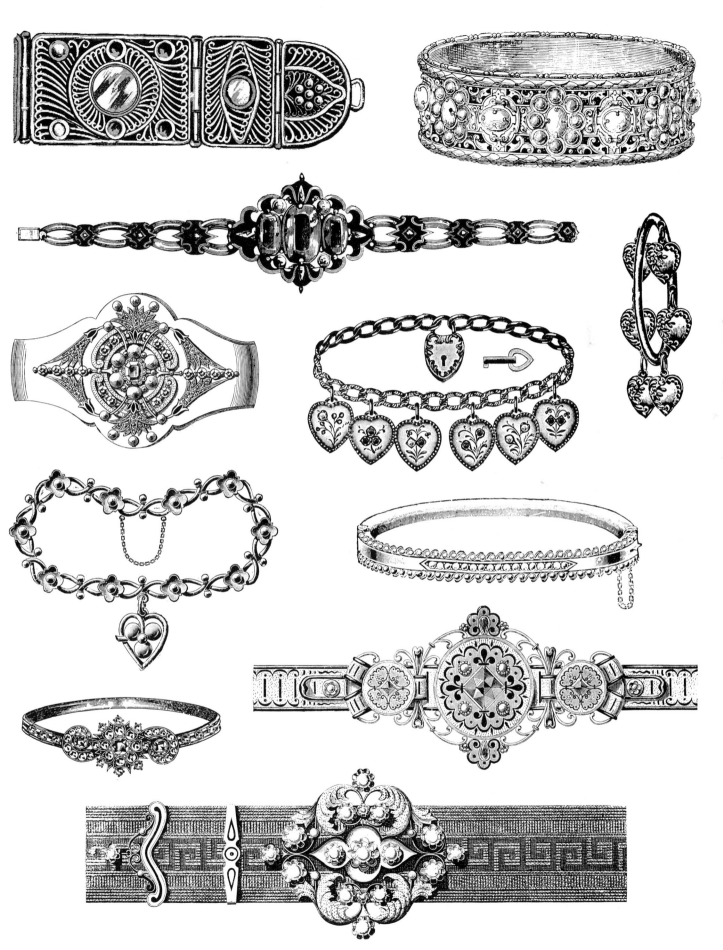

BRIDGES

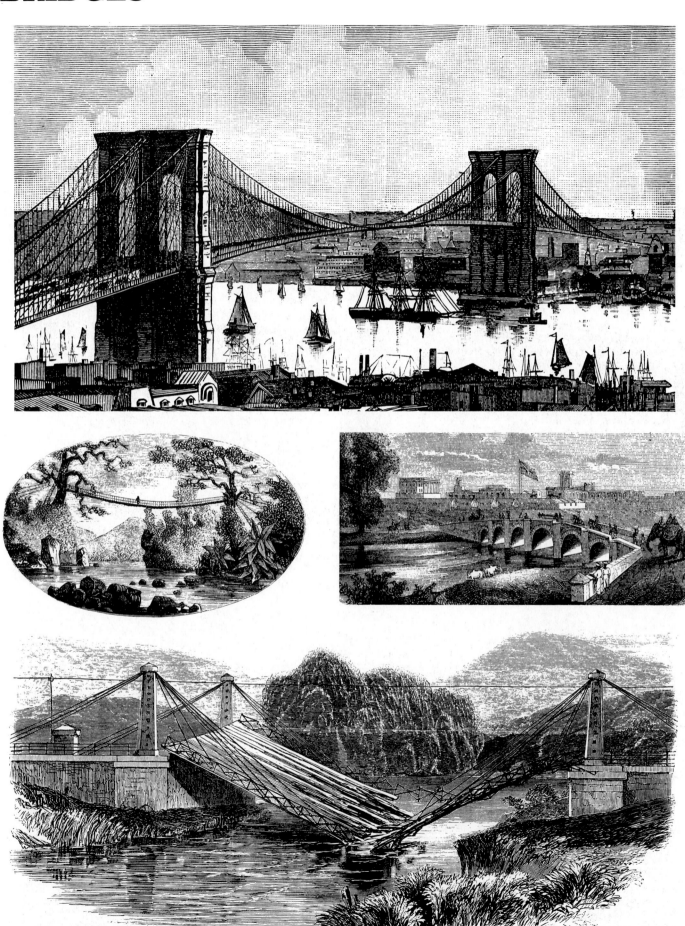

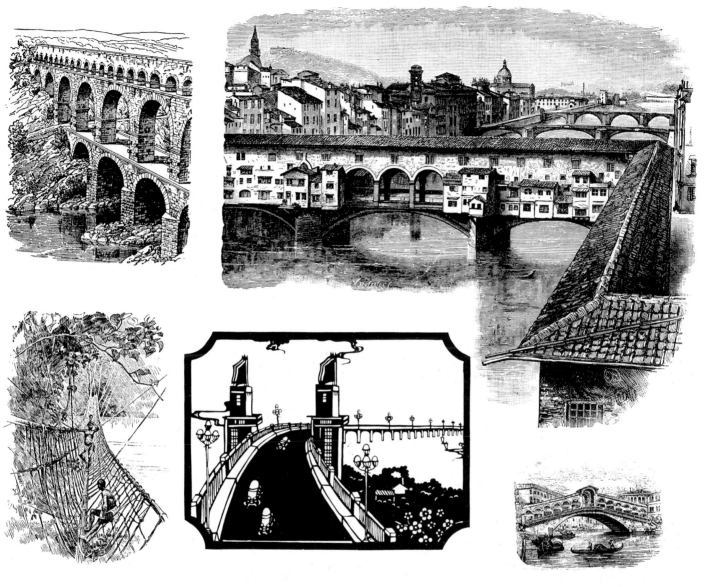

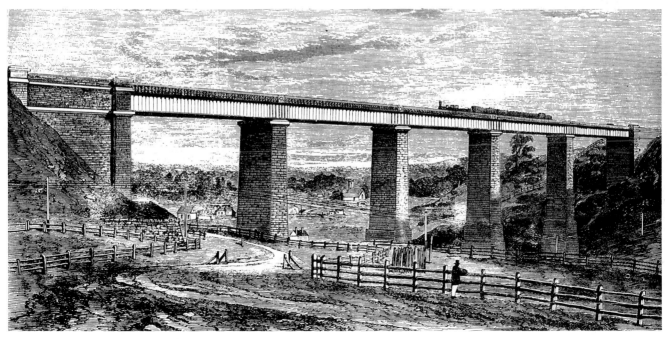

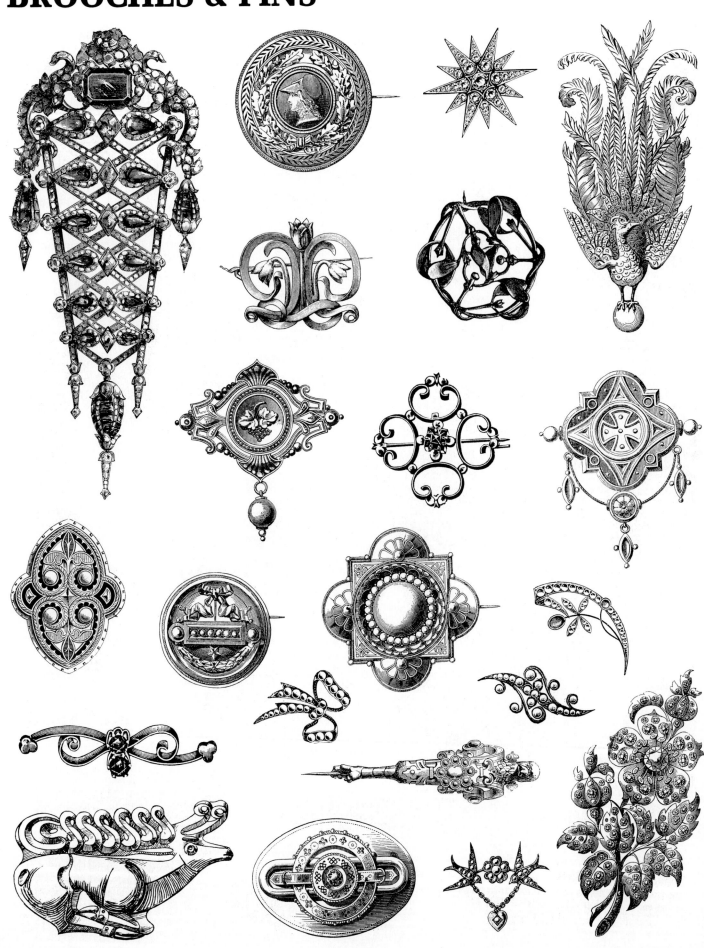

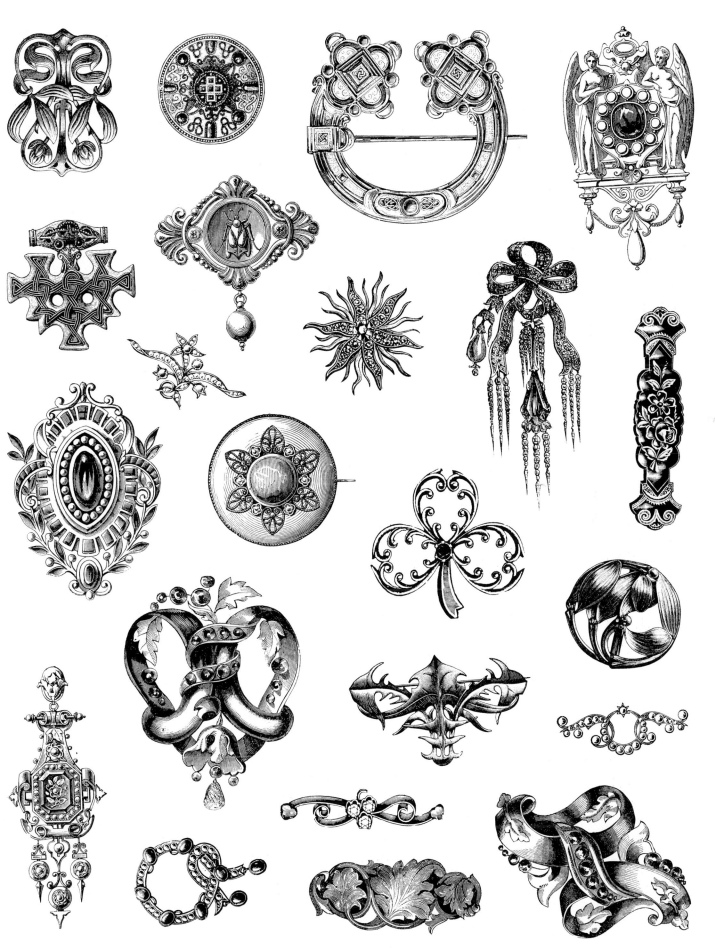

BROOCHES & PINS (continued)

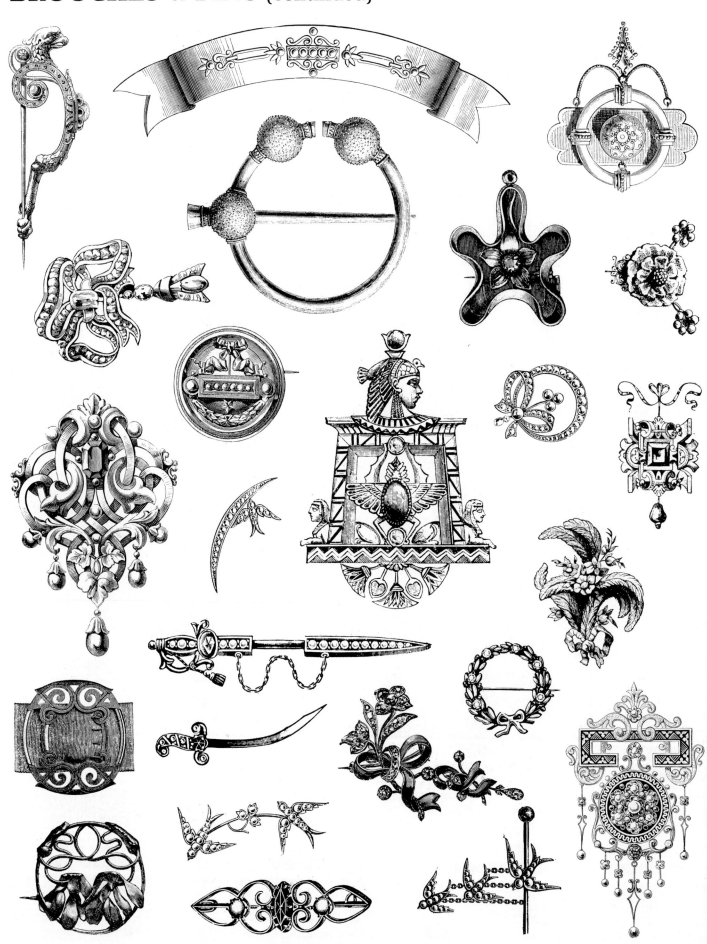

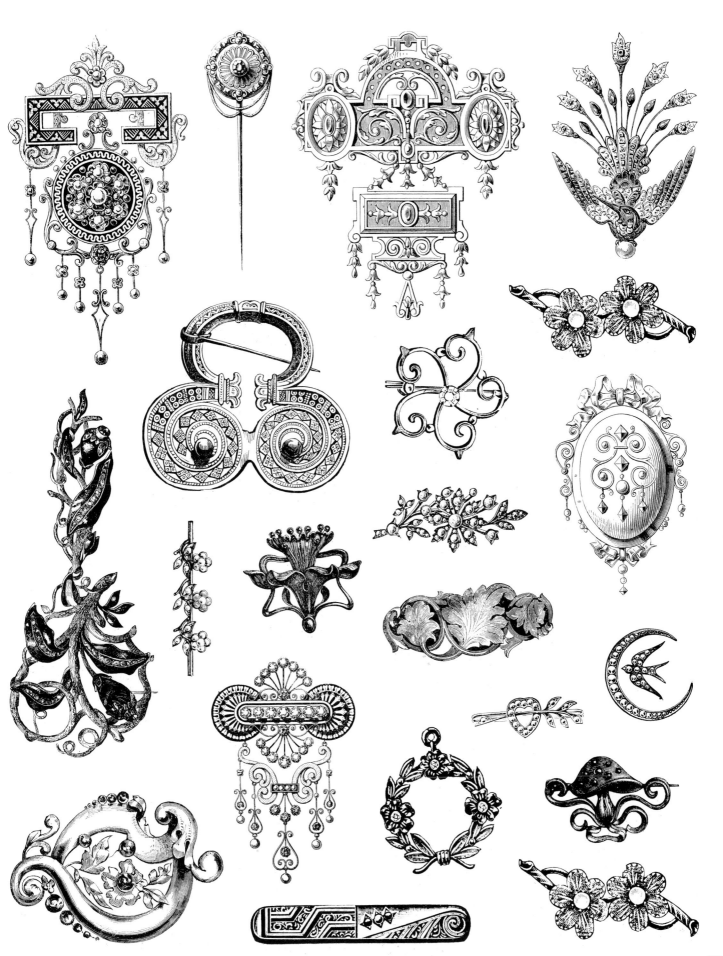

BUILDINGS

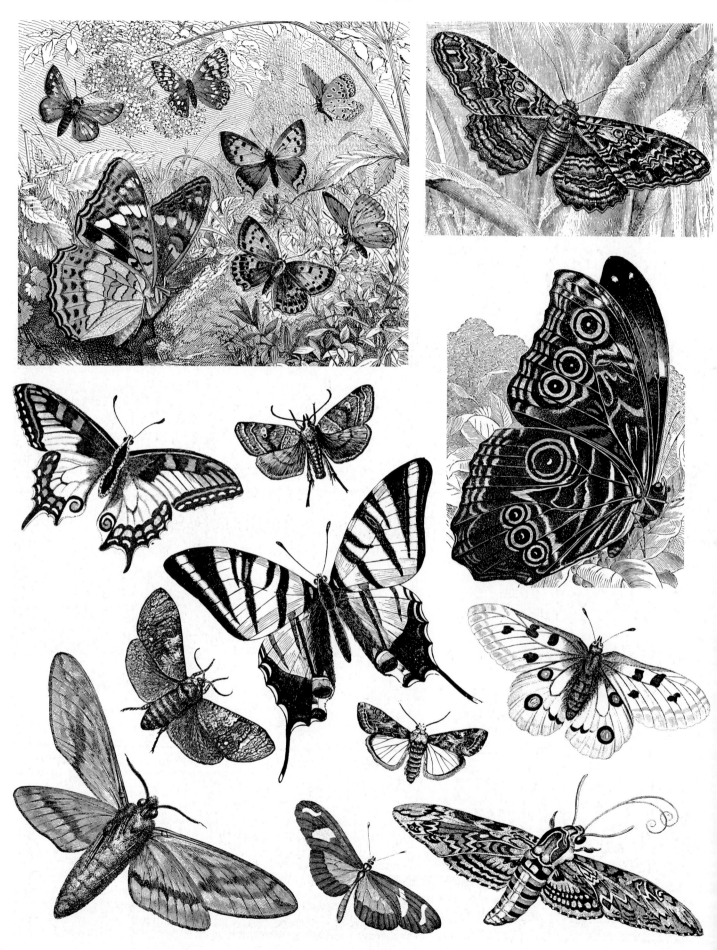

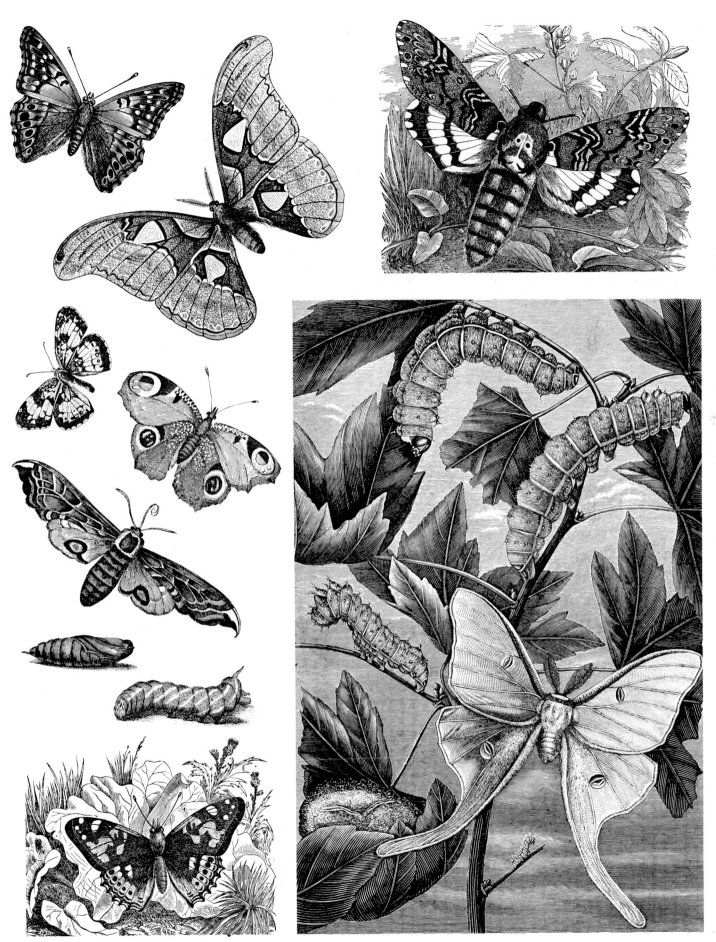

CAMELS & LLAMAS

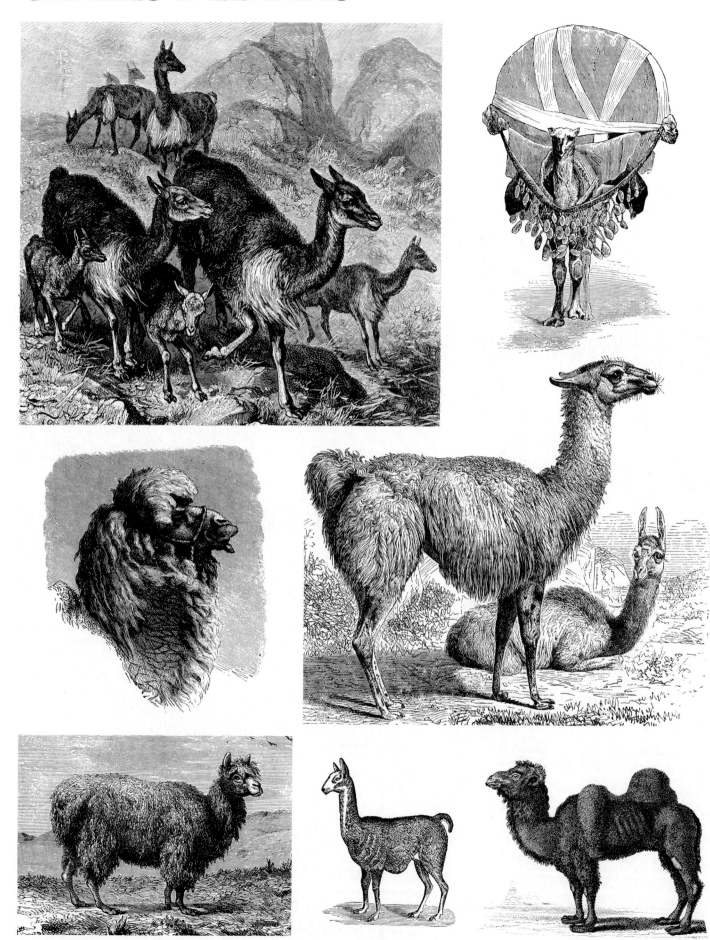

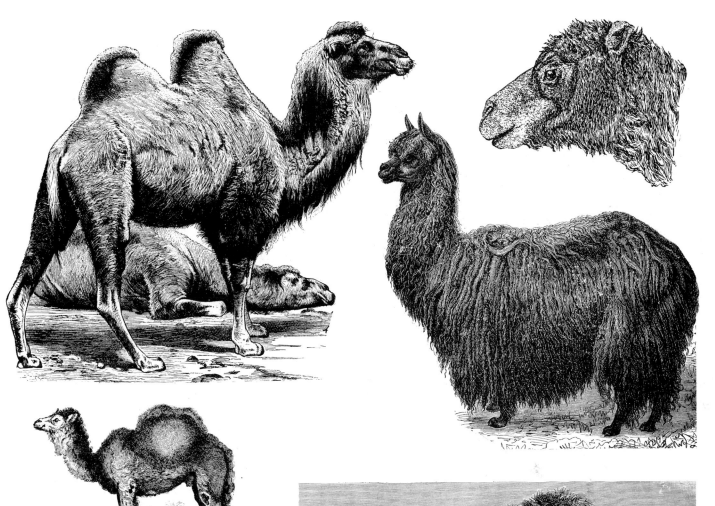

CAMEOS

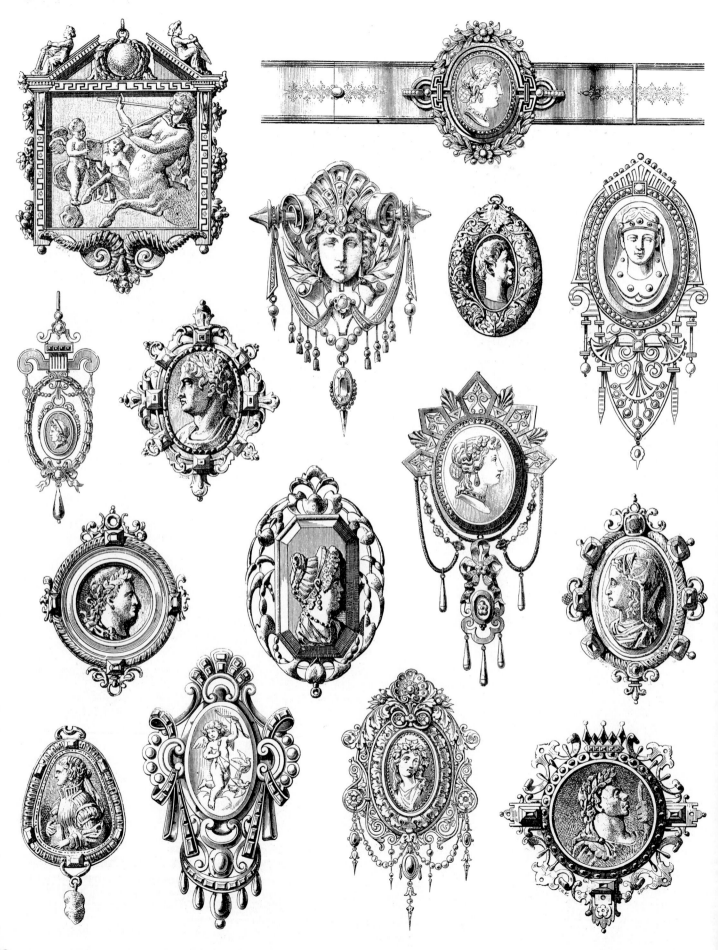

CARICATURES

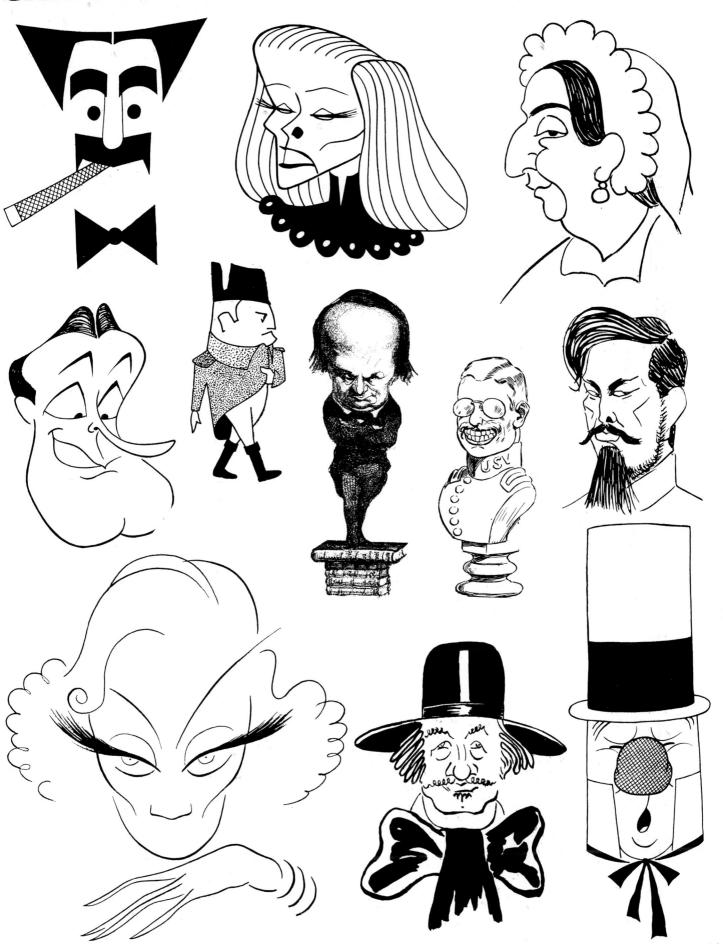

CATS

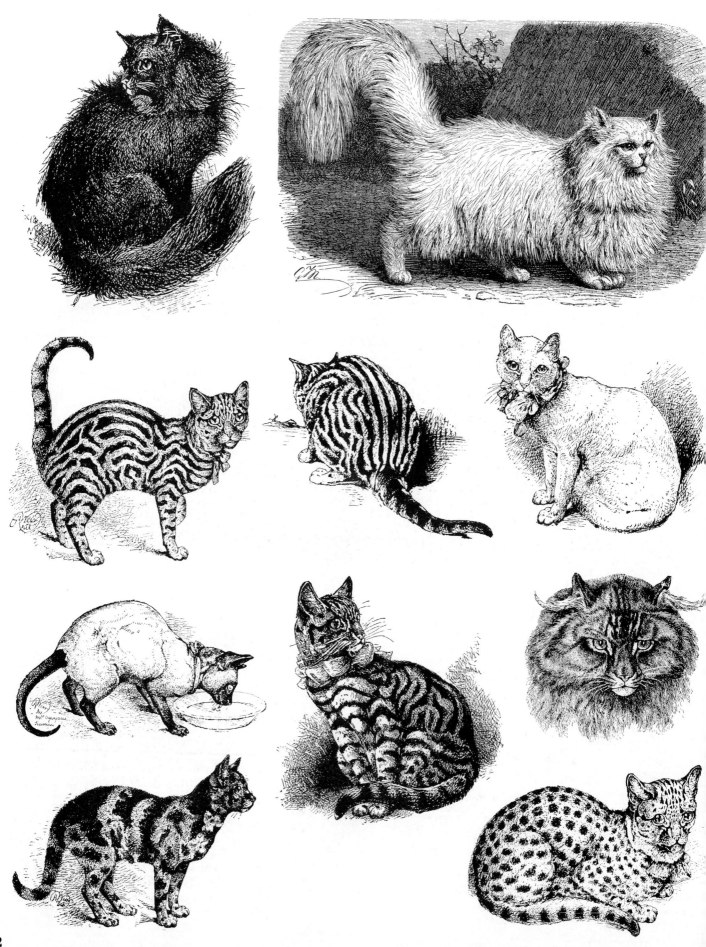

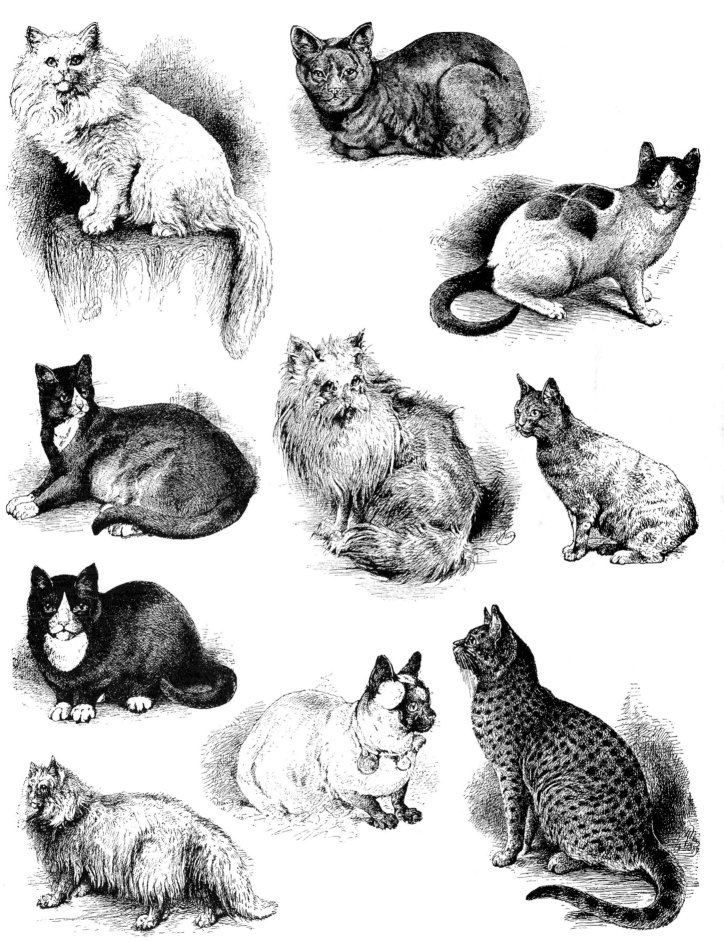

CATTLE

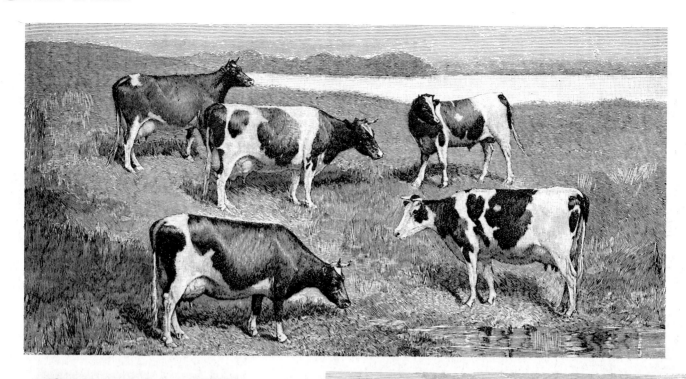

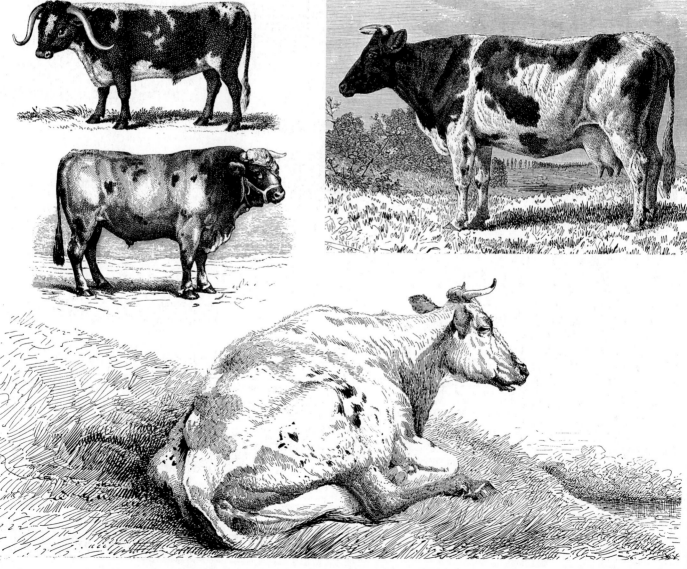

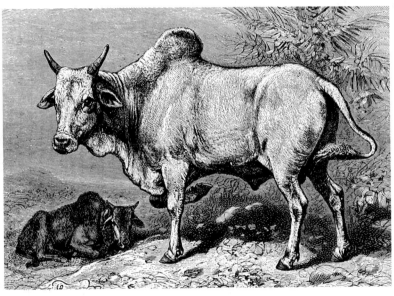

CELEBRATED PERSONS

CHAIRS

CHILDREN

CHRISTMAS

MERRY CHRISTMAS
SEASON'S GREETINGS

MERRY CHRISTMAS
SEASON'S GREETINGS

CITY SCENES

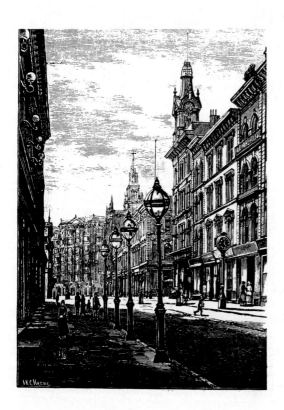

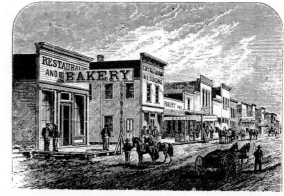

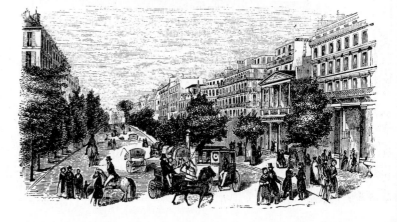

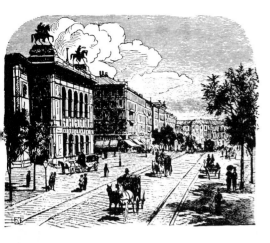

CLASSIC SCENES

CLERGY

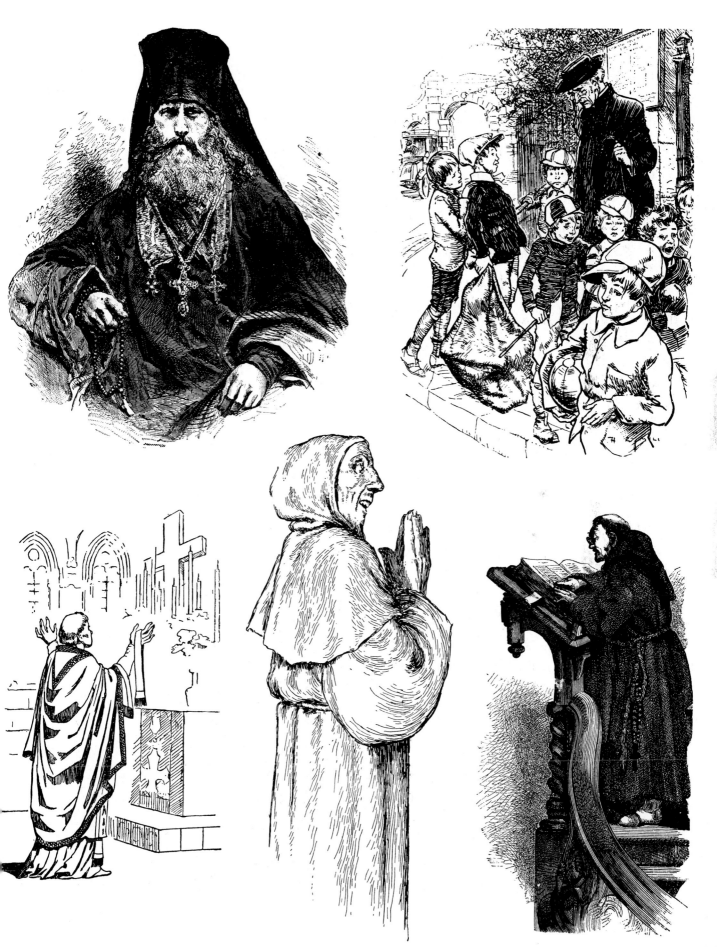

CLOUDS

100

COACHMEN

COINS

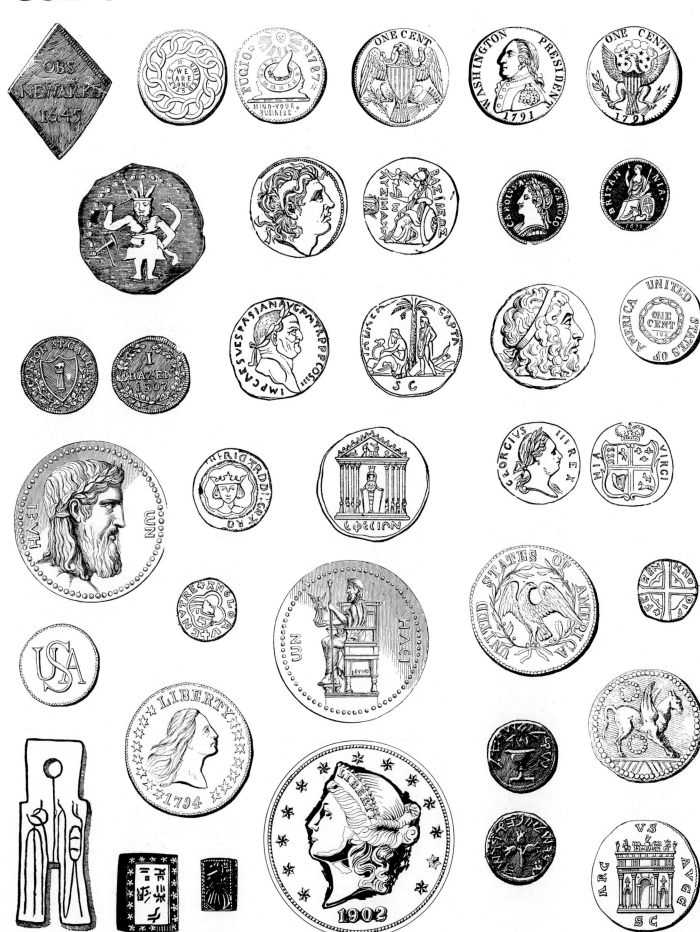

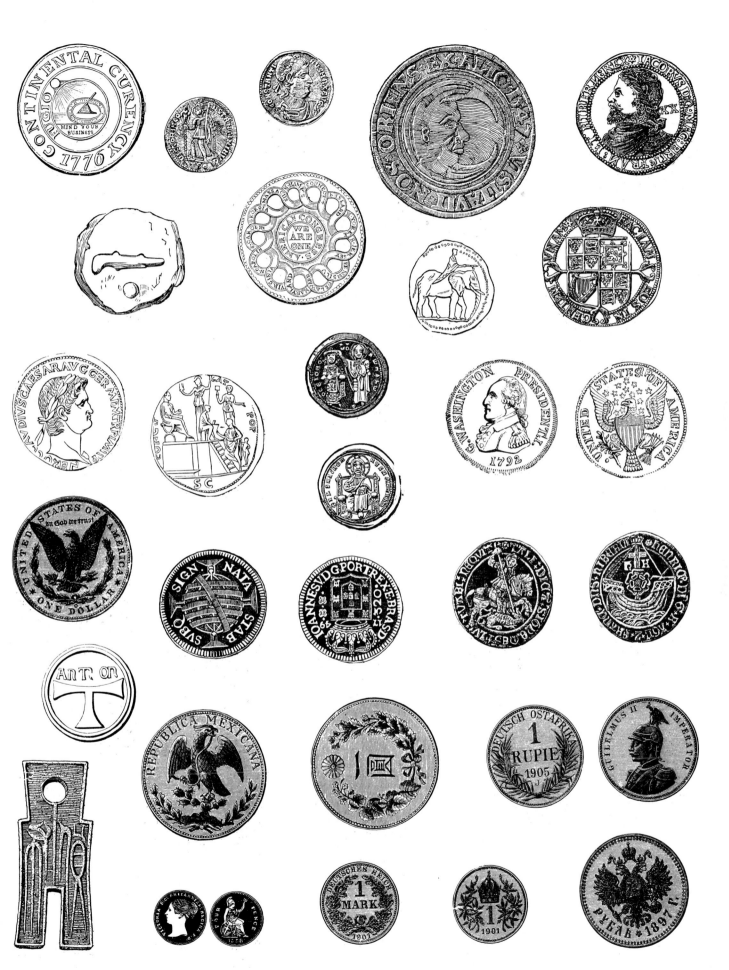

COMIC FIGURES

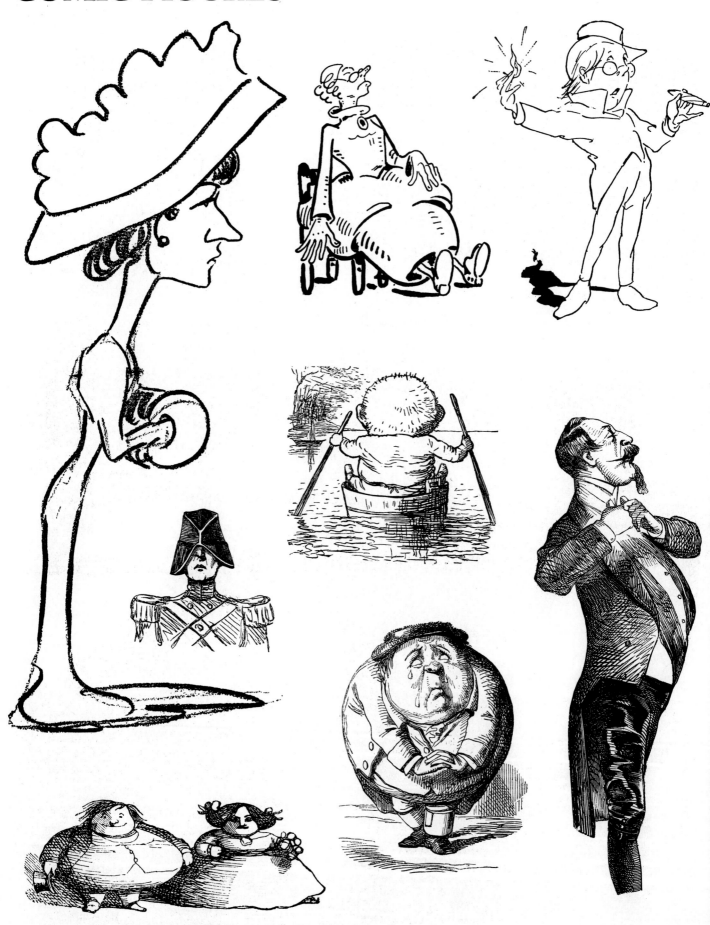

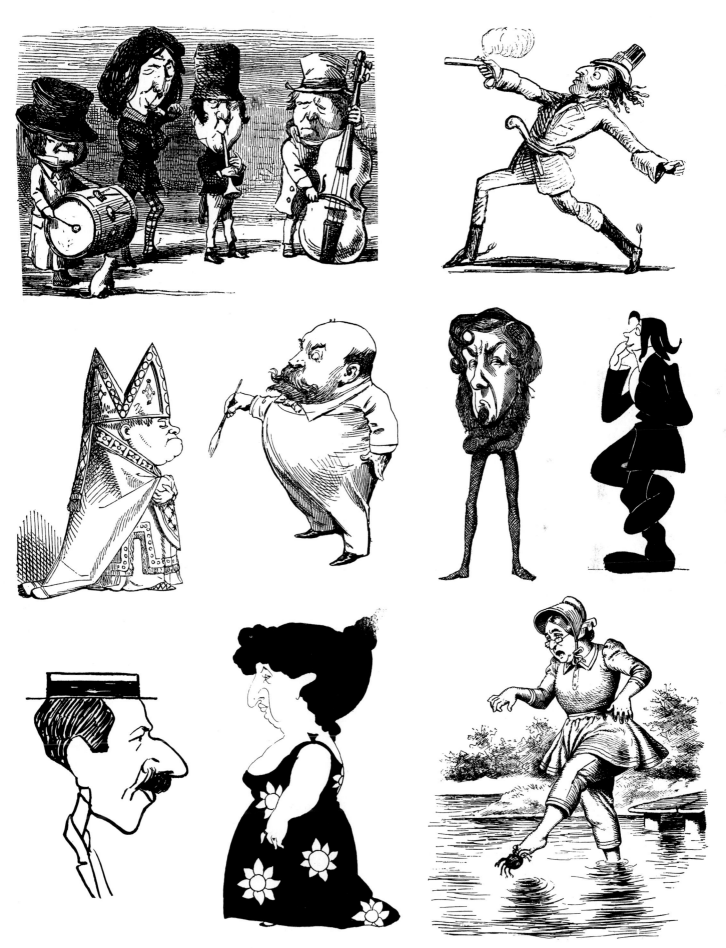

COWBOYS

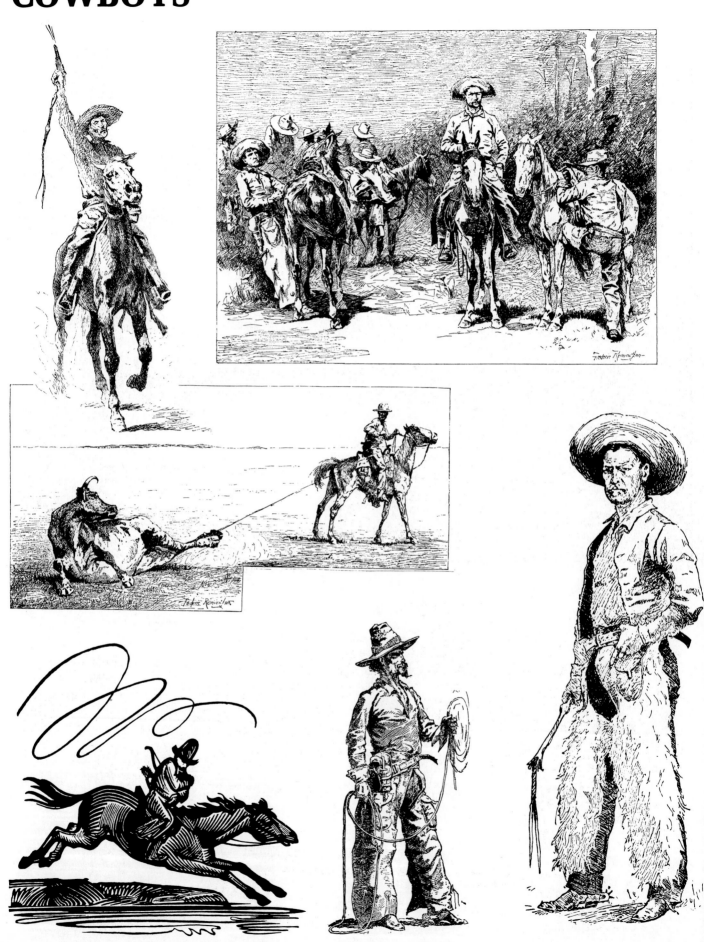

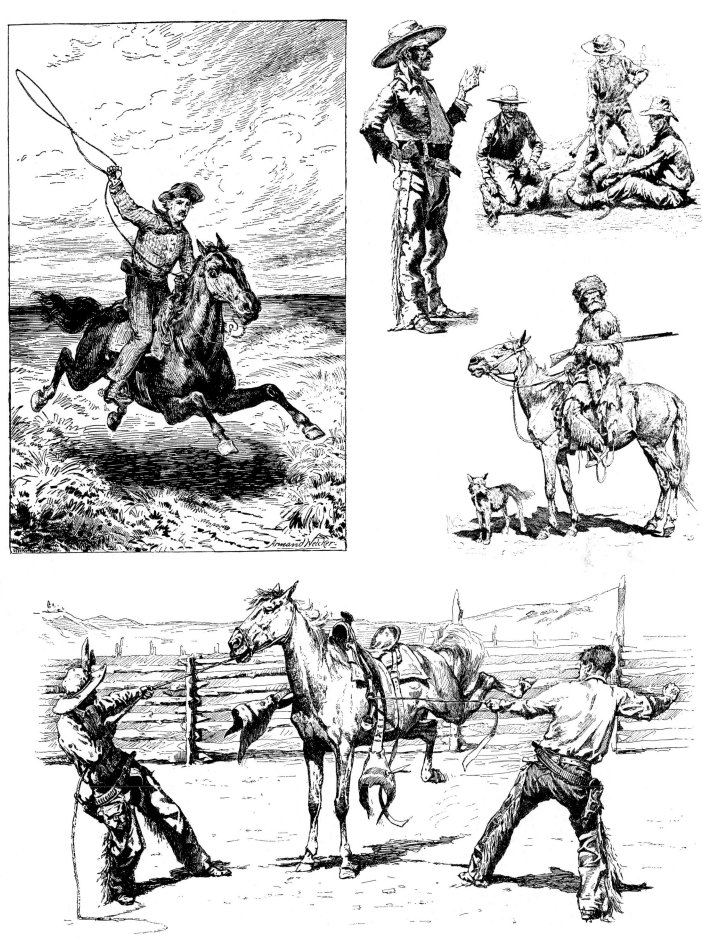

CROWS & BLACKBIRDS

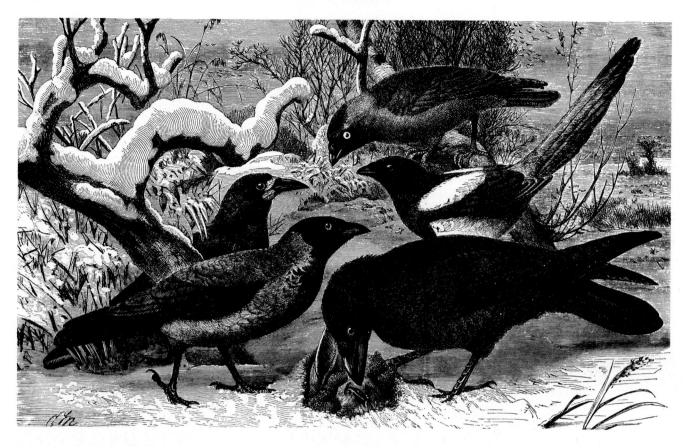

DANCERS

AUBREY BEARDSLEY

DEATH & GRIEVING

DECORATIVE OBJECTS

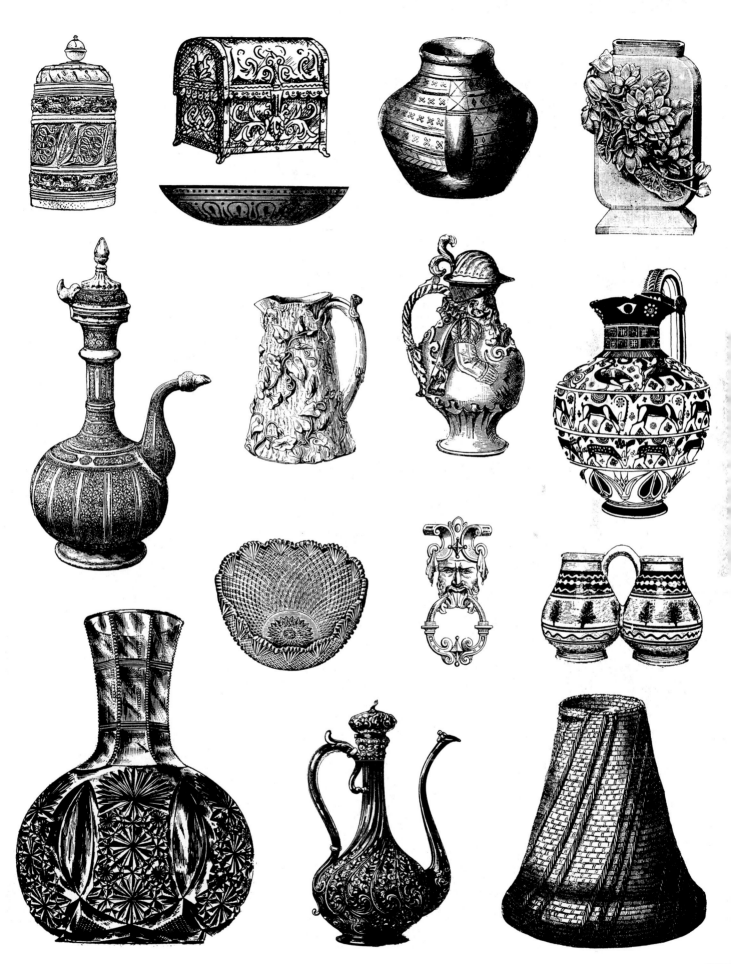

DECORATIVE OBJECTS (continued)

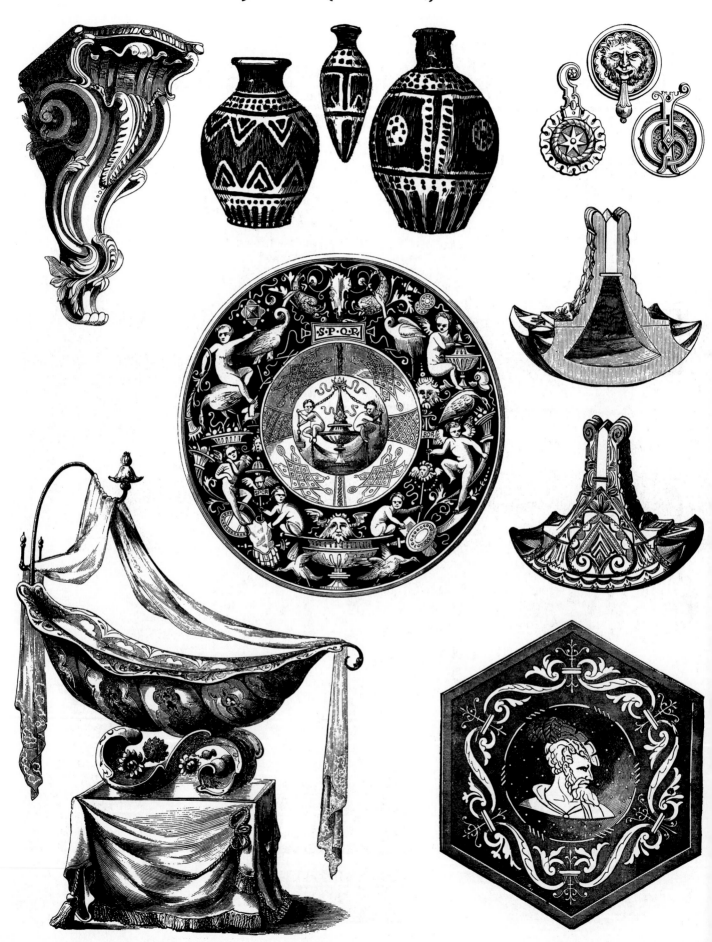

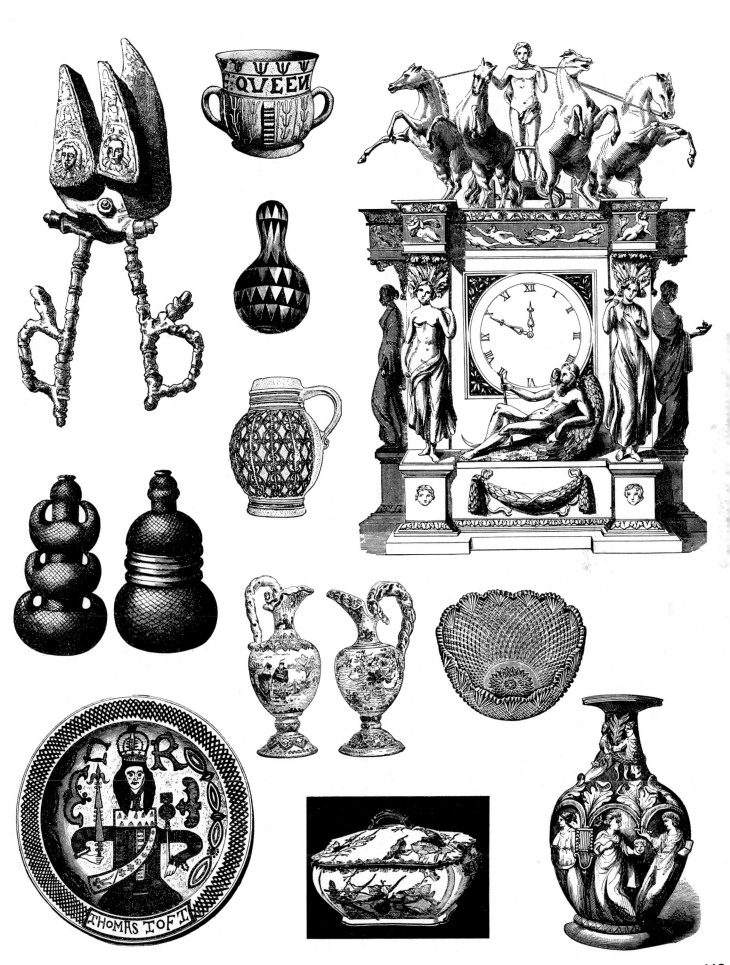

DESIGNS

DESIGNS (continued)

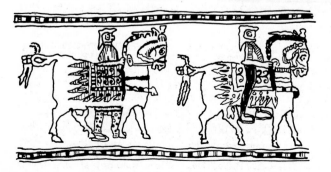

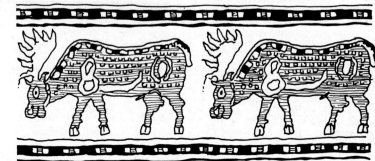

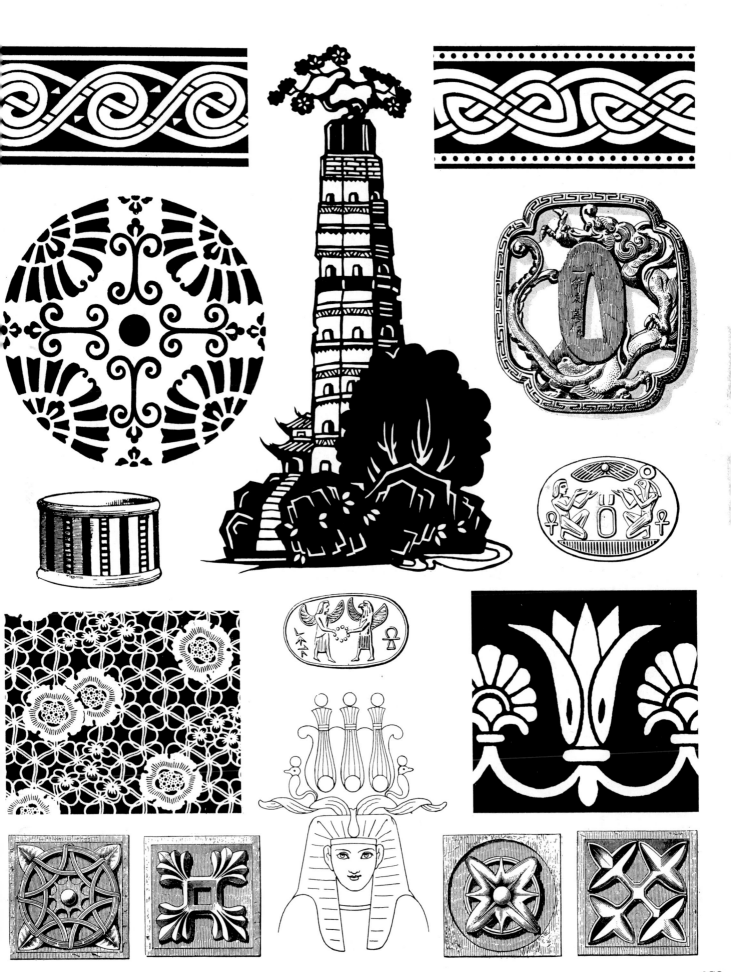

123

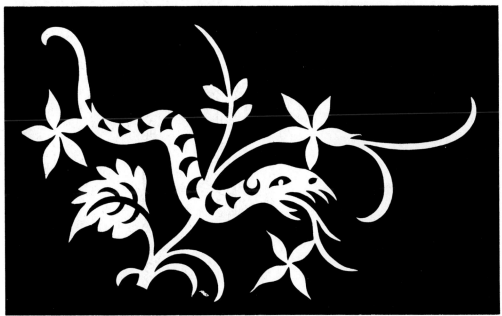

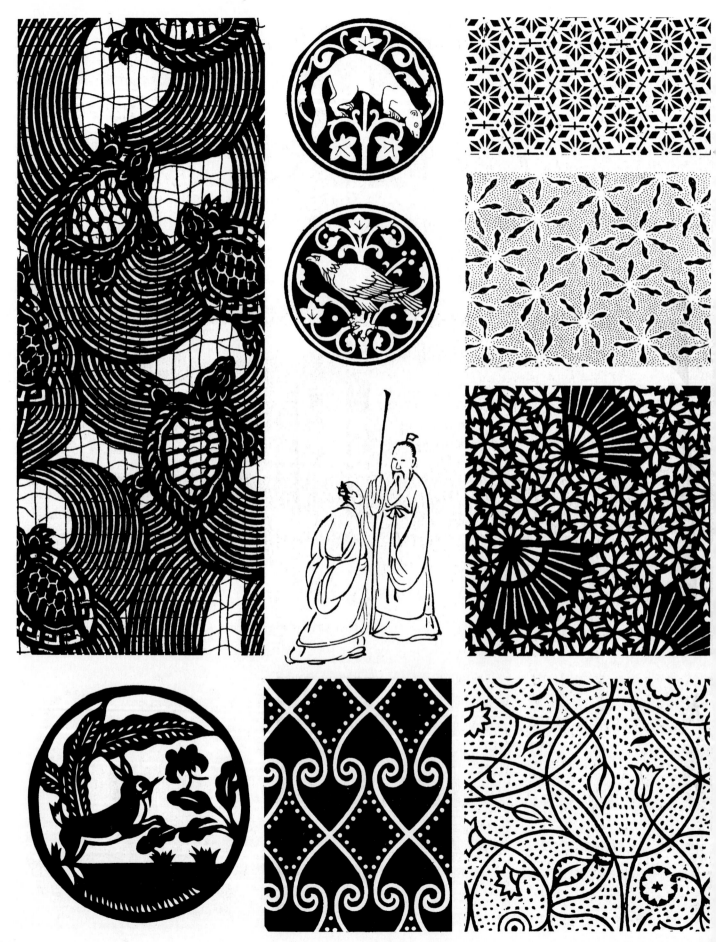

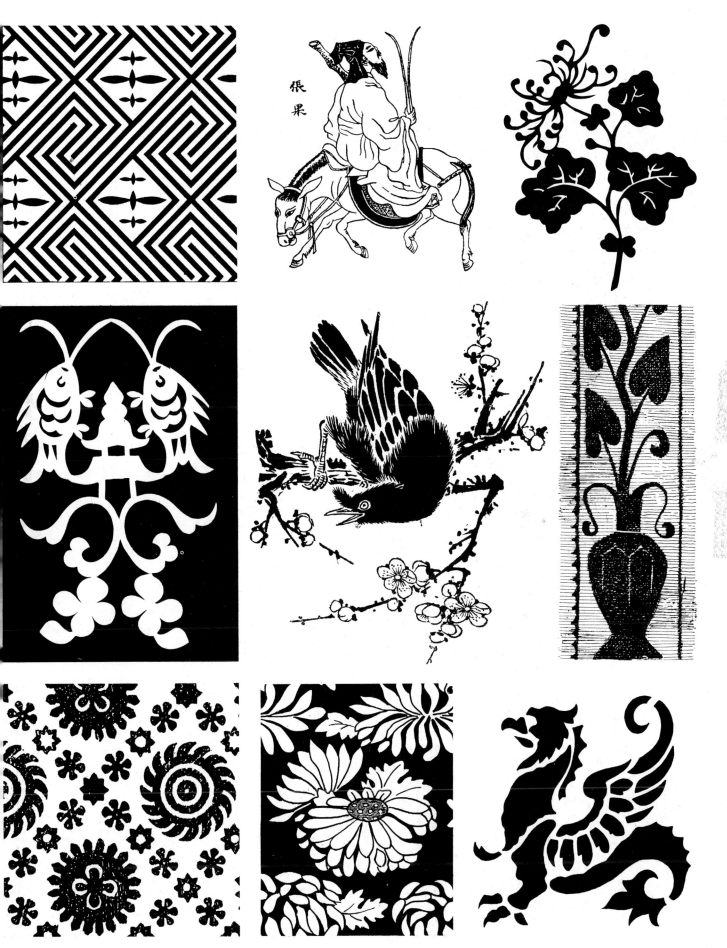

很果

DESIGNS (continued)

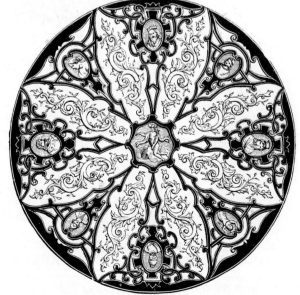

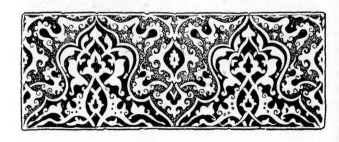

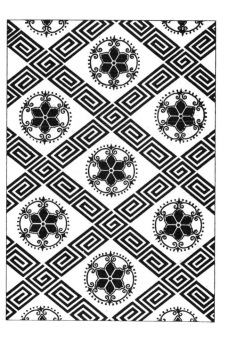
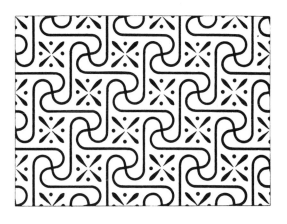

DESIGNS (continued)

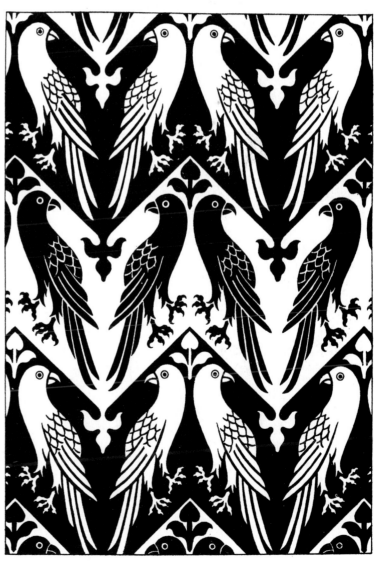

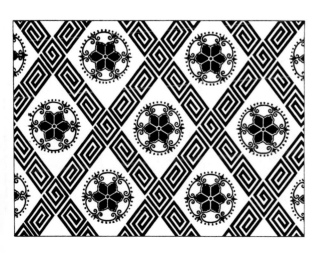

131

DESIGNS (continued)

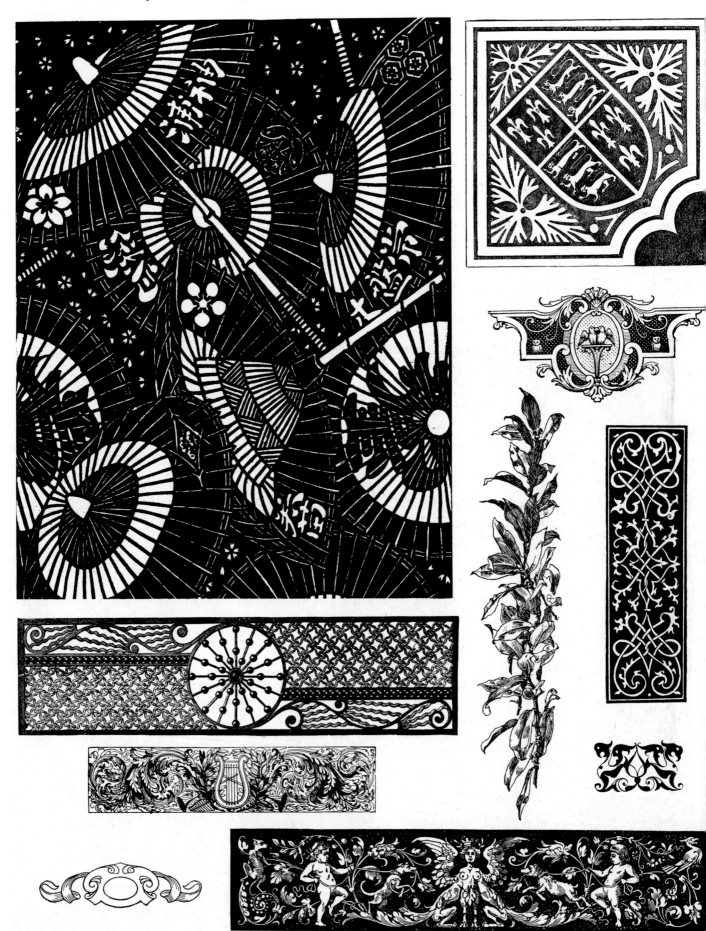

DOGS

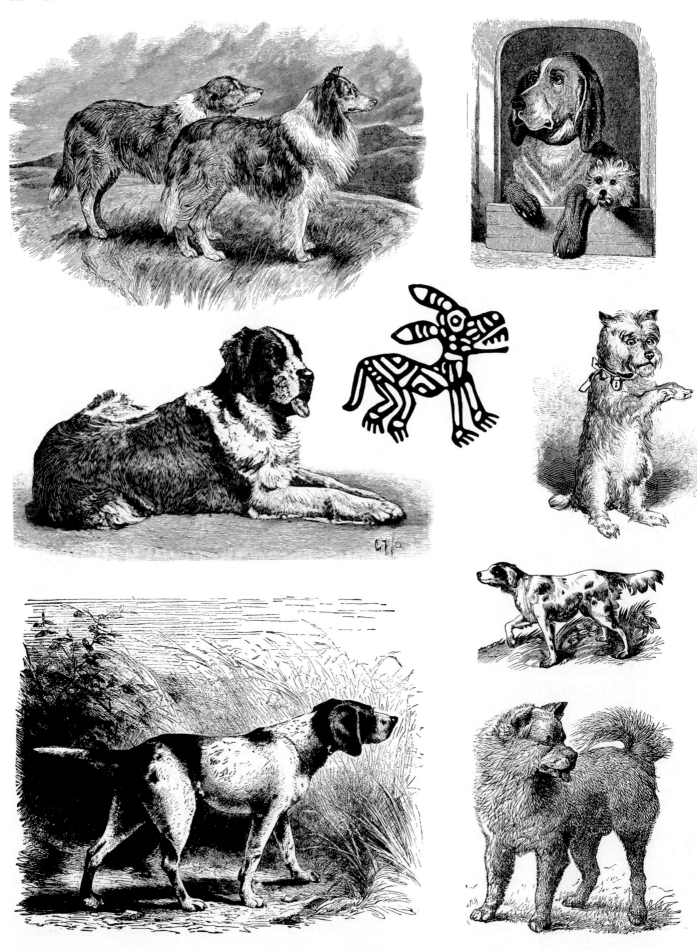

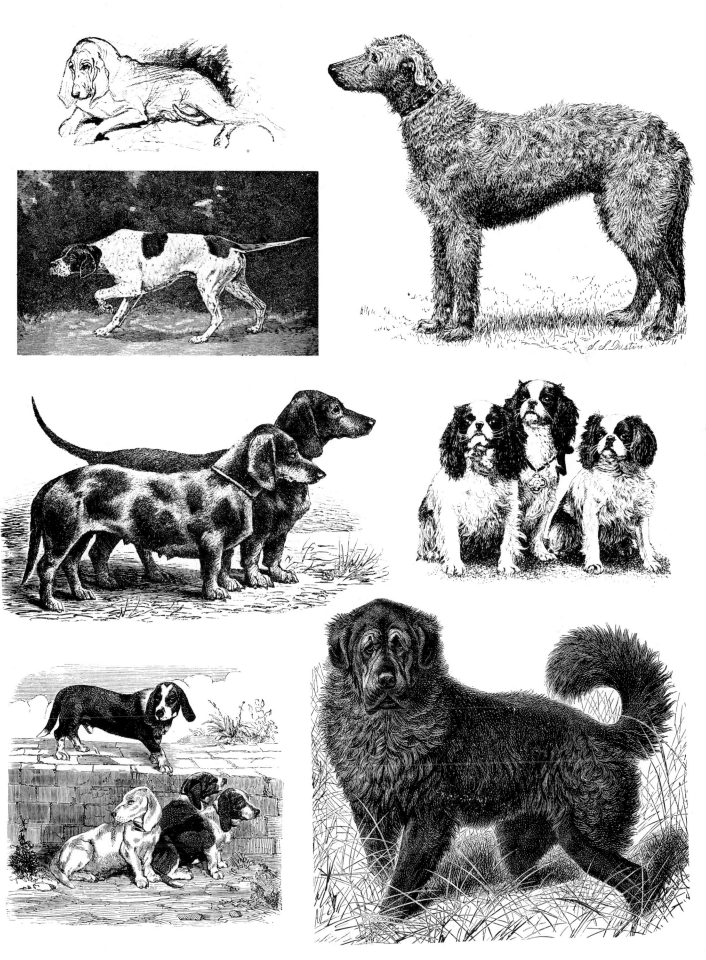

DRINKING

DRINKING (continued)

EARRINGS

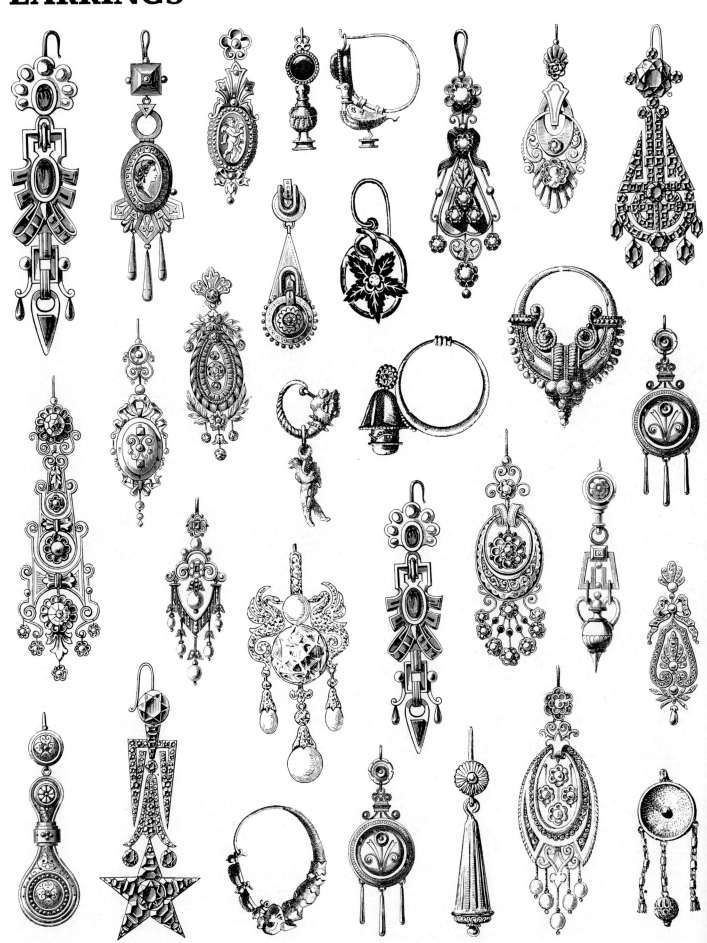

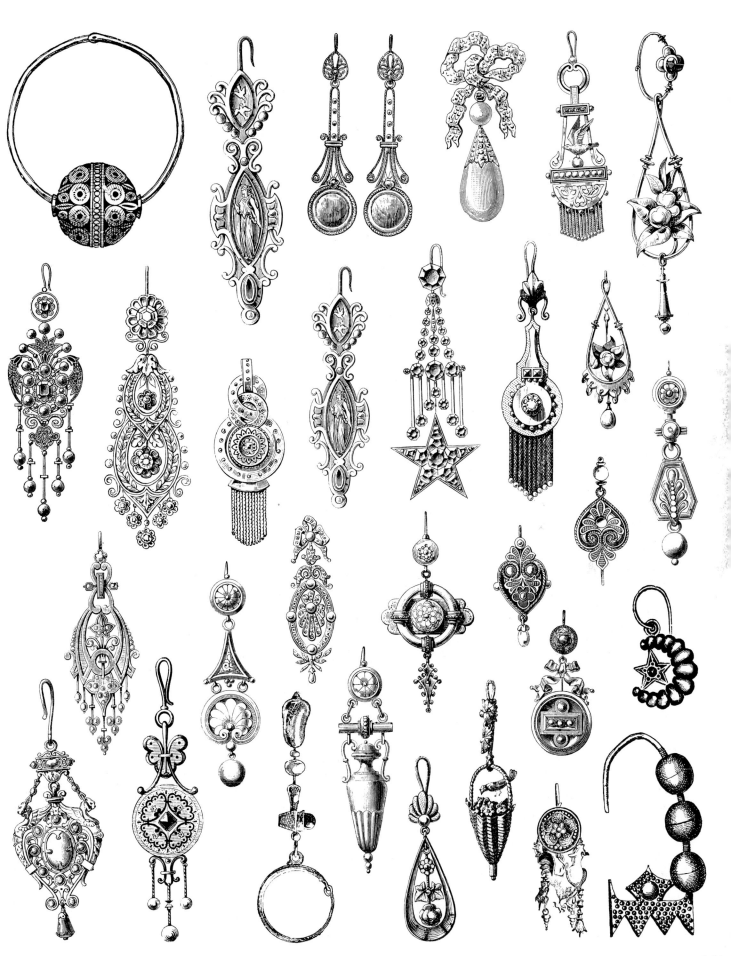

141

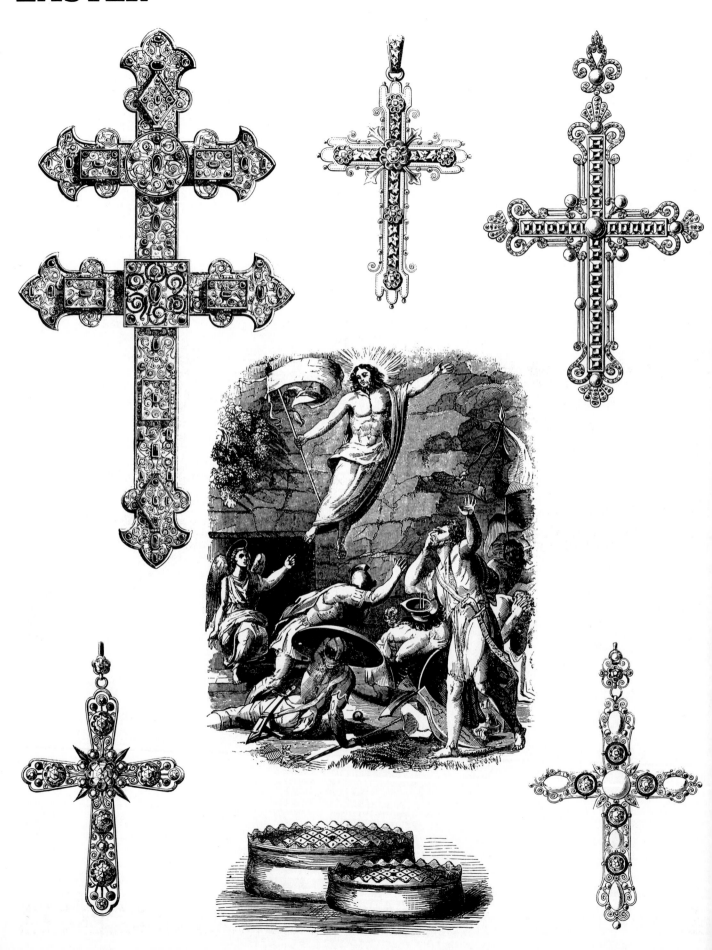

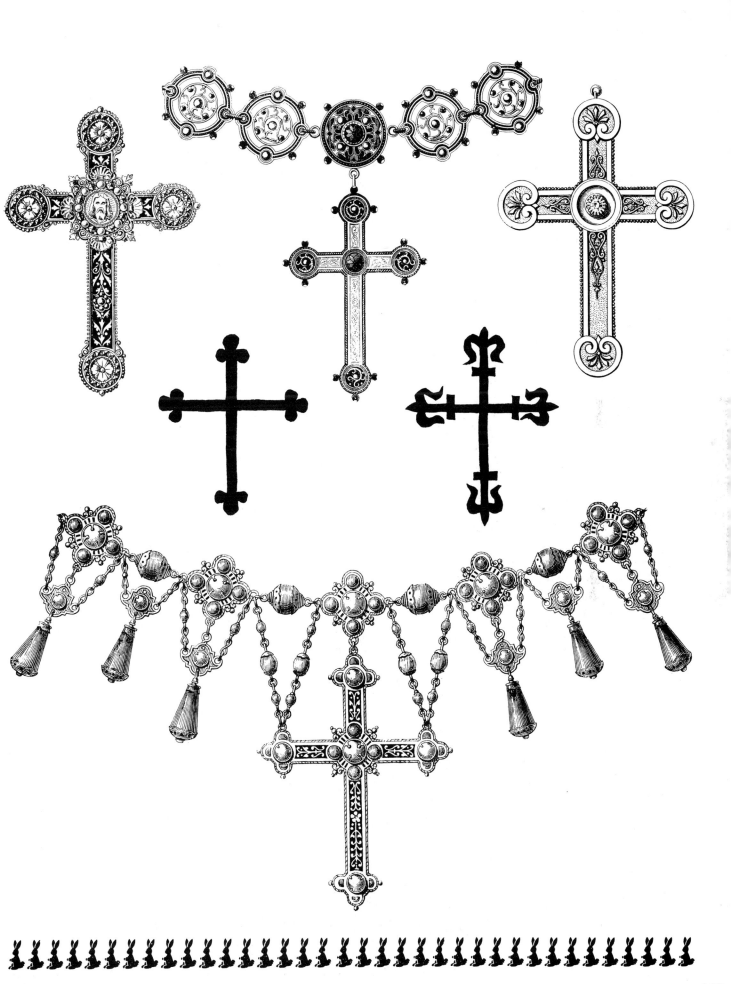

EATING & DINING

Salt the water

Put in colander

ELEPHANTS

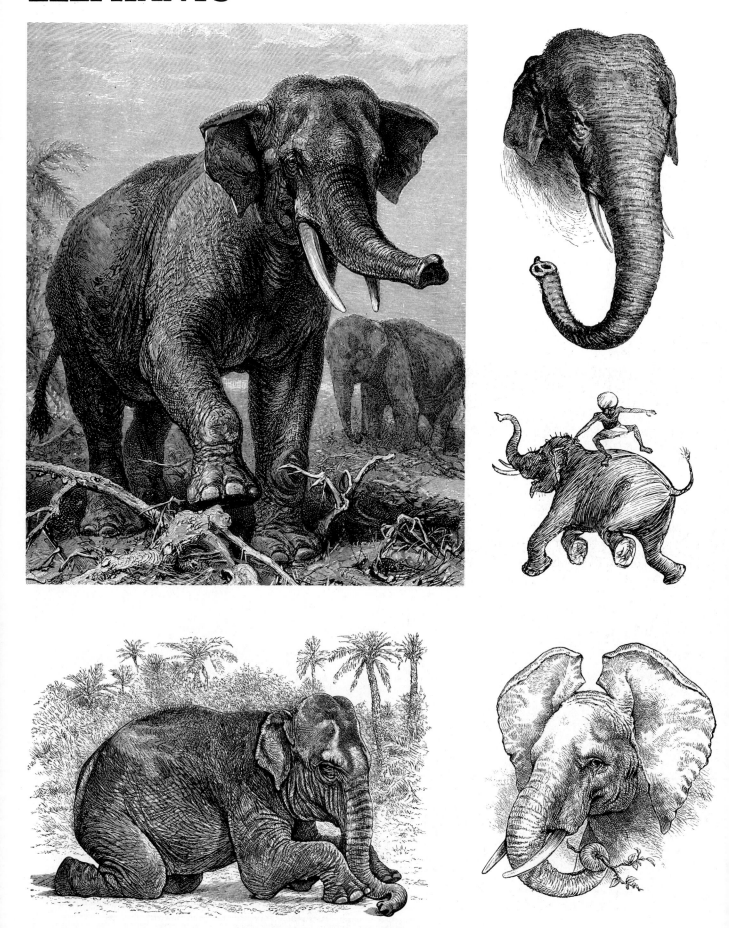

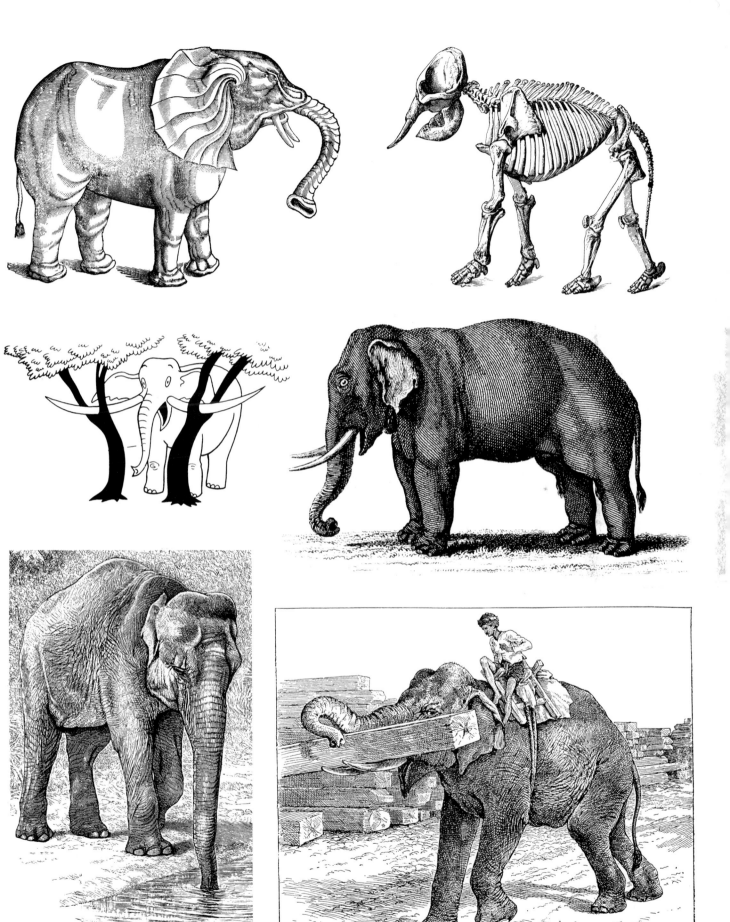

FACES

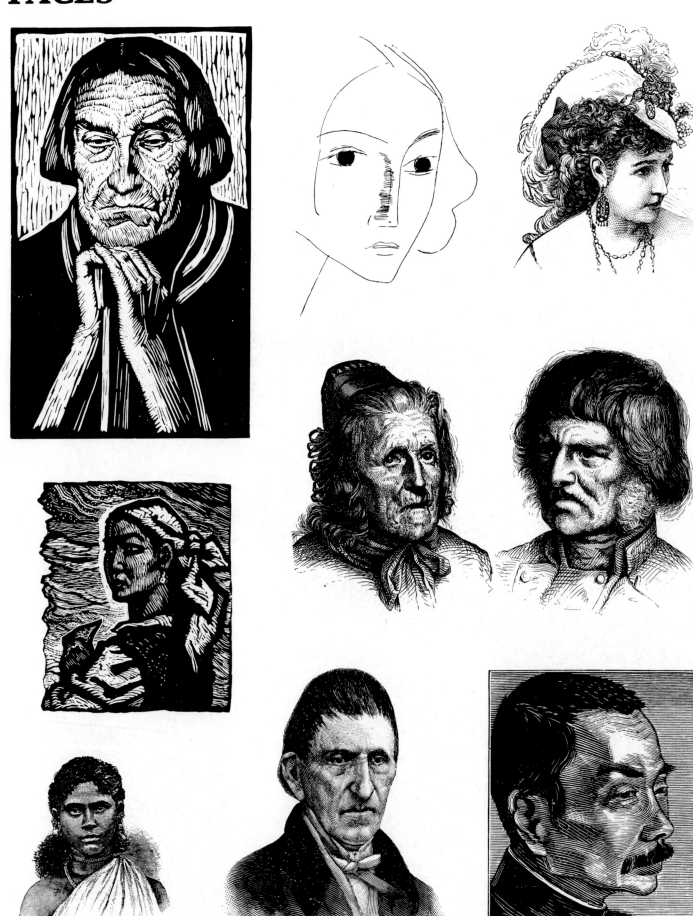

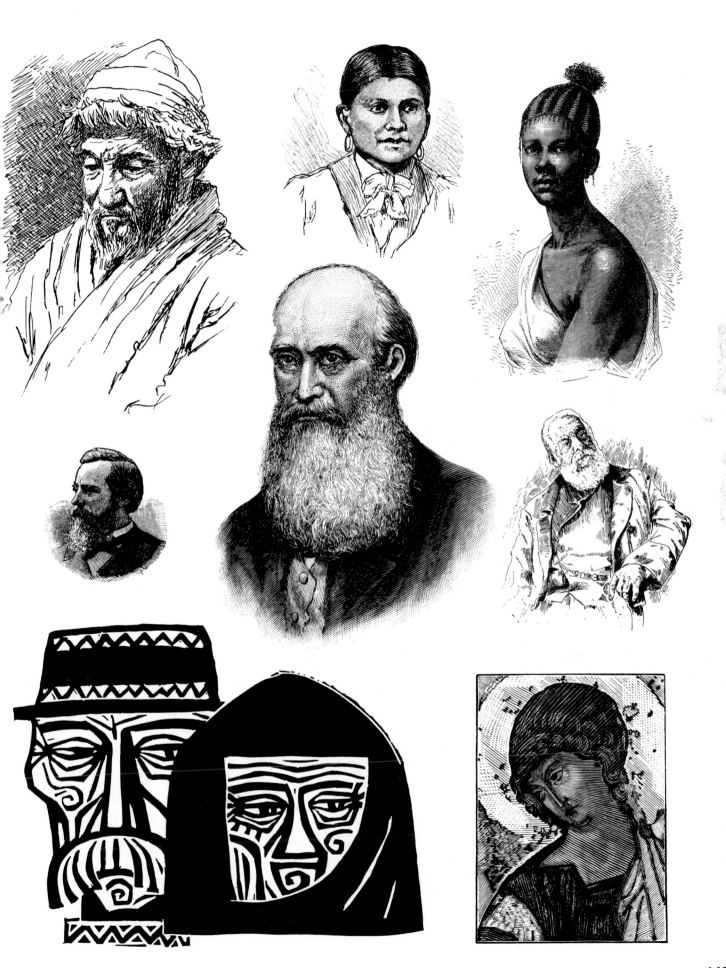

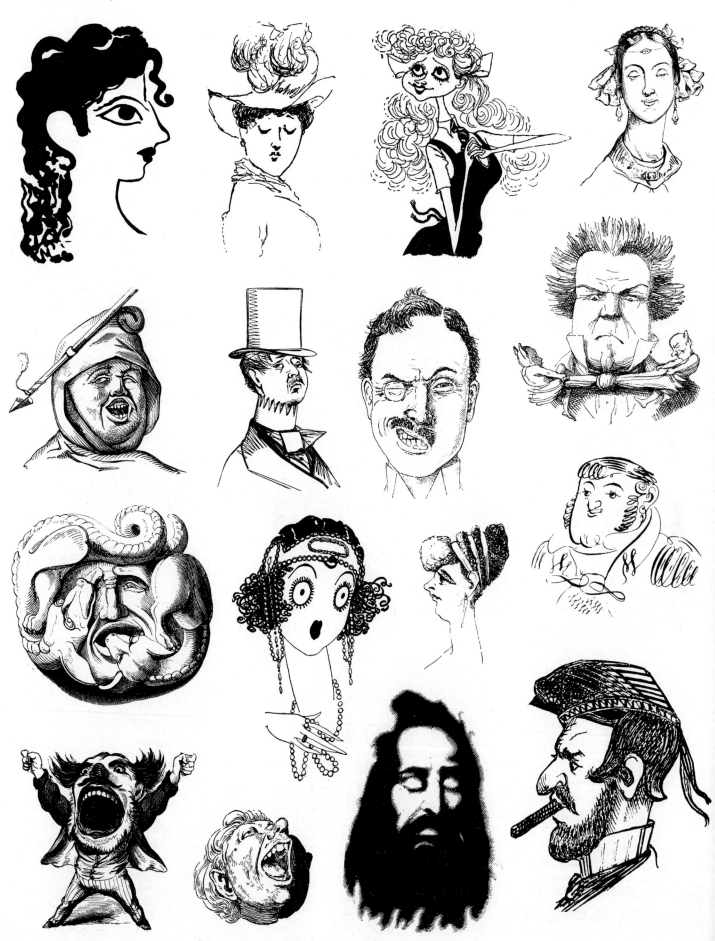

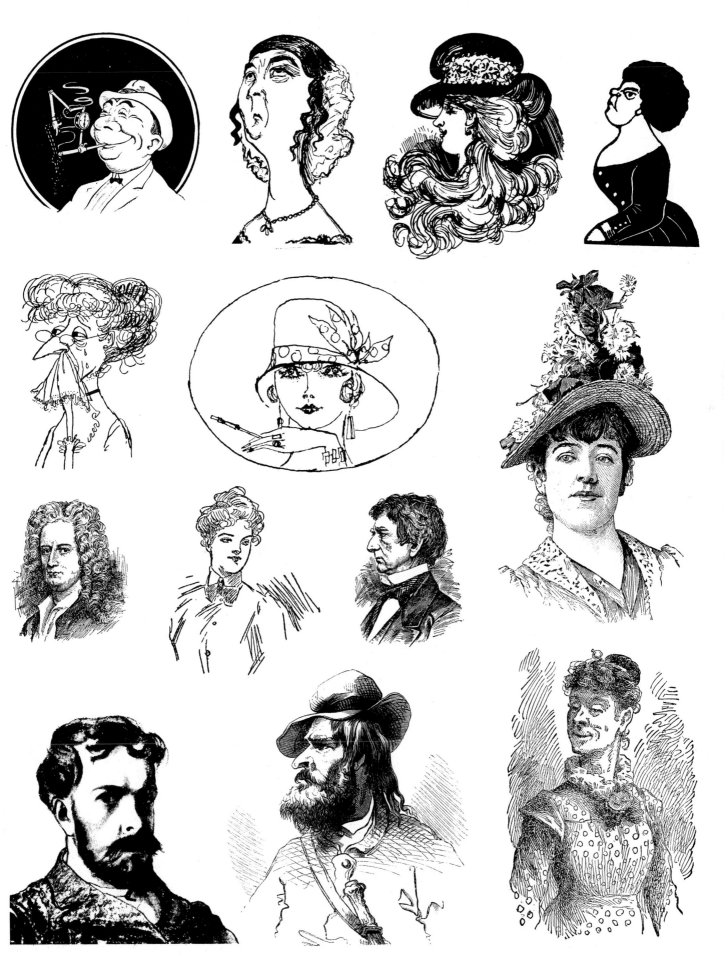

FAMILIES

FANTASIES

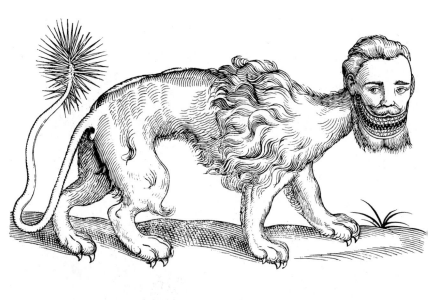

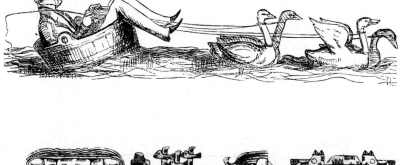

FARMYARD ANIMALS

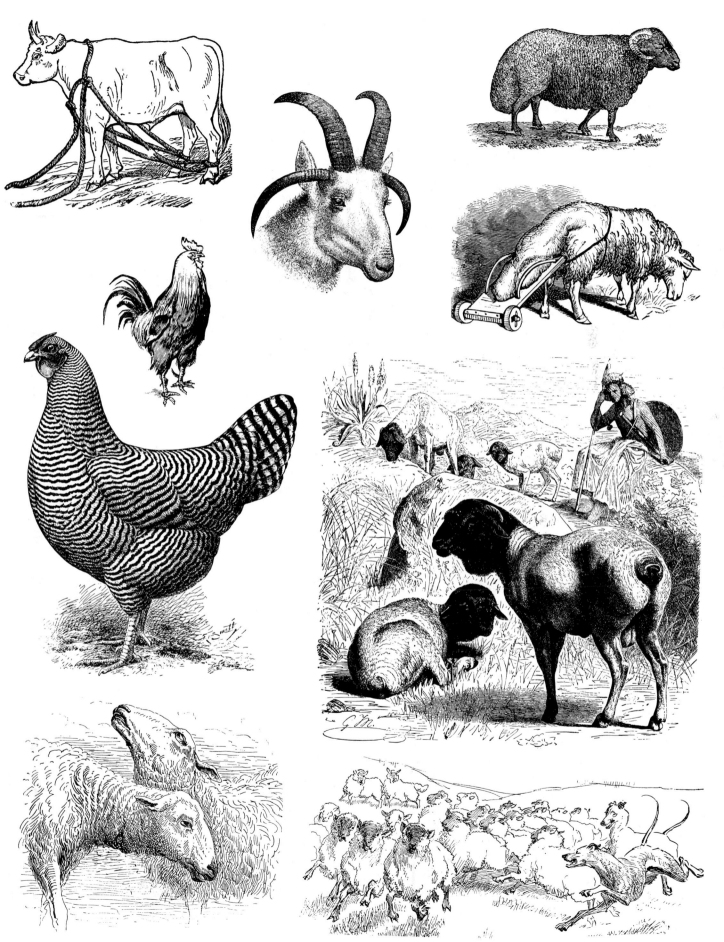

FISH

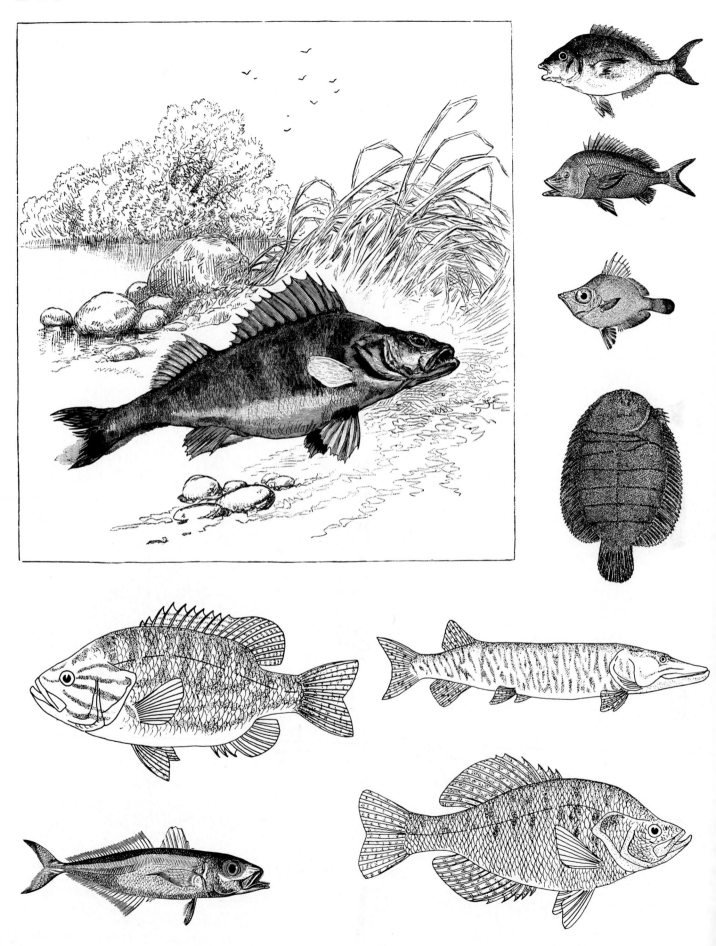

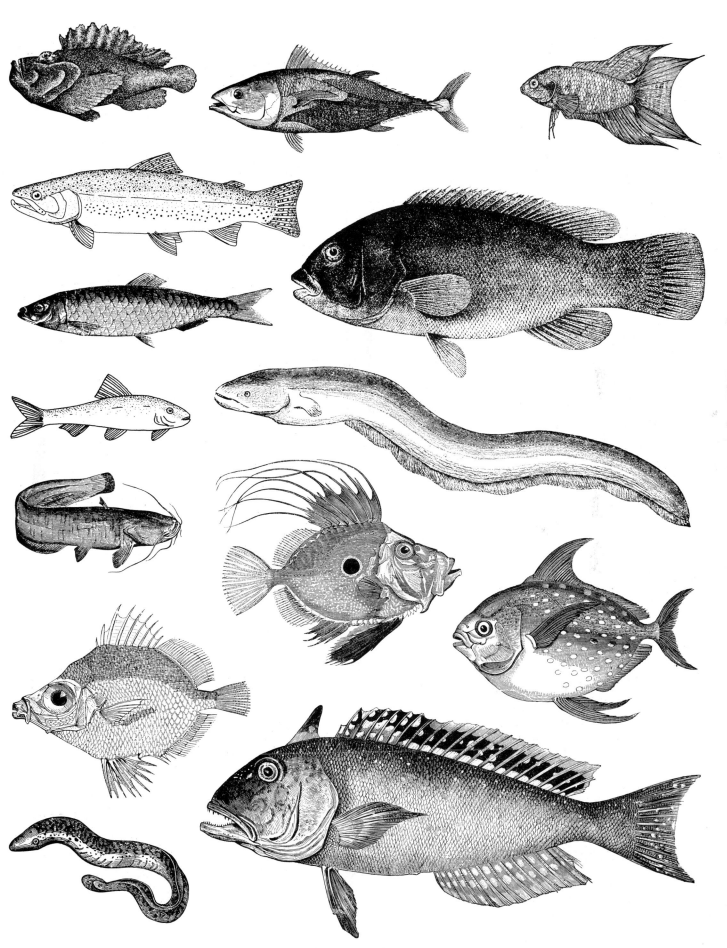

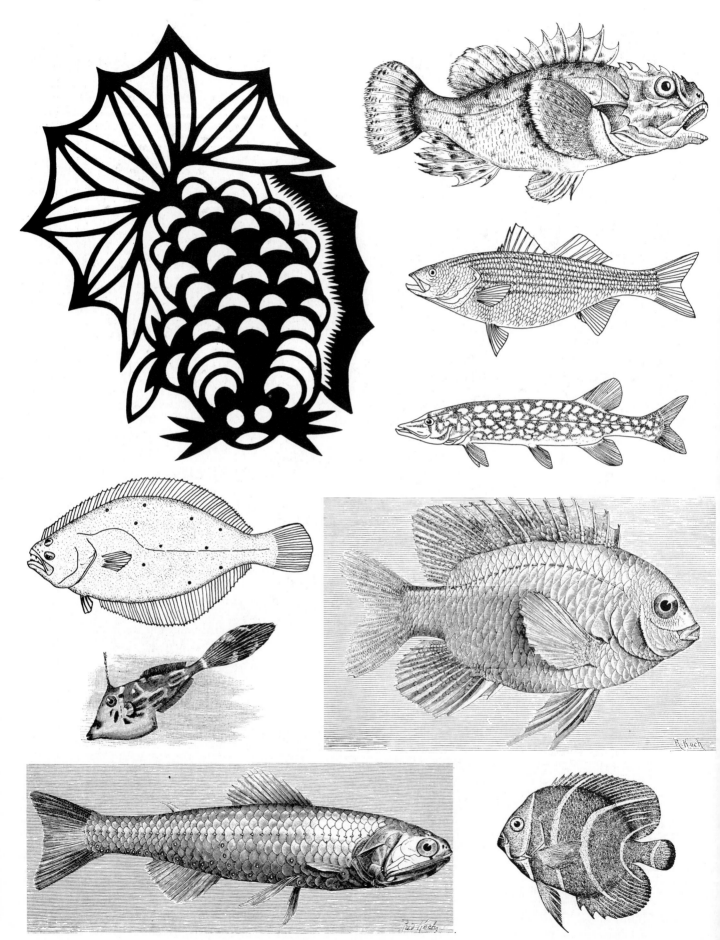

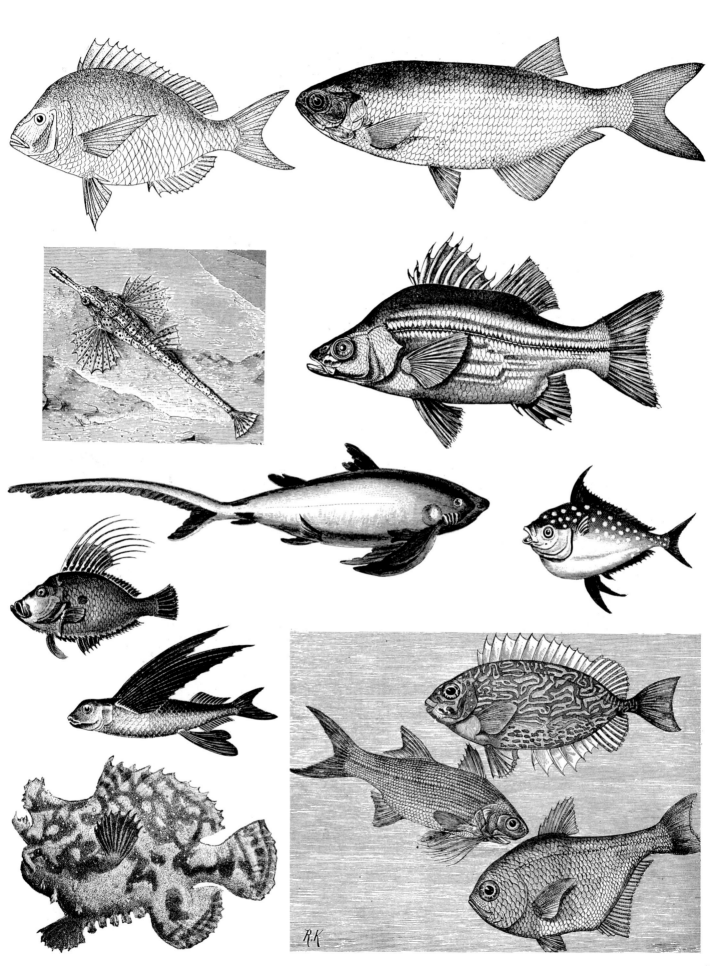

FISHERMEN

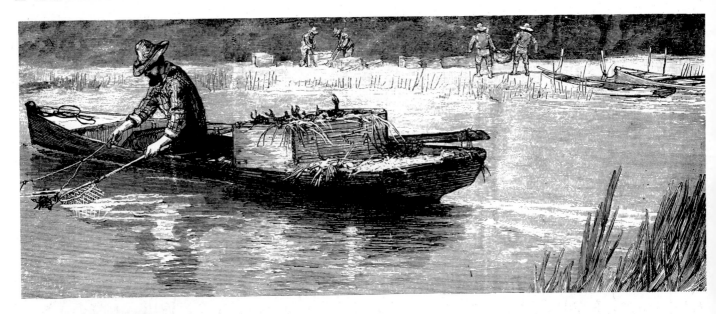

FOODS

FOUNTAINS

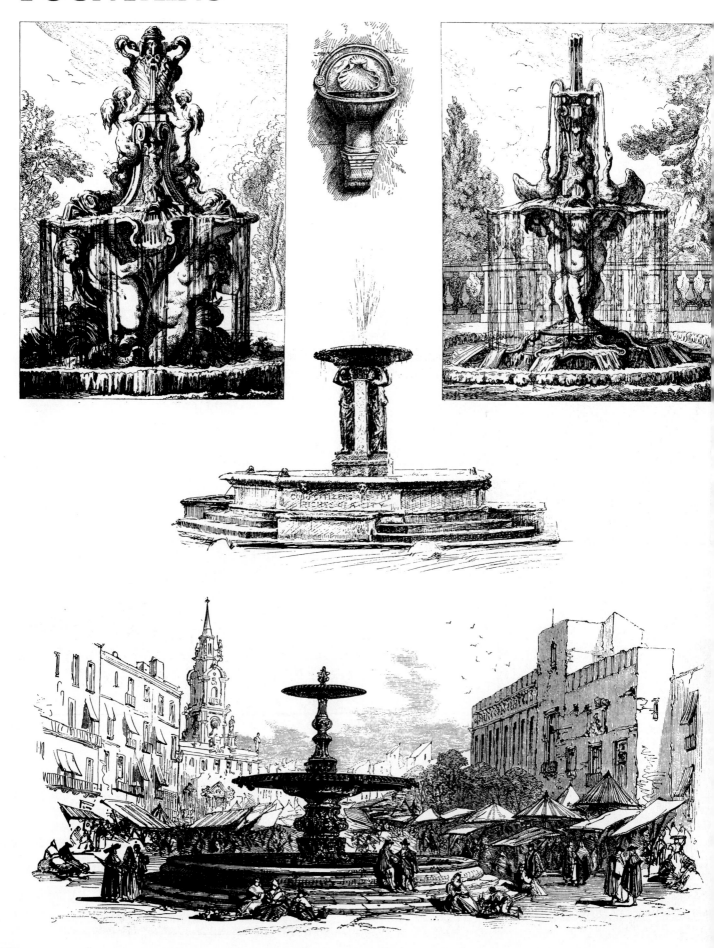

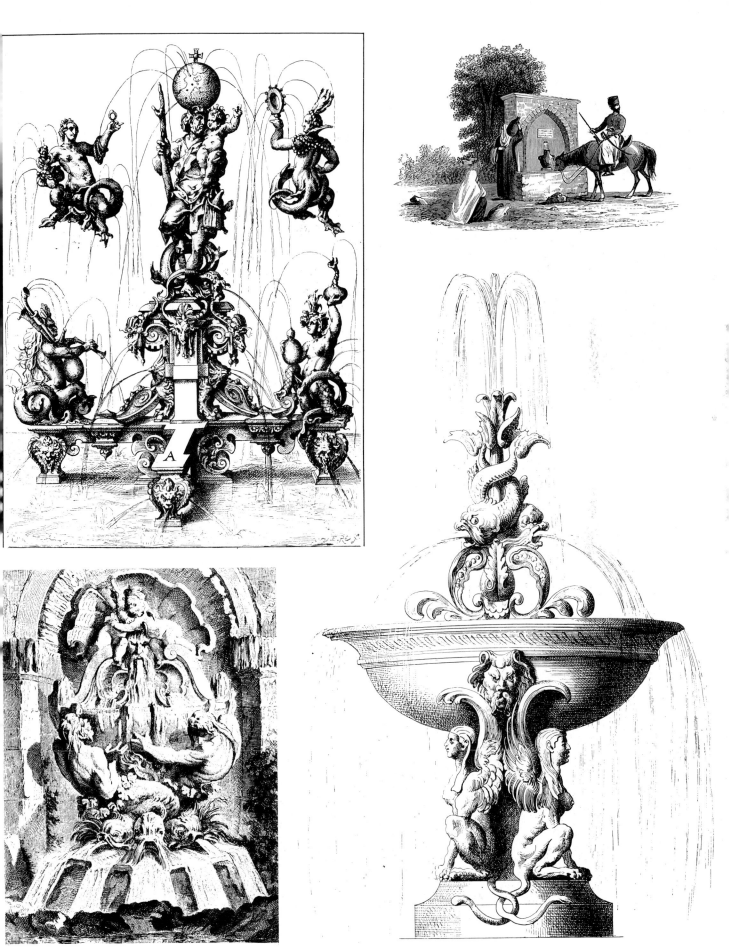

FURNITURE

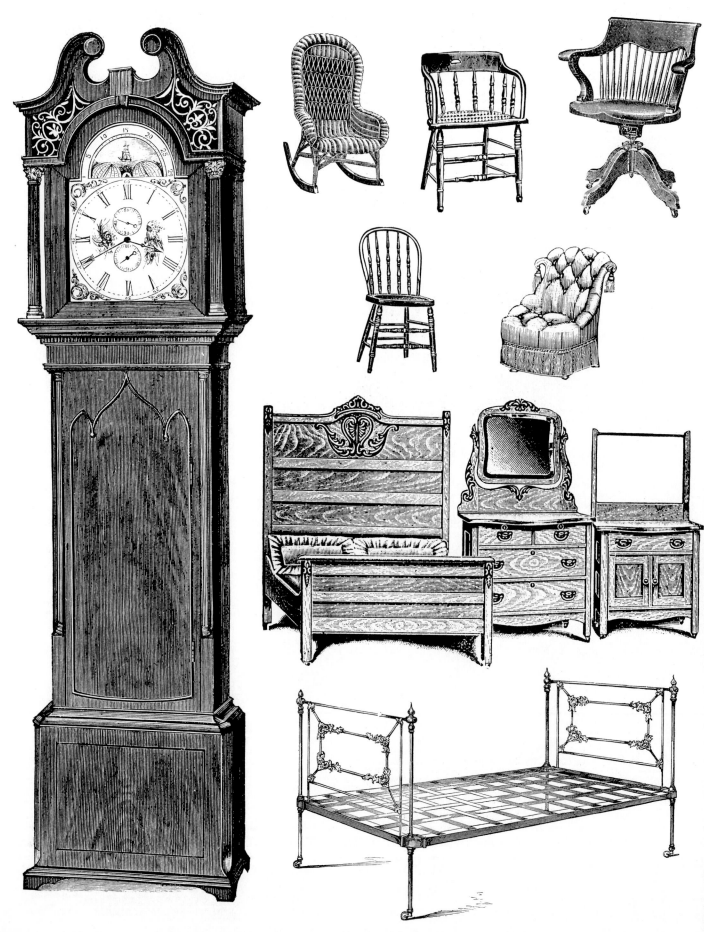

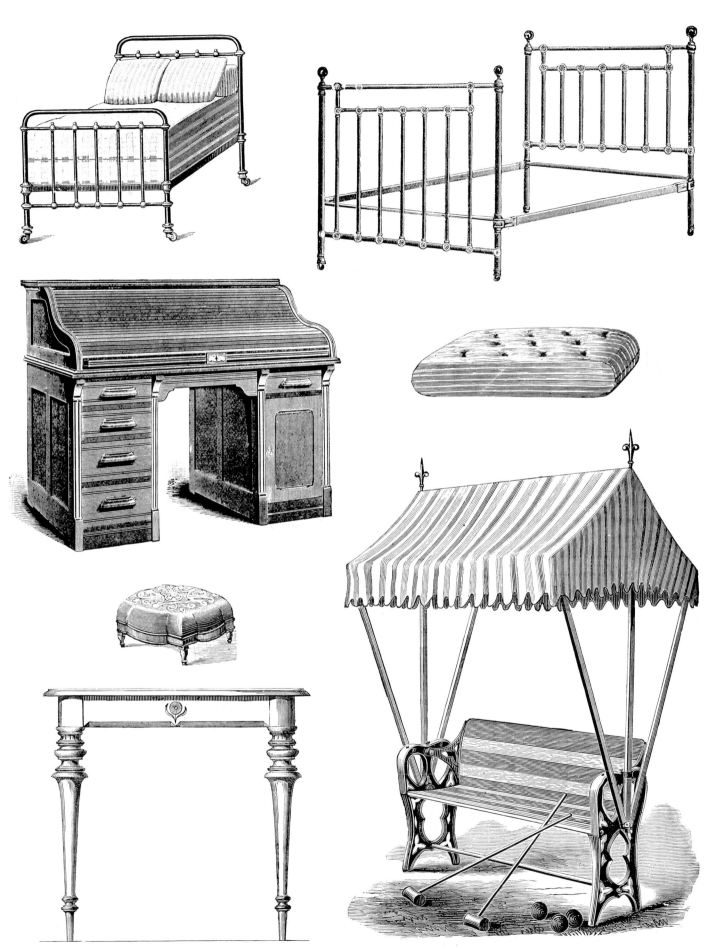

GLASSWARE

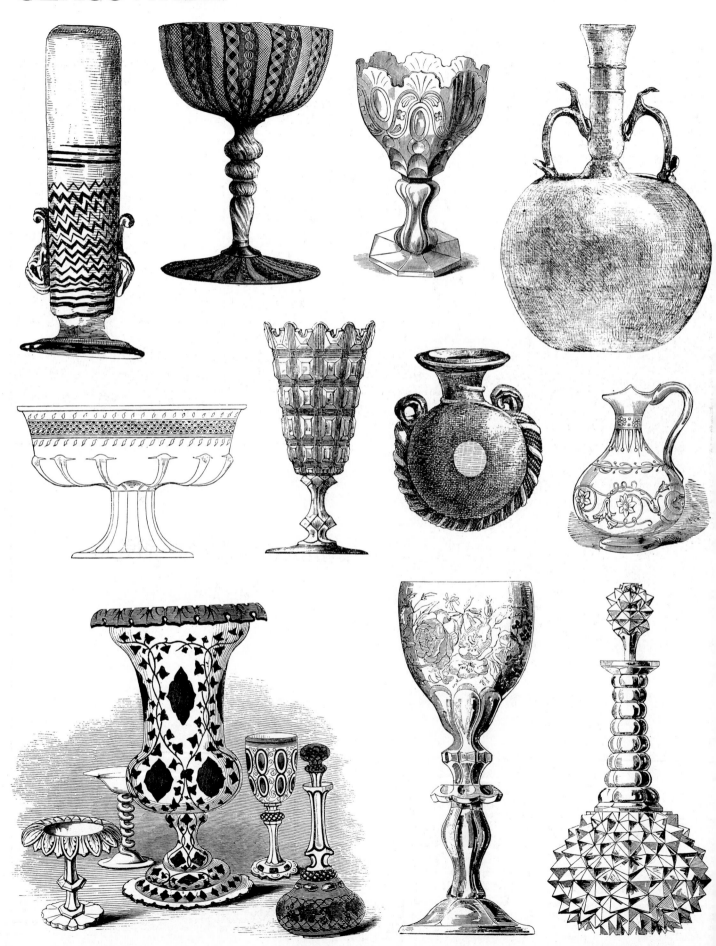

HALLOWEEN

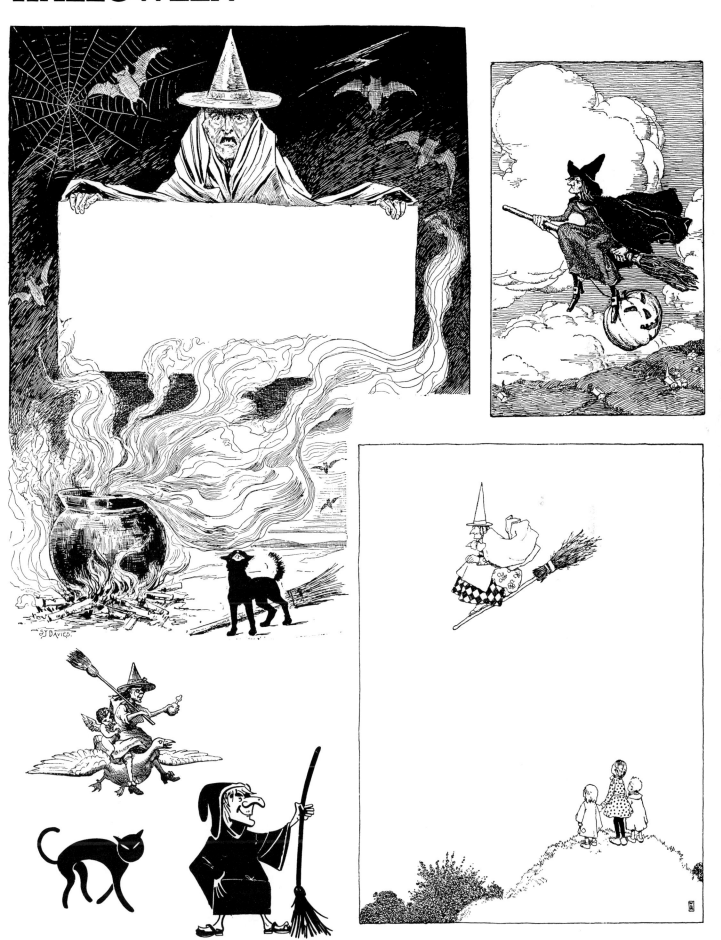

HARBORS & WHARVES

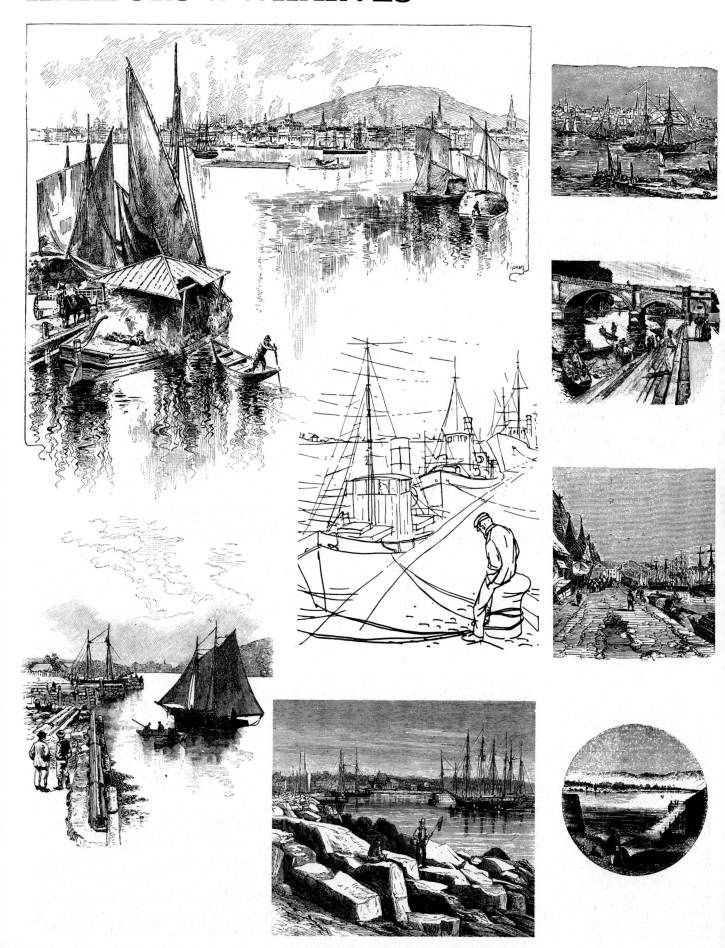

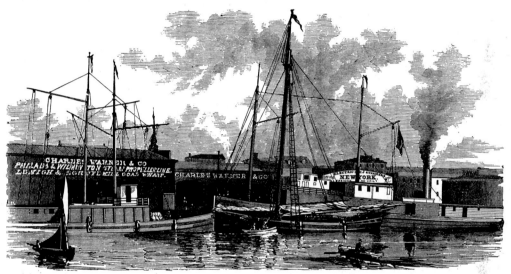

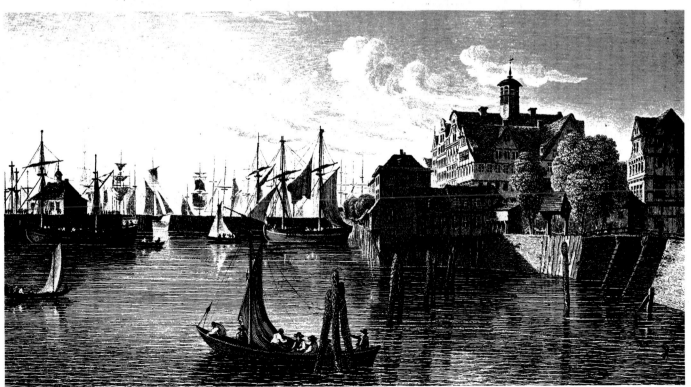

HARDWARE

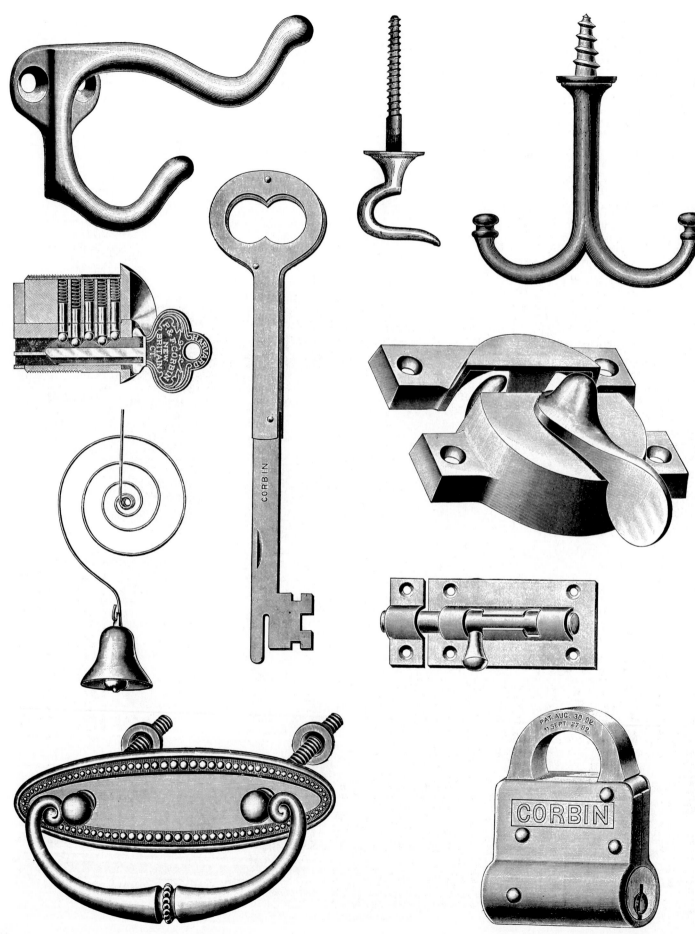

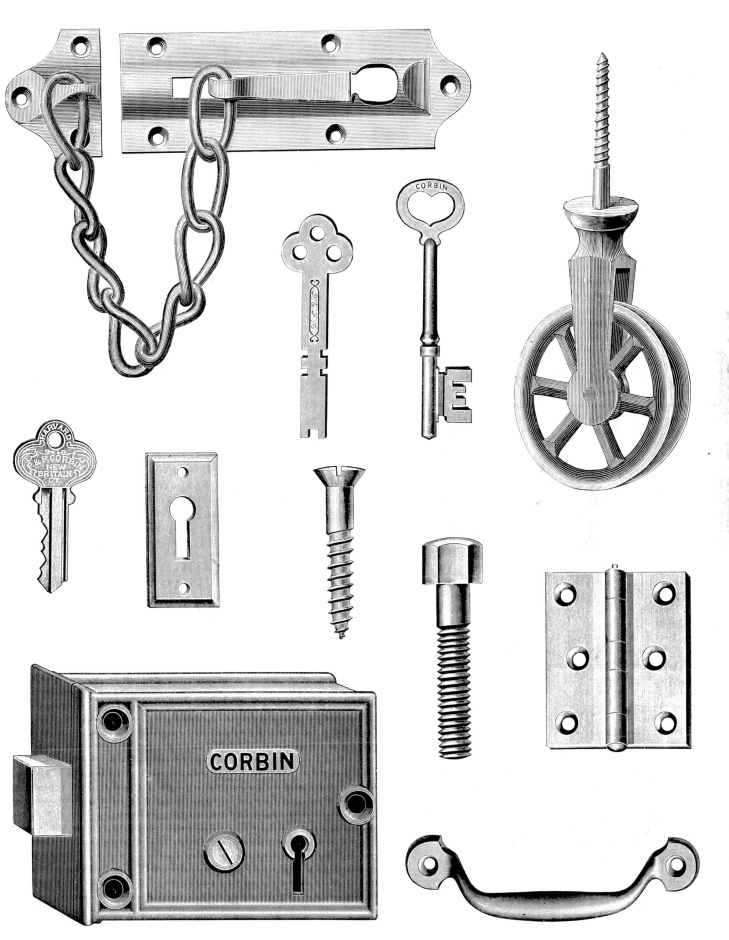

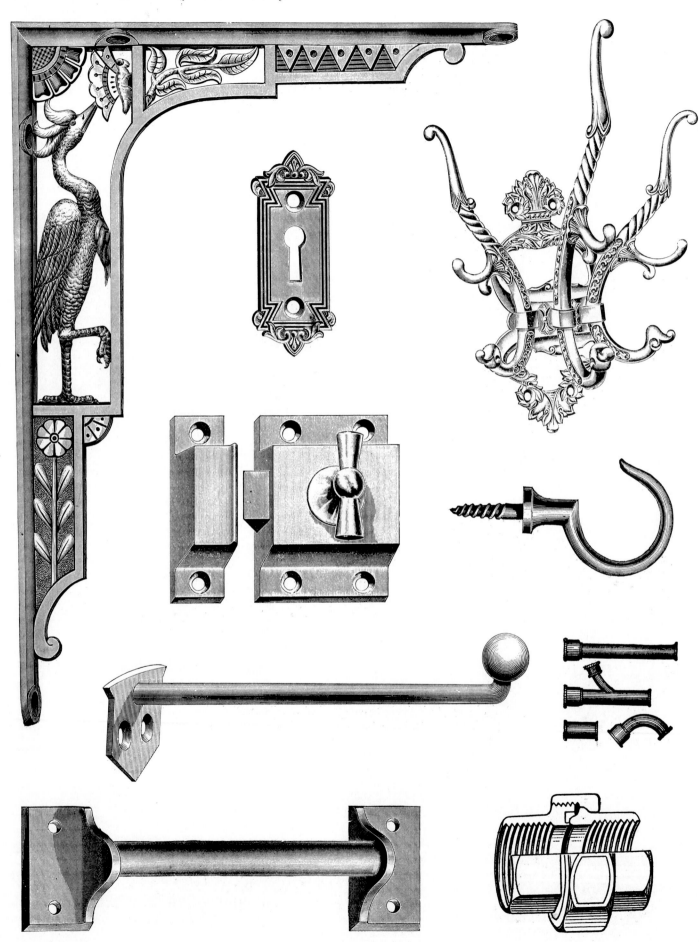

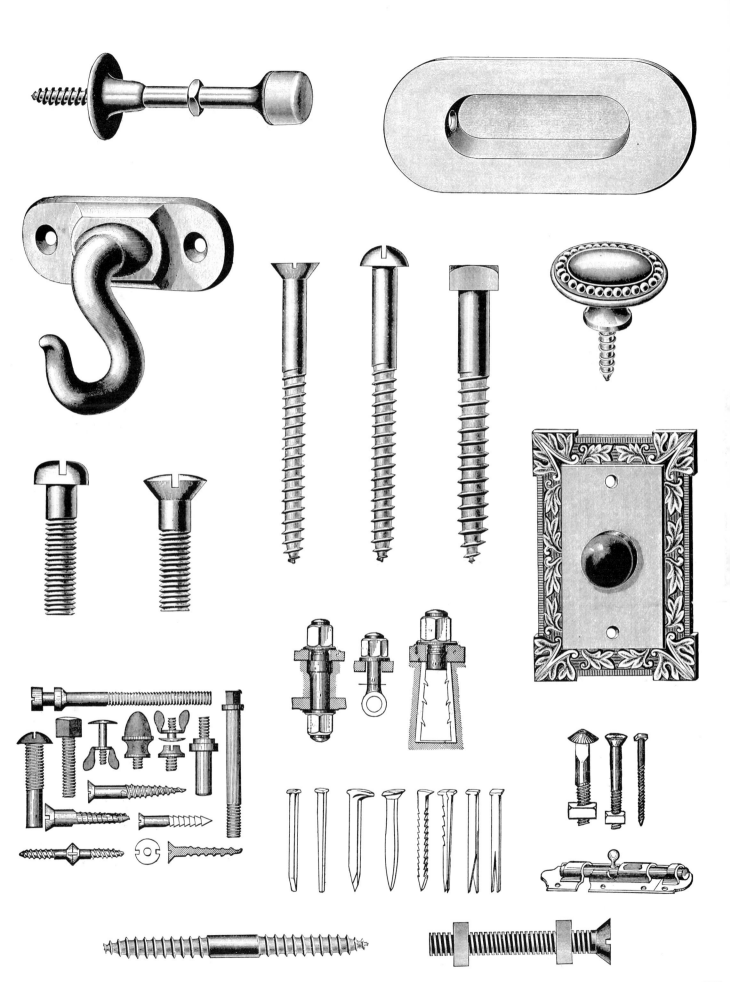

HEADPIECES & TAILPIECES

END OF THE VOLUME.

CONTENTS.

PREFACE

INDEX

INDEX

List of Illustrations.

FINIS

HERDERS

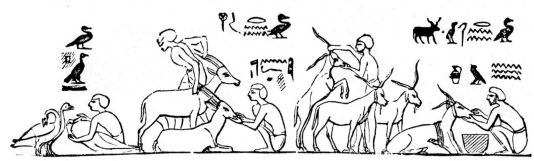

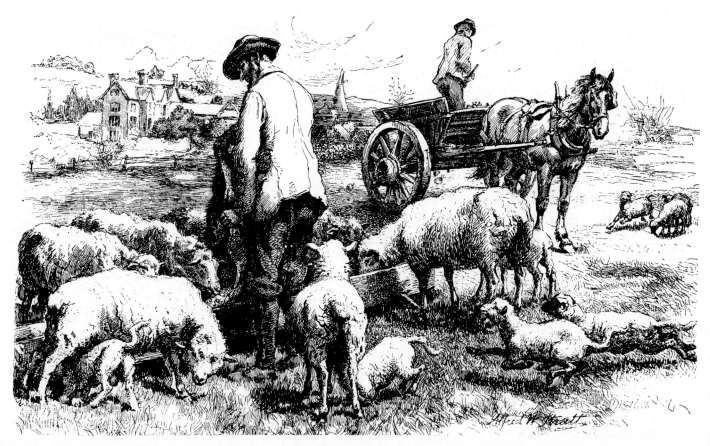

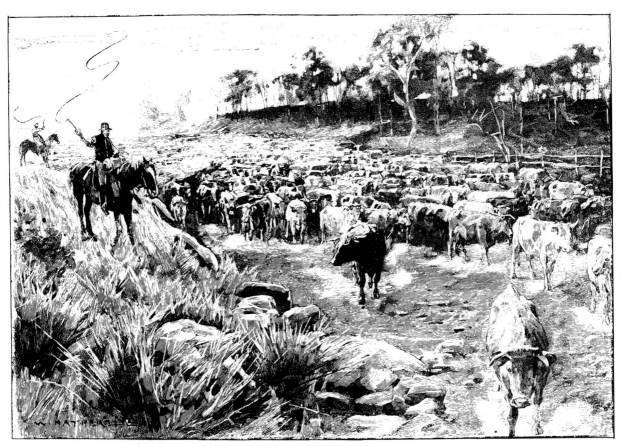

HOMES

HORSES

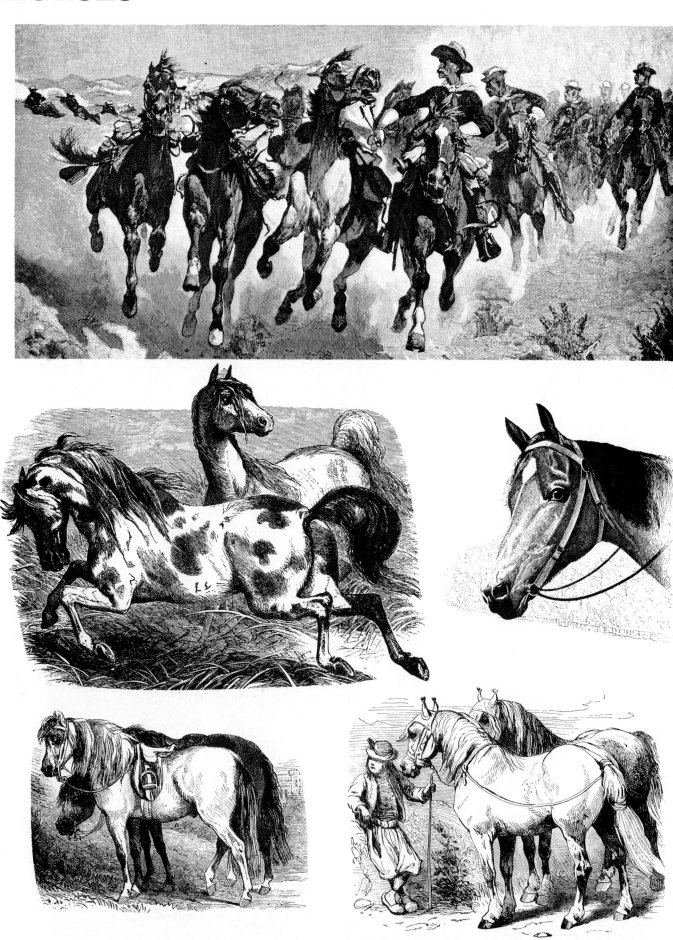

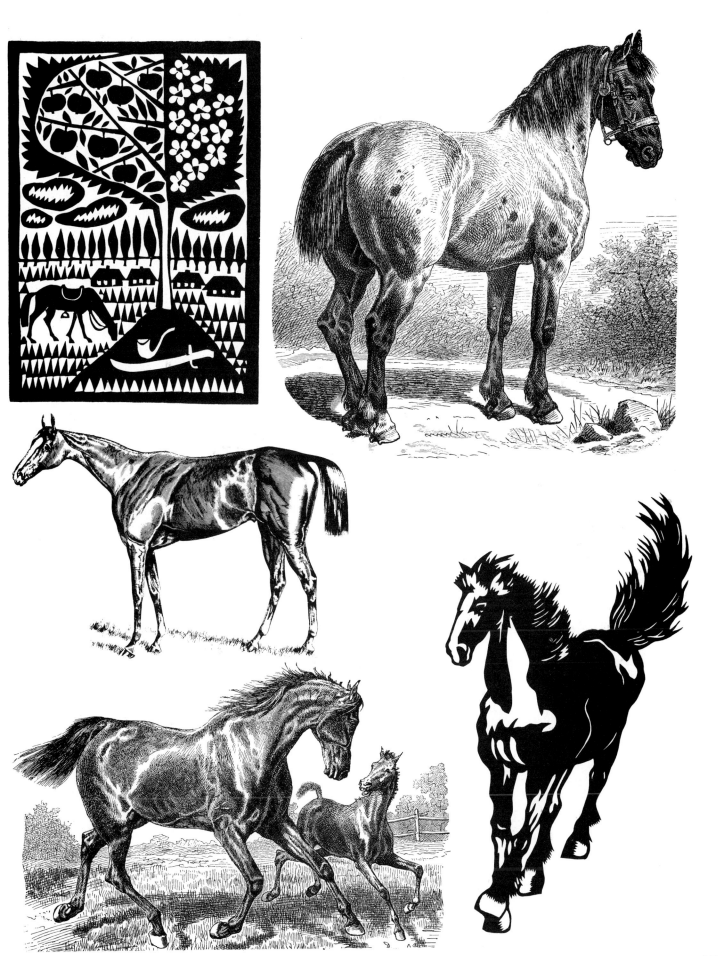

HOUSEWARES

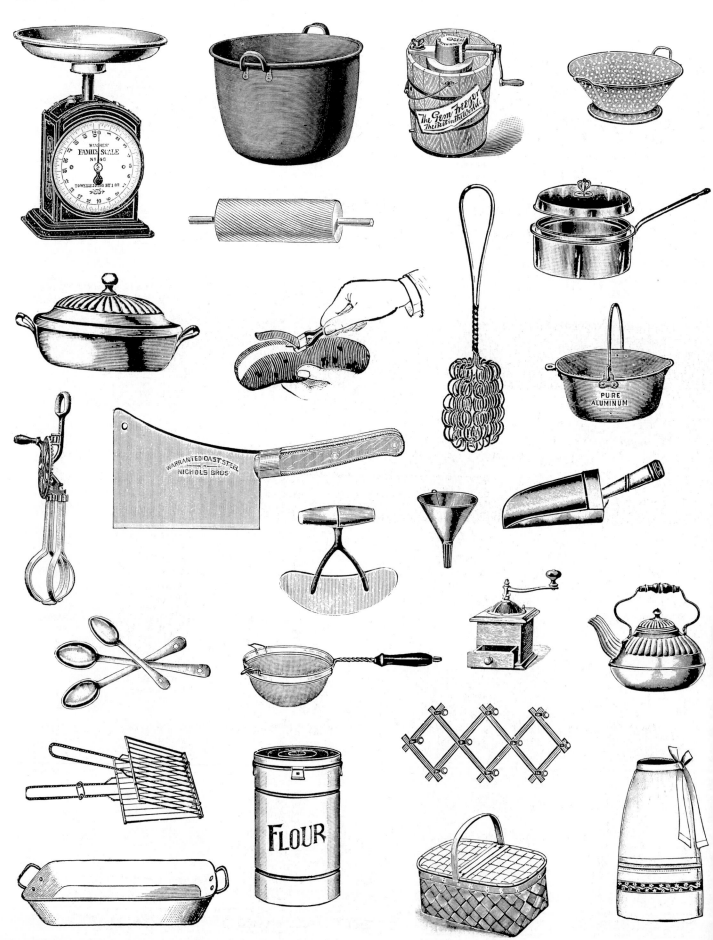

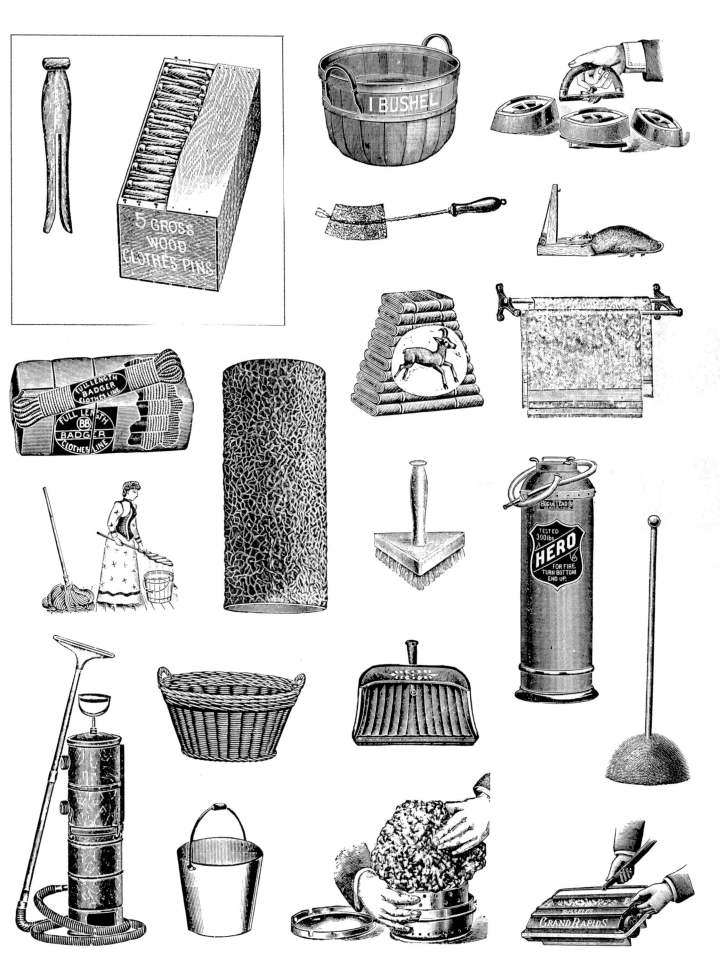

5 GROSS WOOD CLOTHES PINS

I BUSHEL

FULL LENGTH BADGER CLOTHES LINE

BB FULL LENGTH BADGER CLOTHES LINE

TESTED 300 lbs HERO FOR FIRE TURN BOTTOM END UP.

BISSELL'S GRAND RAPIDS

HUNTERS

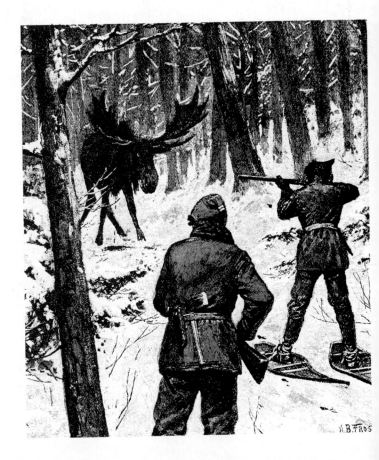

HYENAS

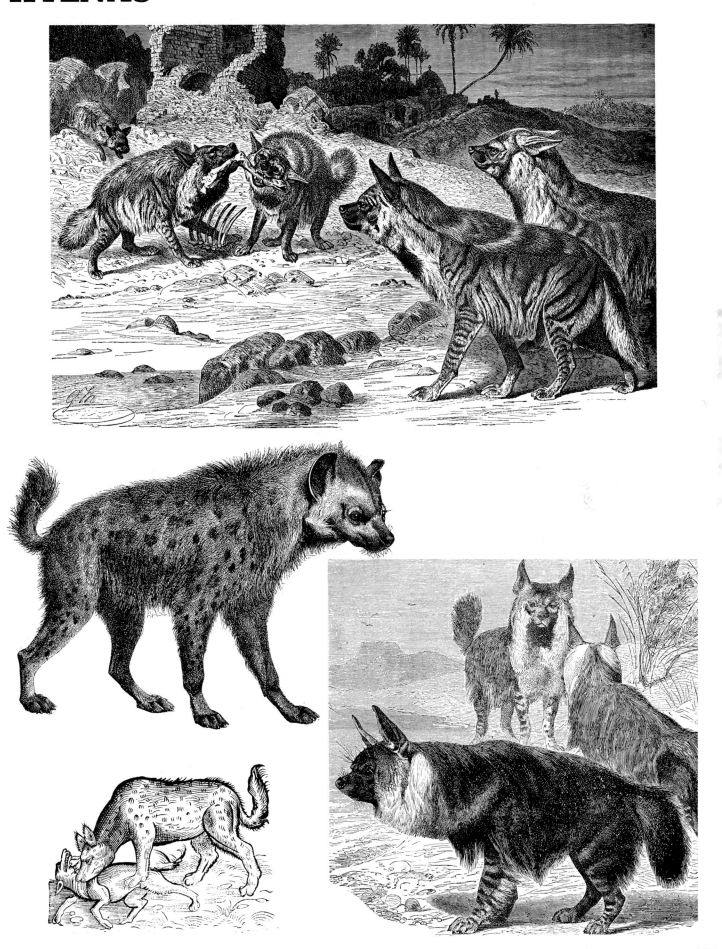

INITIALS

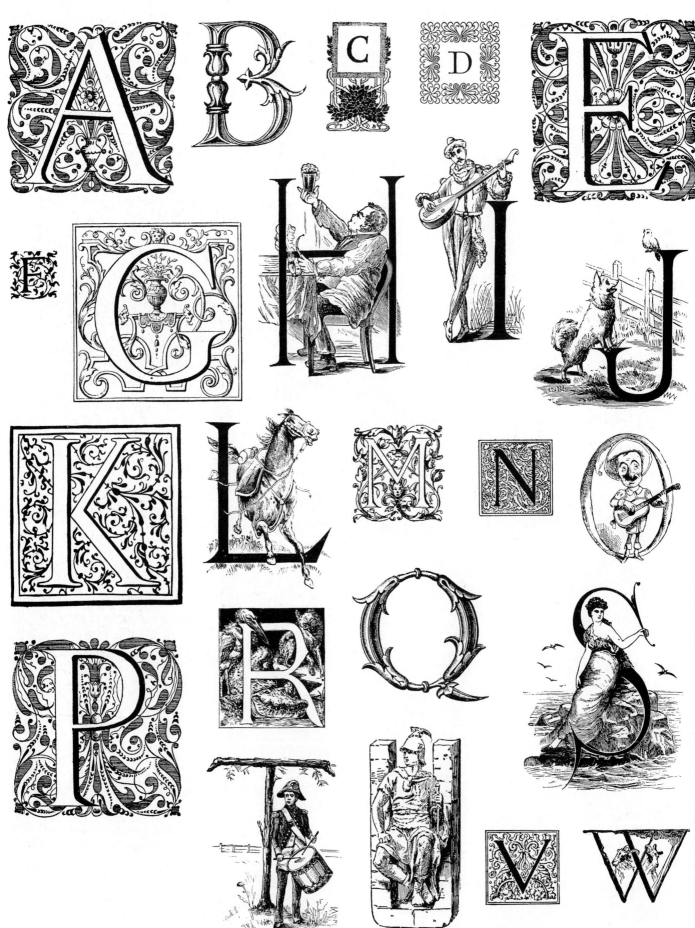

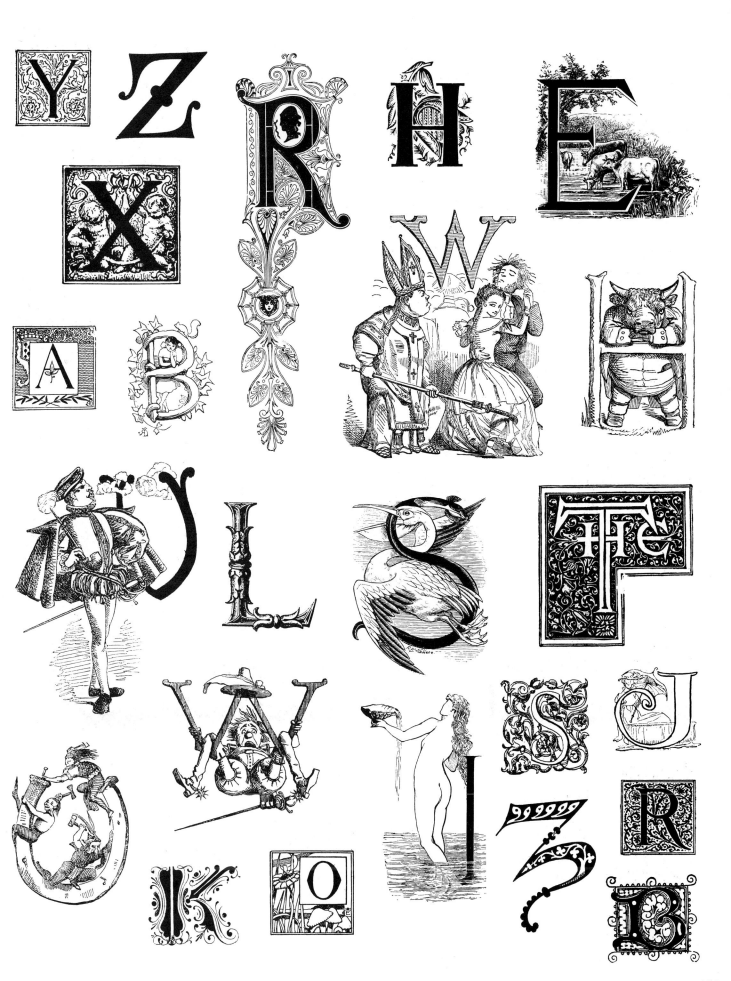

INSECTS

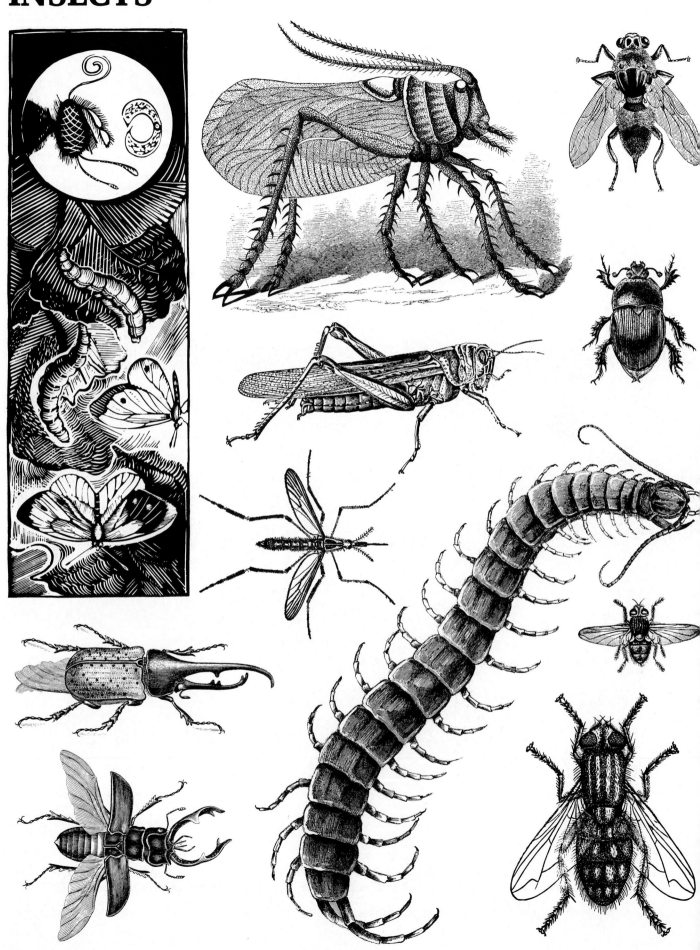

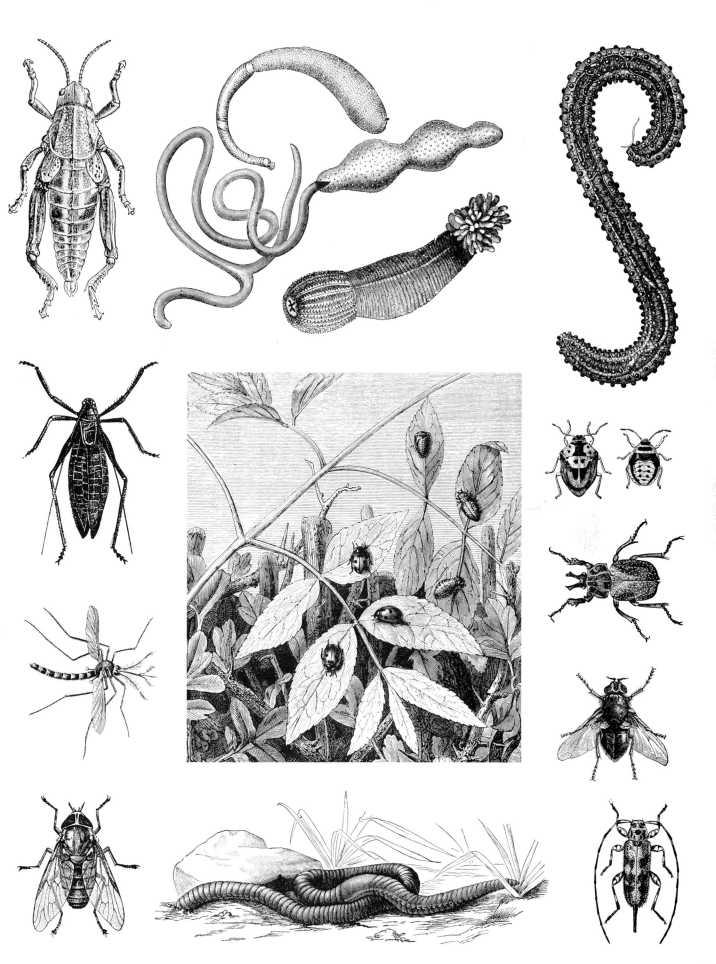

LABORERS

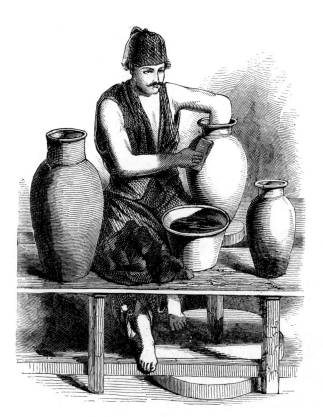

LANDSCAPES

LIGHTHOUSES

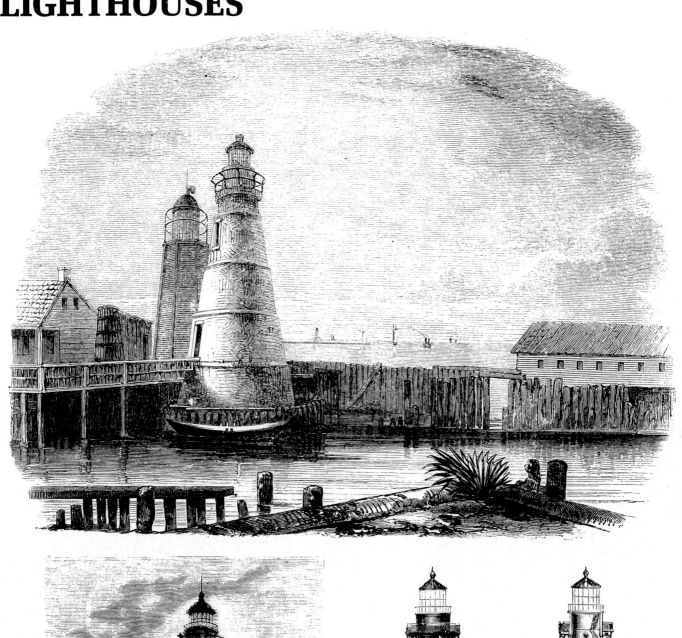

LIGHTNING

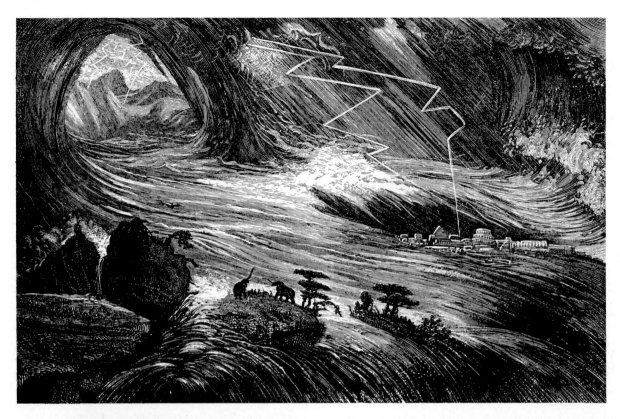

LOGGERS

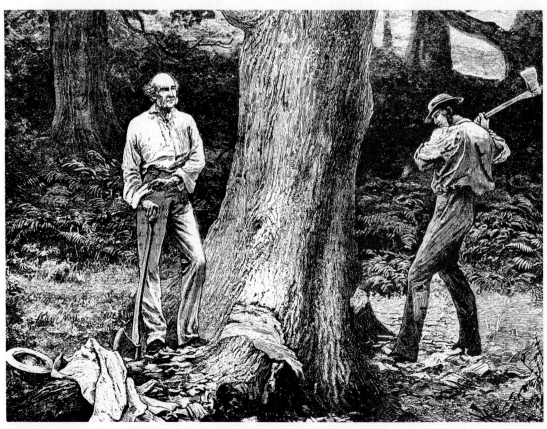

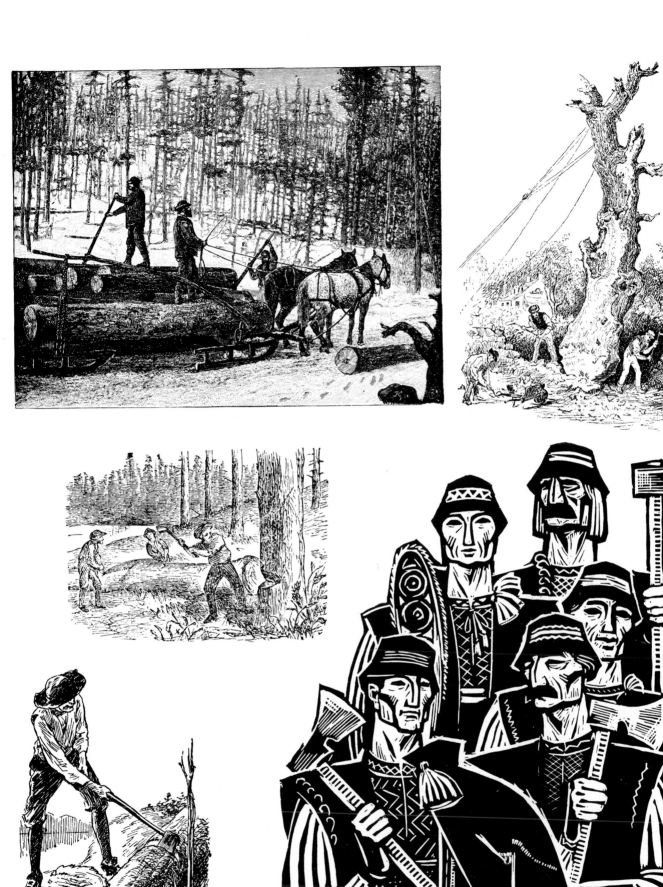

LOVE & COURTSHIP

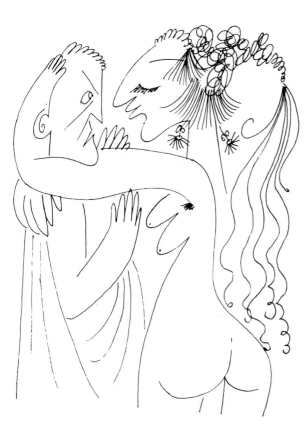

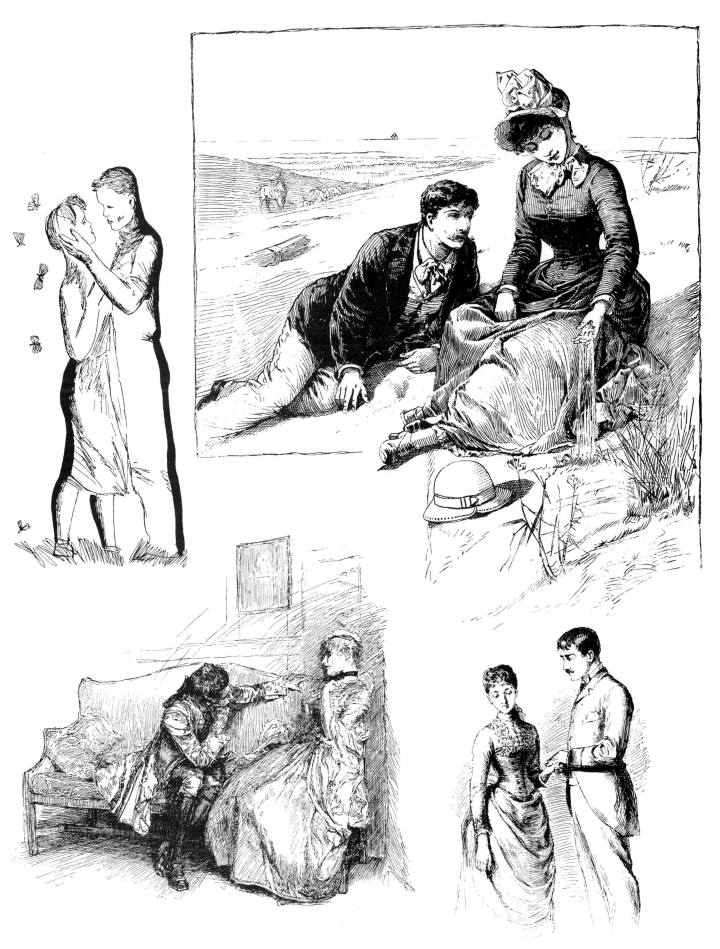

MACHINES

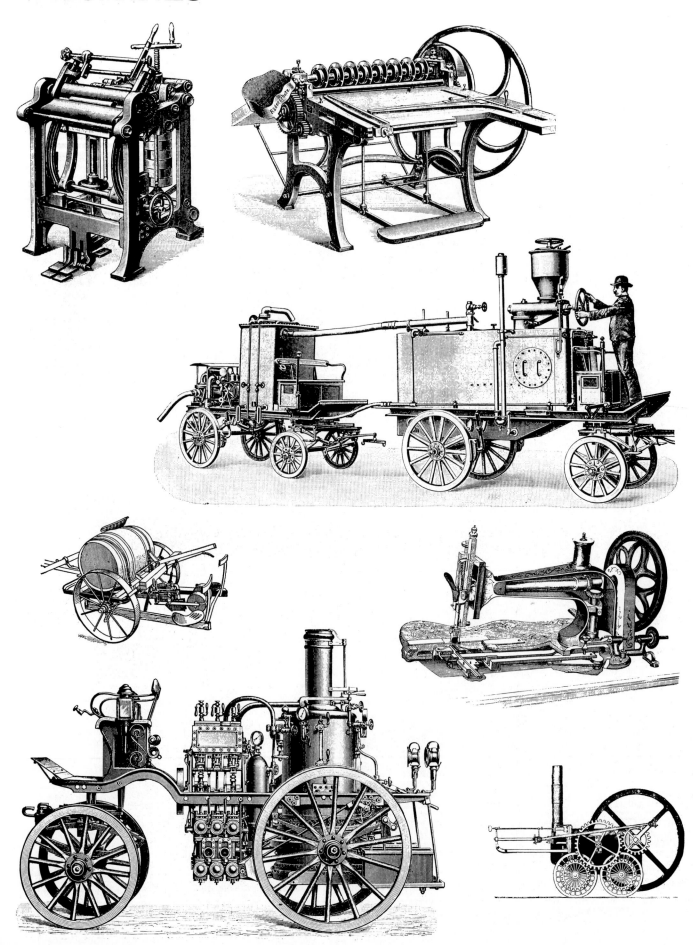

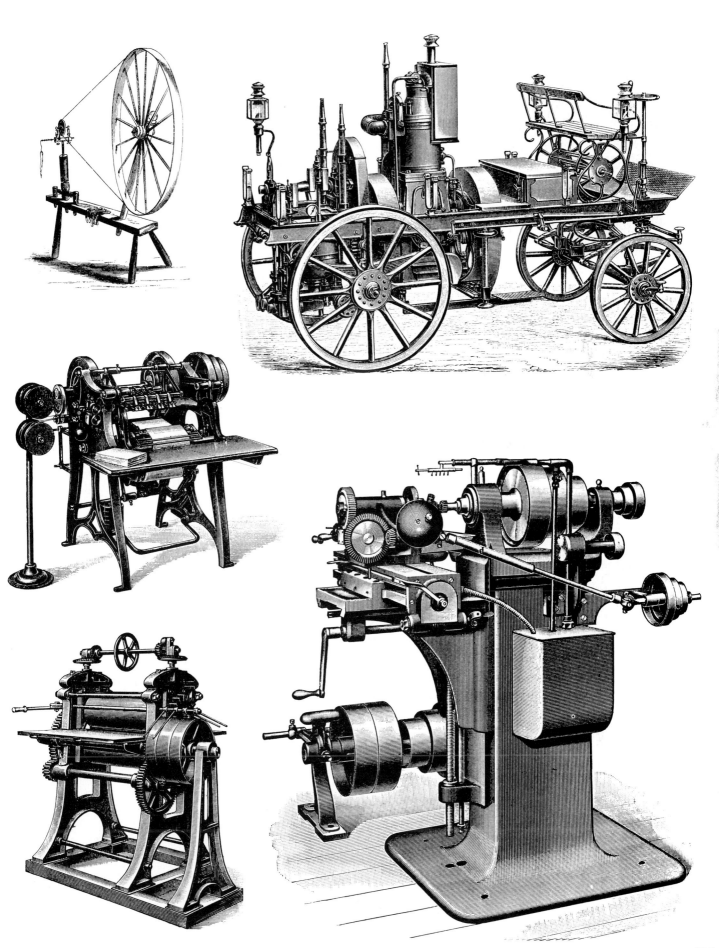

MEN'S CLOTHING

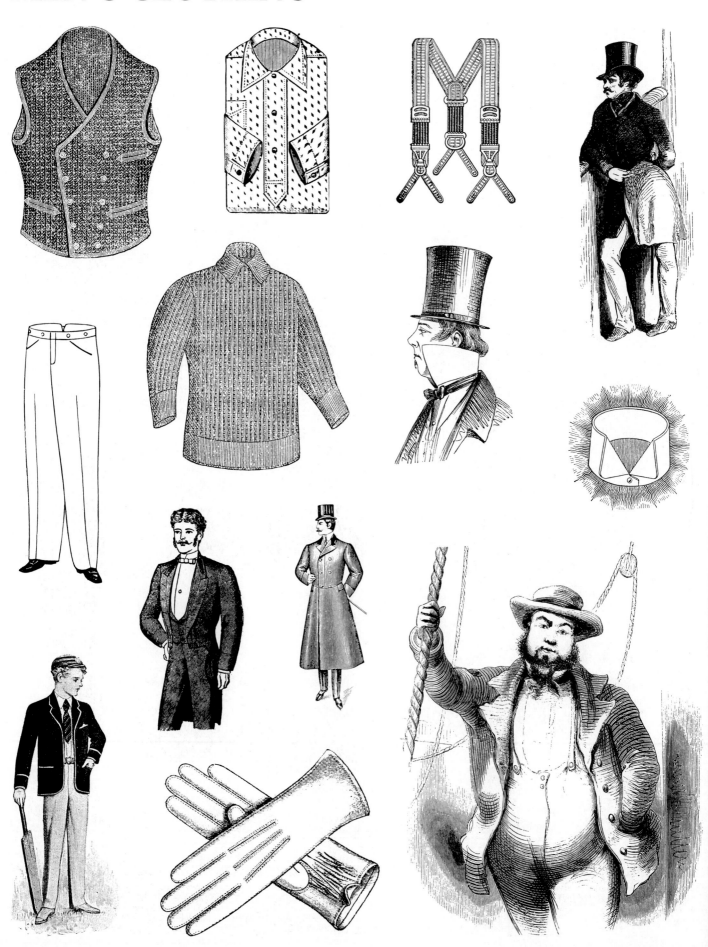

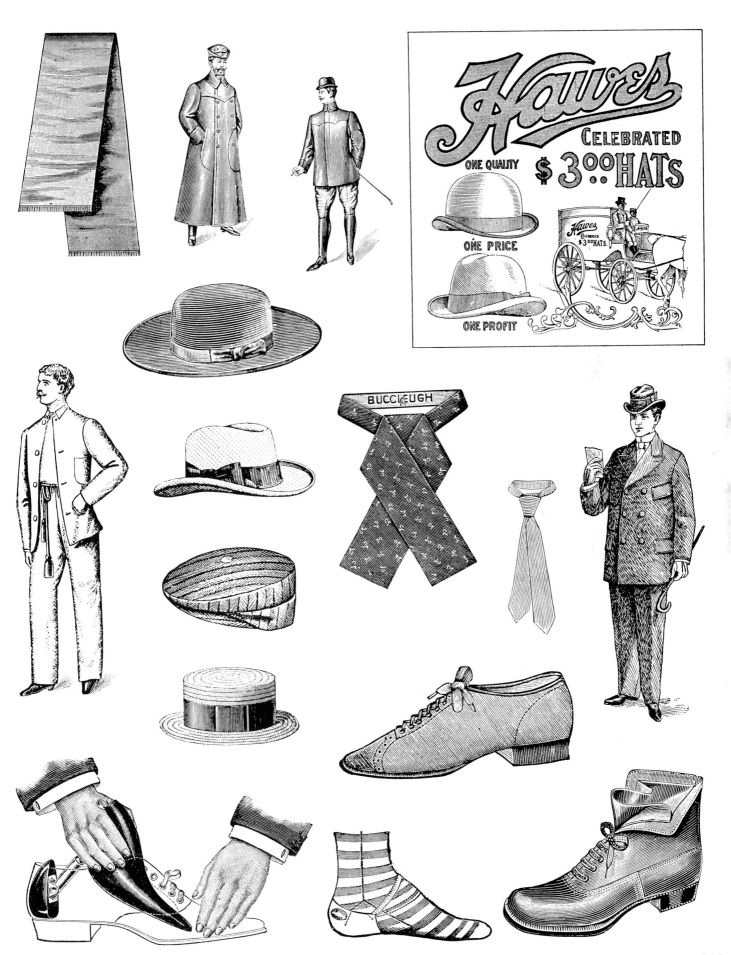

MERRIMENT

MINERS

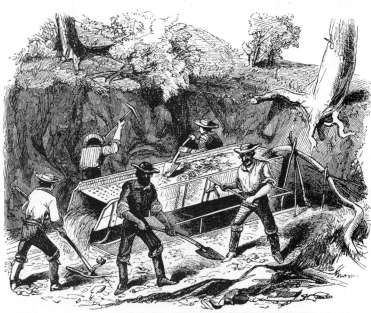

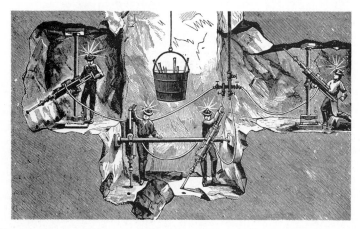

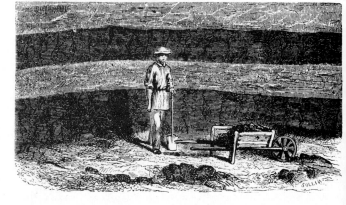

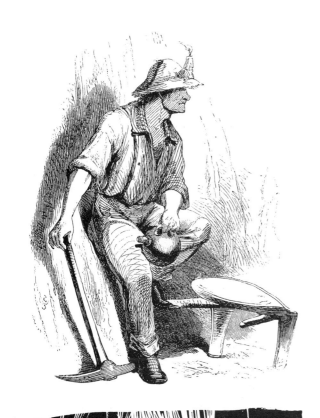

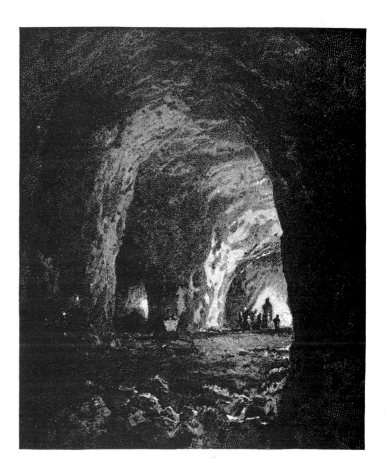

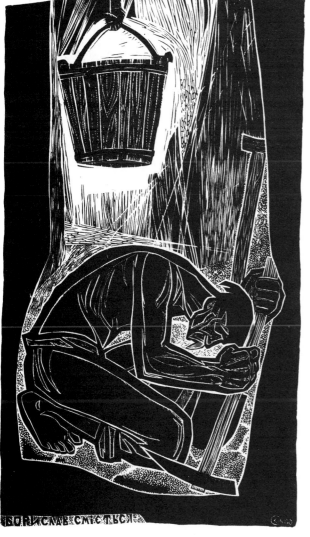

БОРИСЛАВ СМІЄТЬСЯ

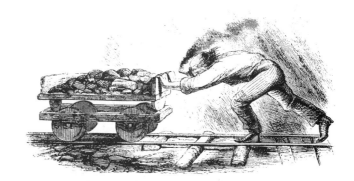

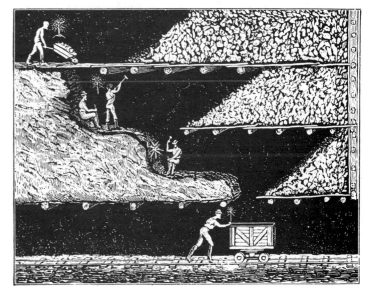

MONKEYS

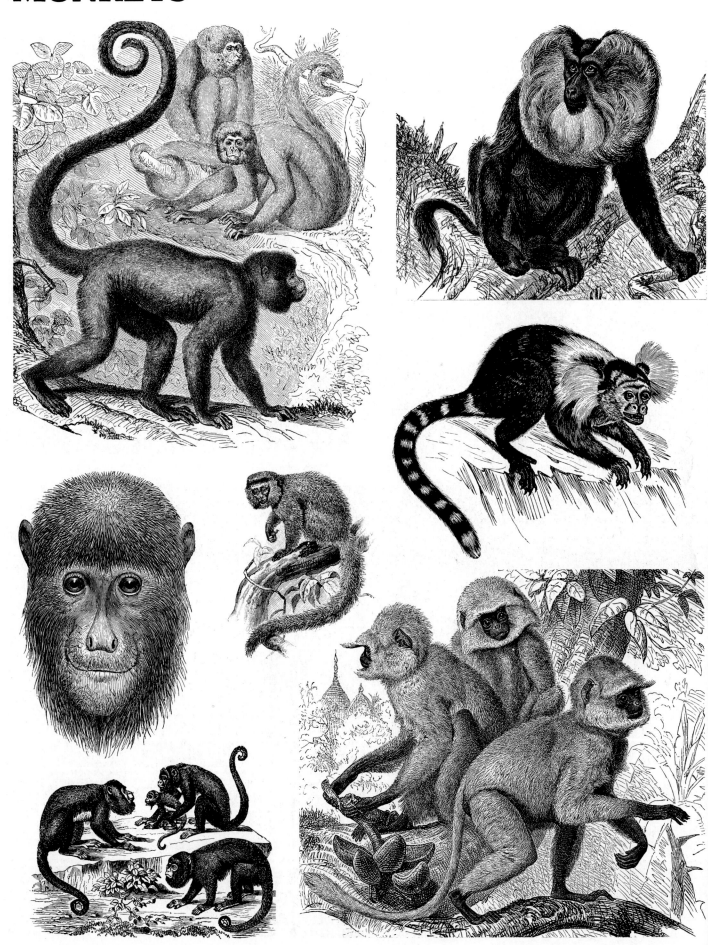

218

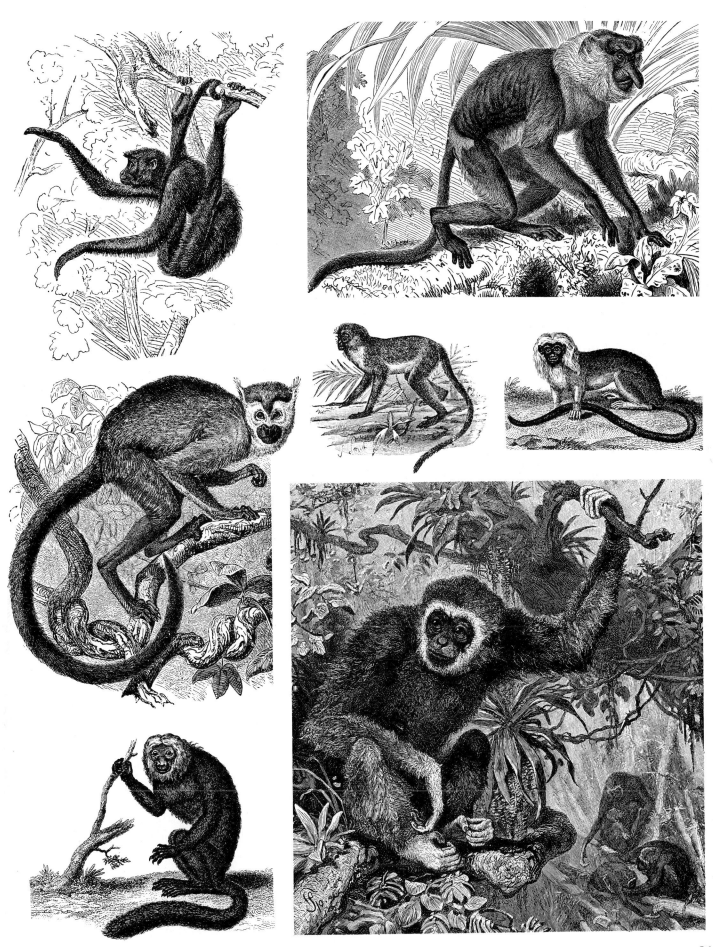

MOTHERHOOD

MOTHERHOOD (continued)

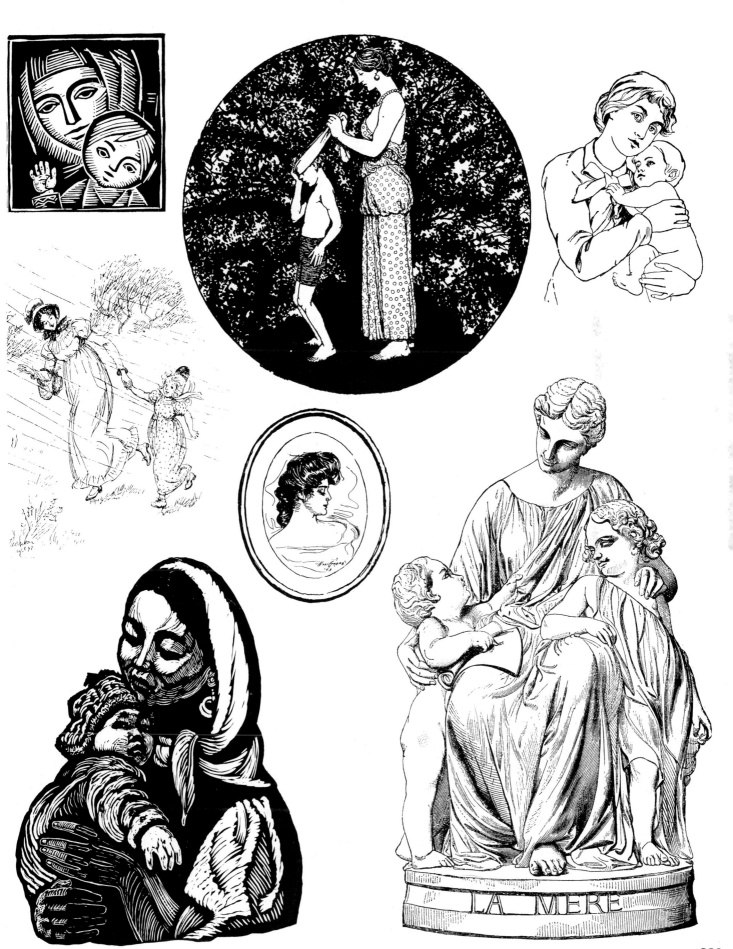

LA MERE

MOUNTAINS & VALLEYS

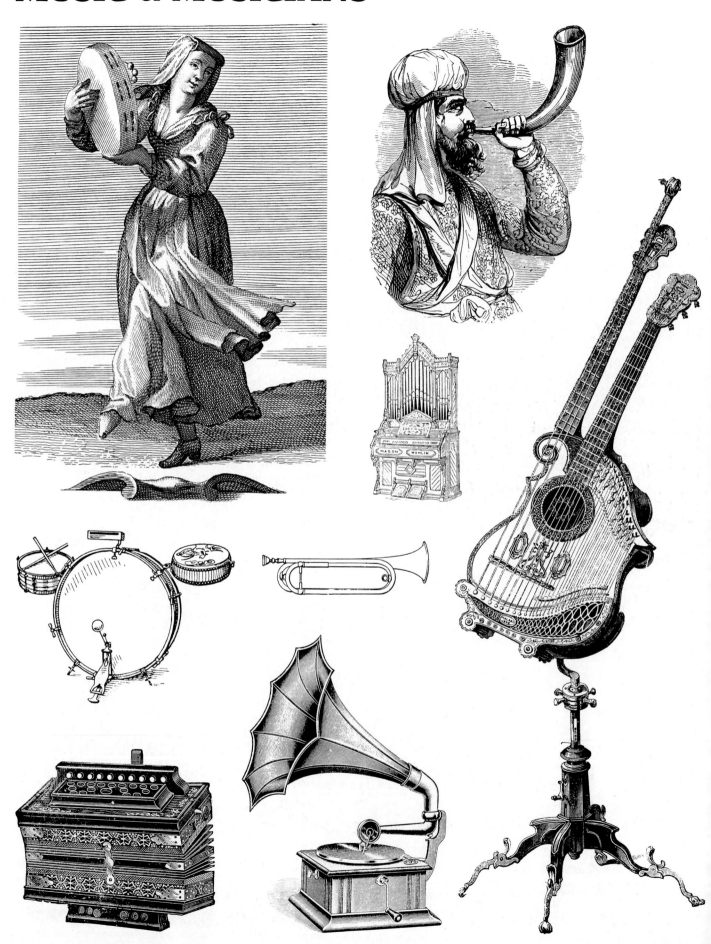

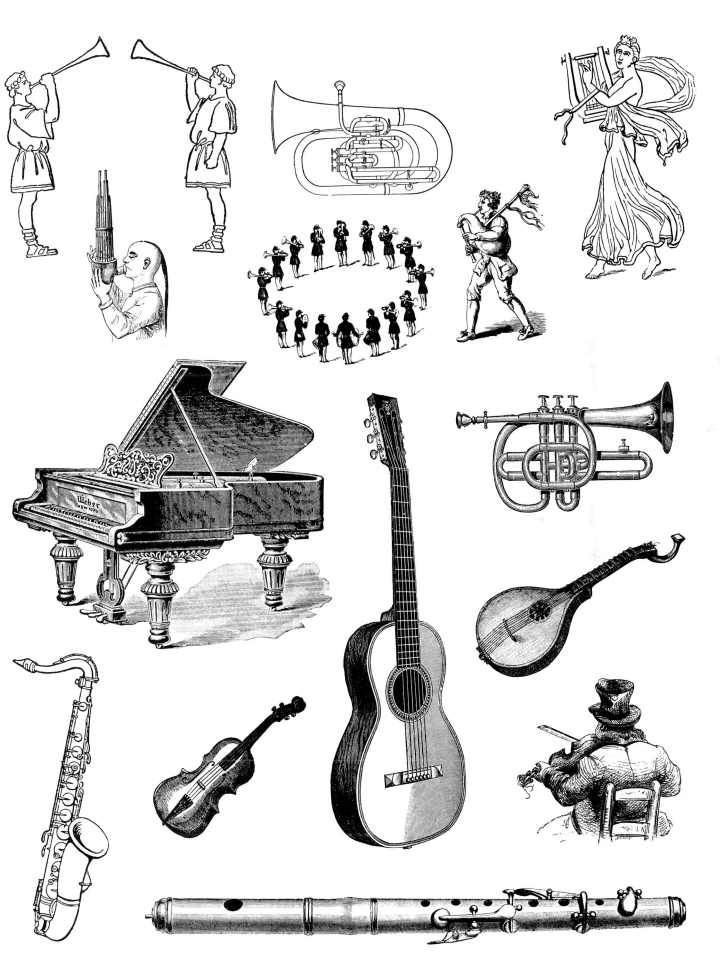

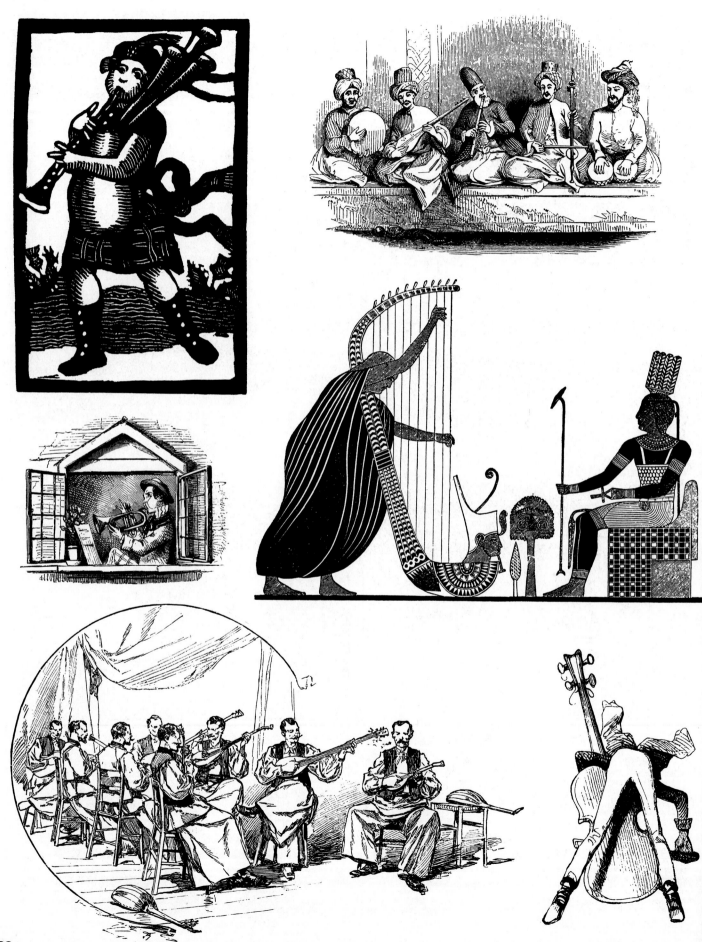

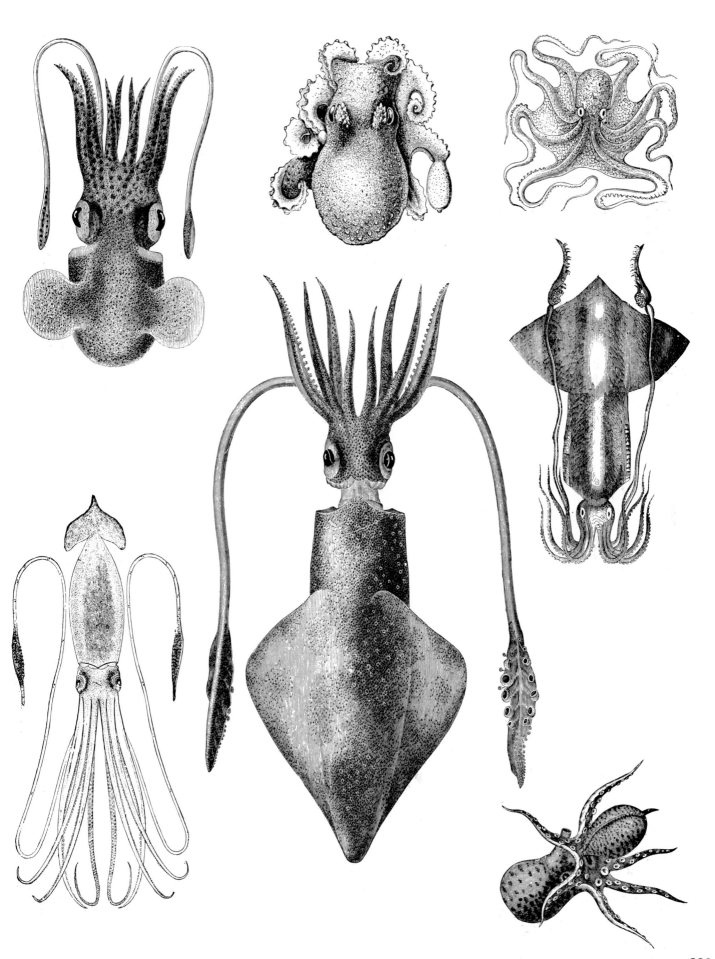

OFFICE SUPPLIES

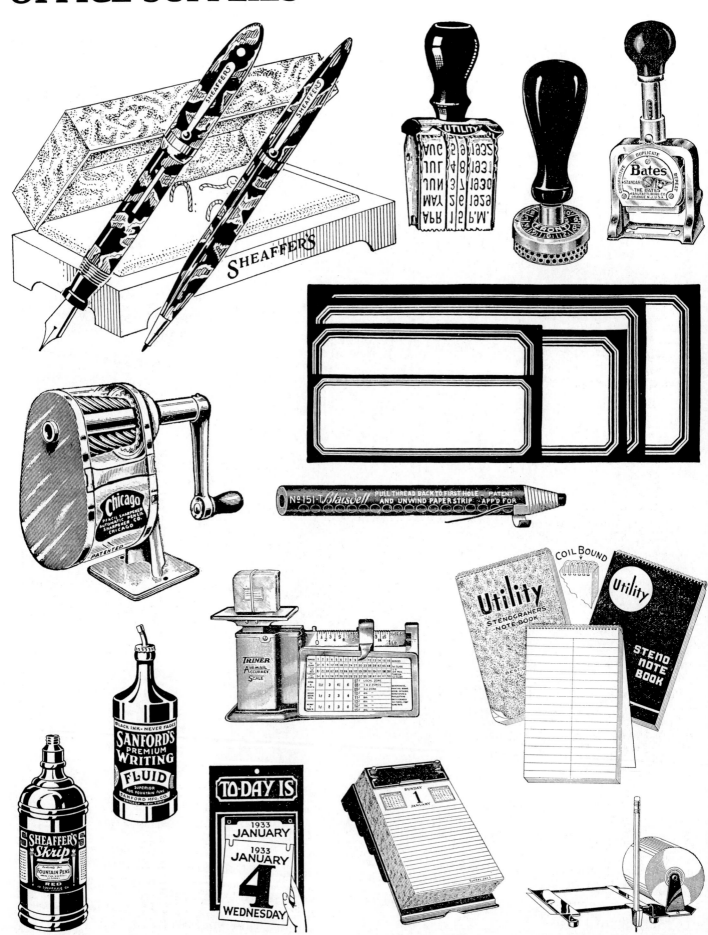

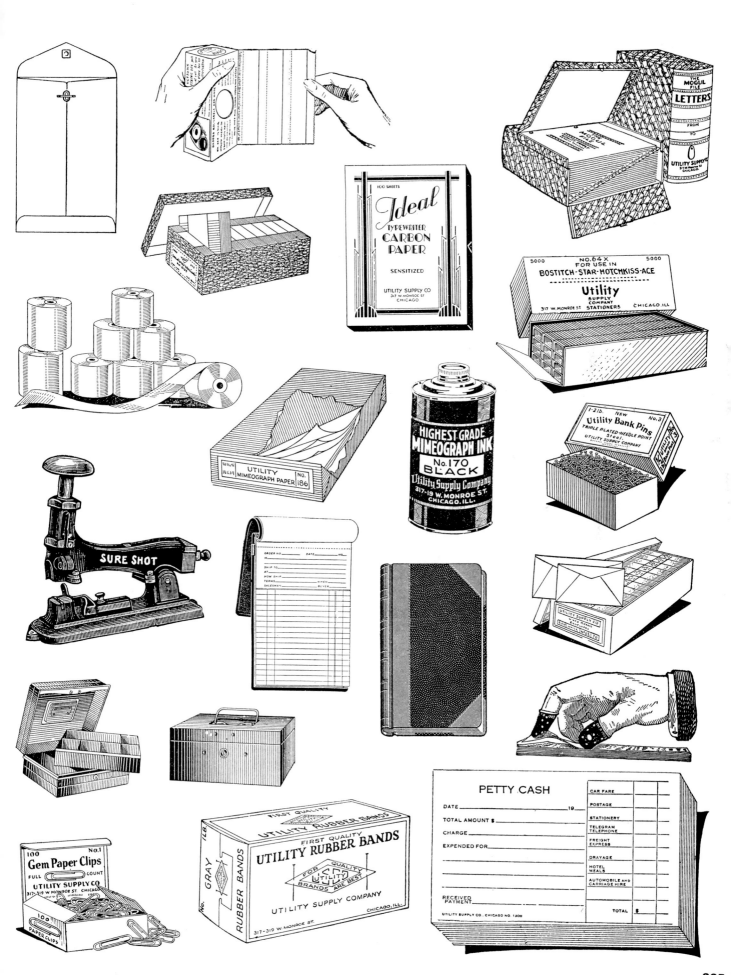

OUTLAWS & SCALAWAGS

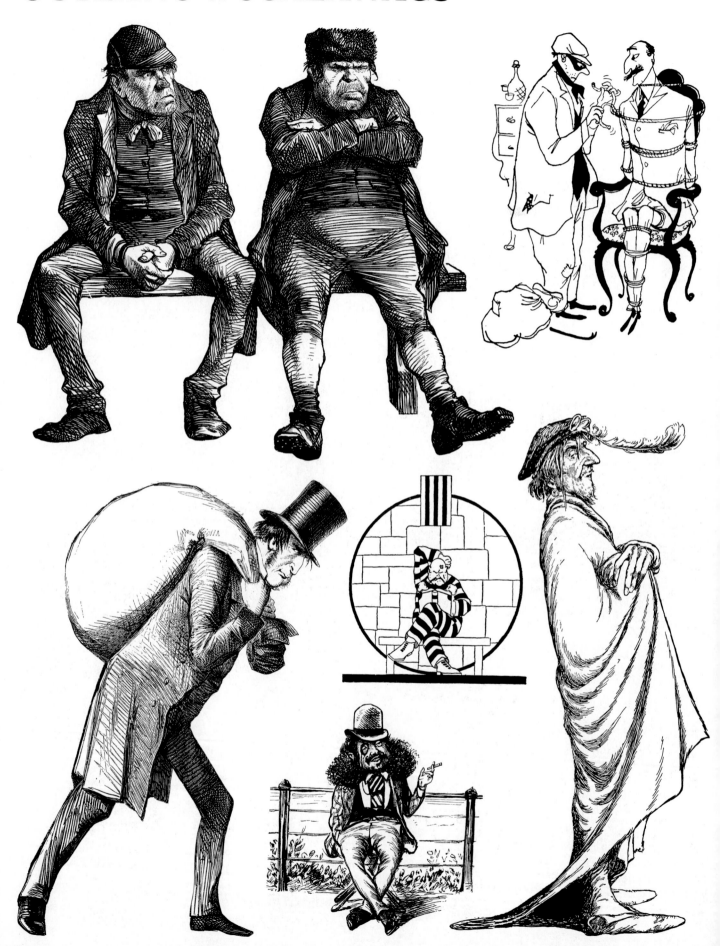

OWLS

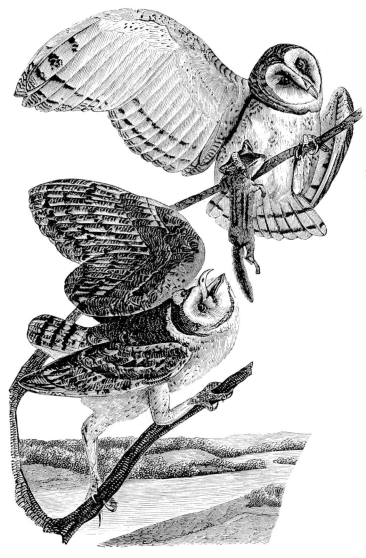

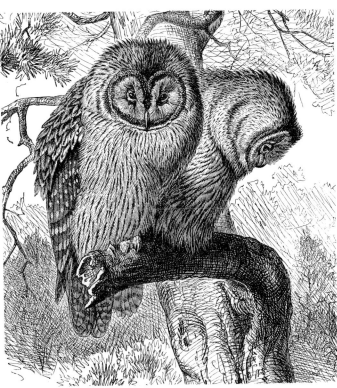

PARROTS & COCKATOOS

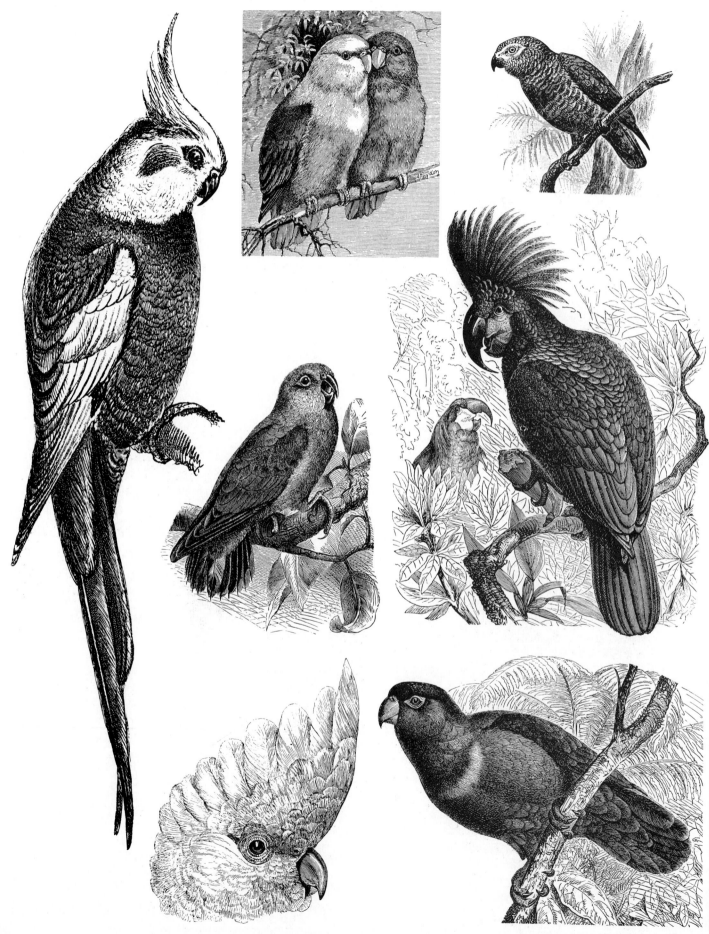

PASSOVER

PEDDLERS

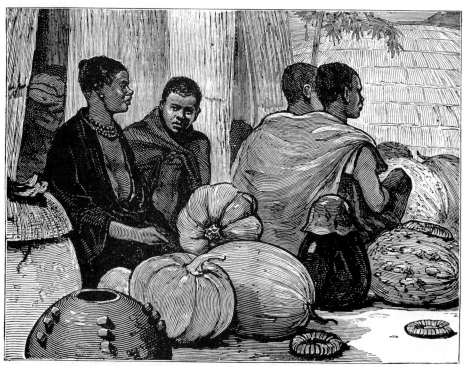

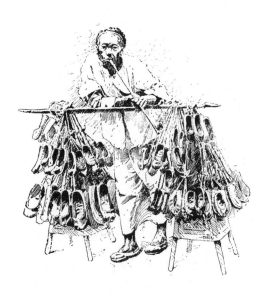

PEOPLES OF THE WORLD

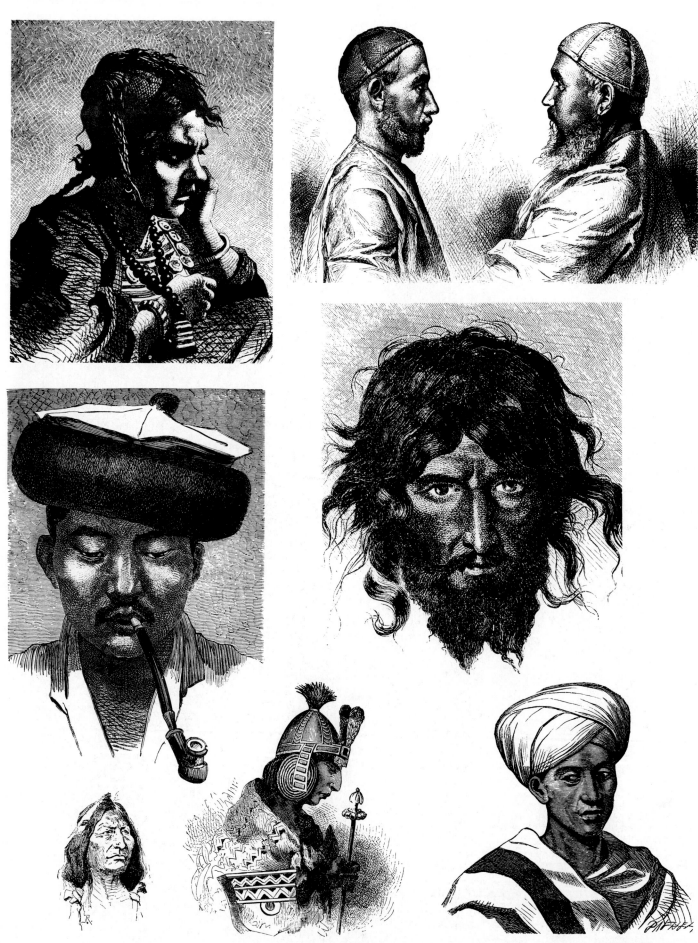

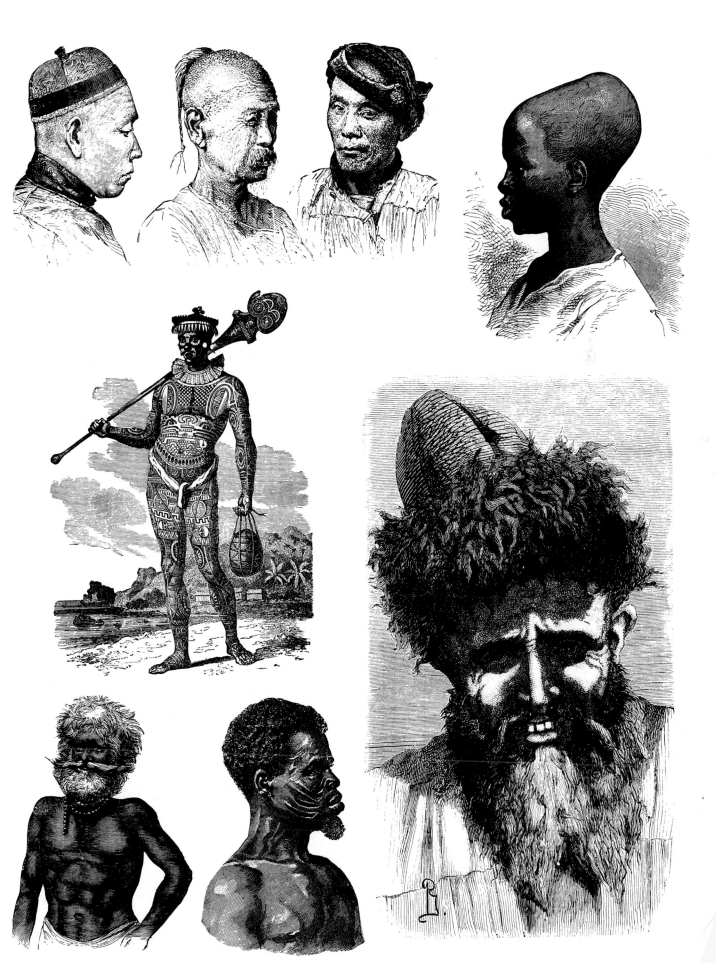

PHYSICIANS

POLICEMEN

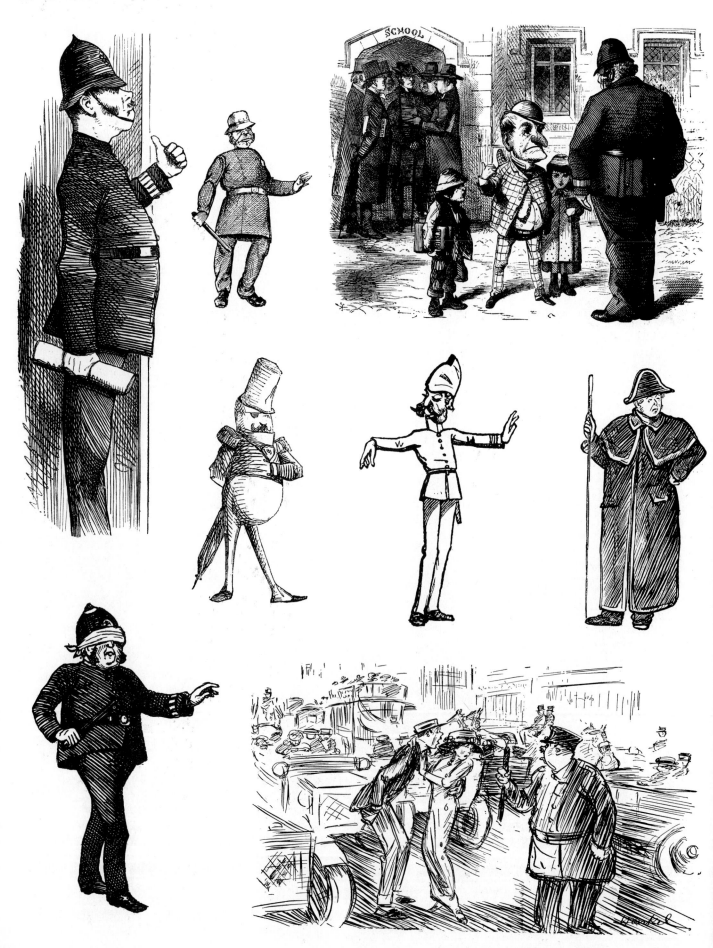

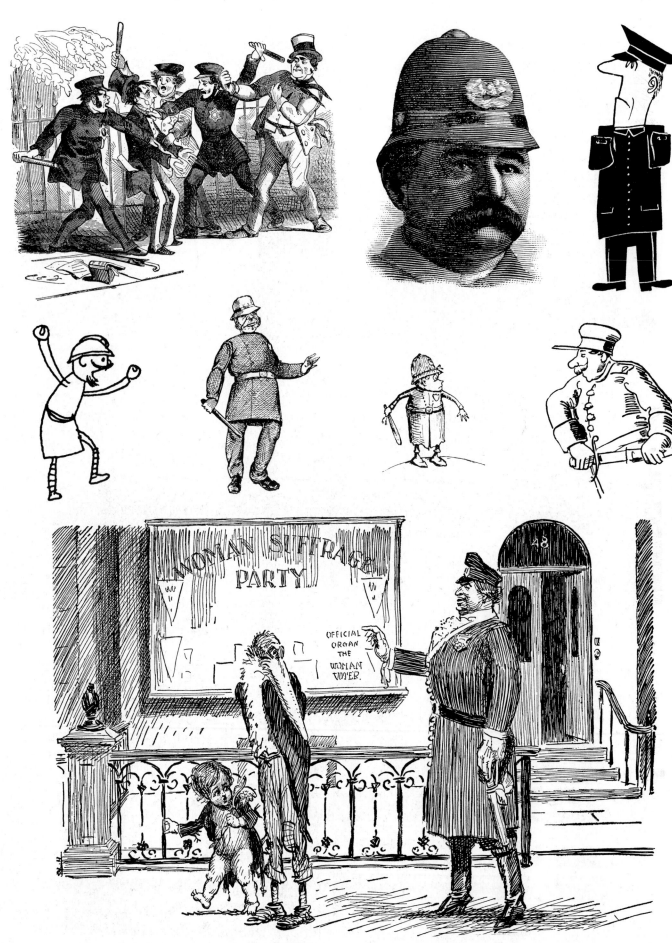

PORCUPINES & HEDGEHOGS

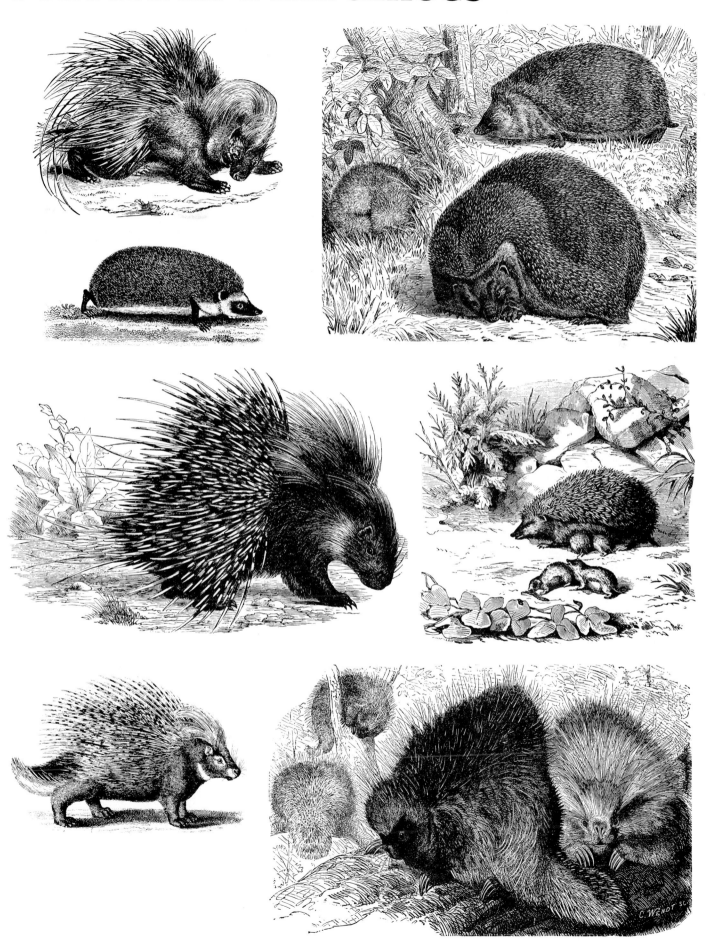

POULTRY

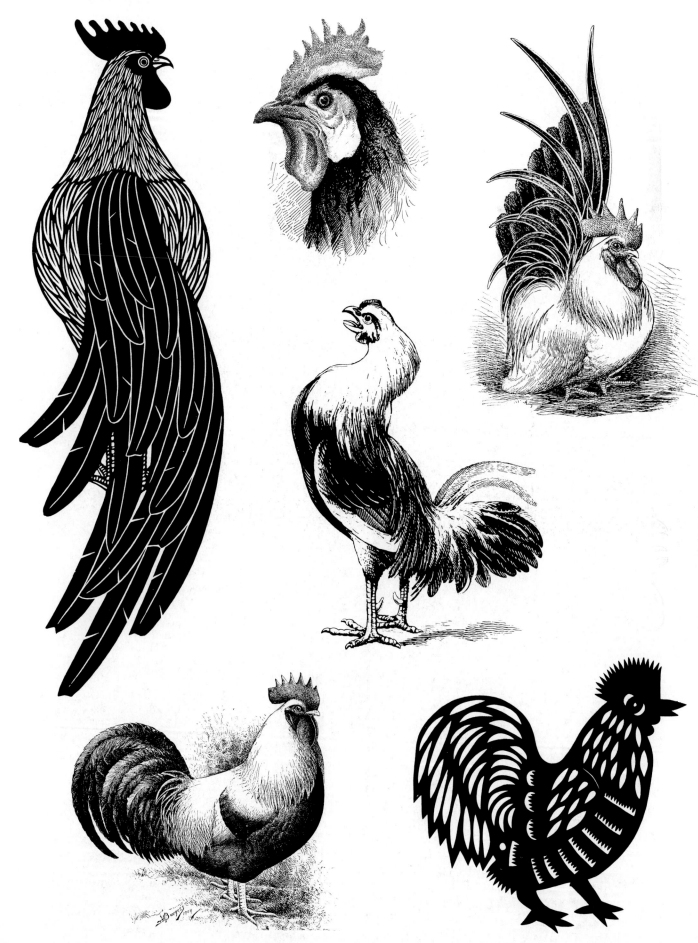

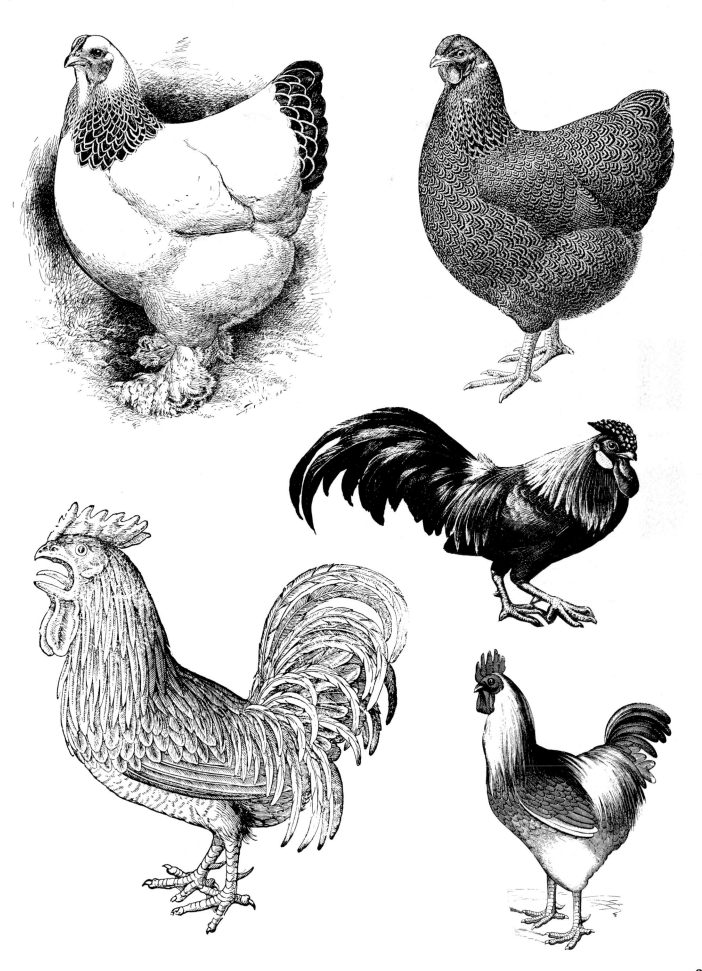

PRESIDENTS

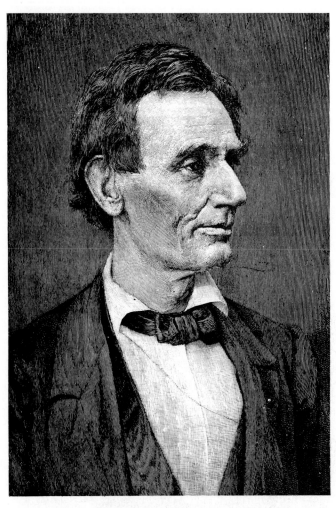

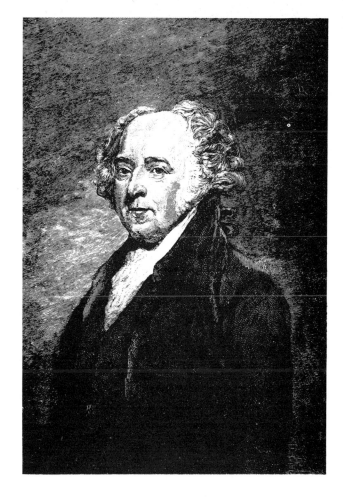
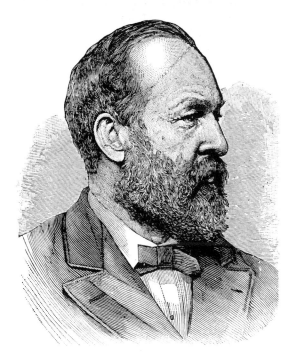

QUADRUPEDS

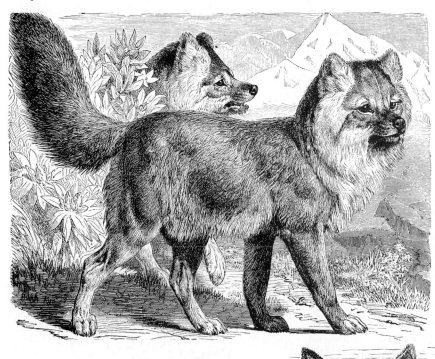

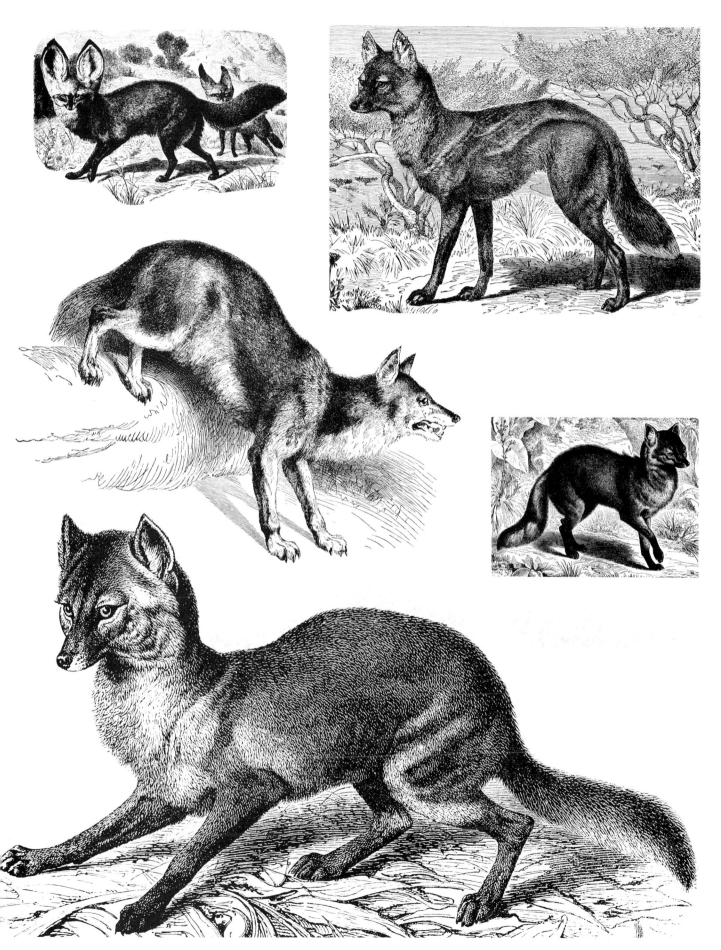

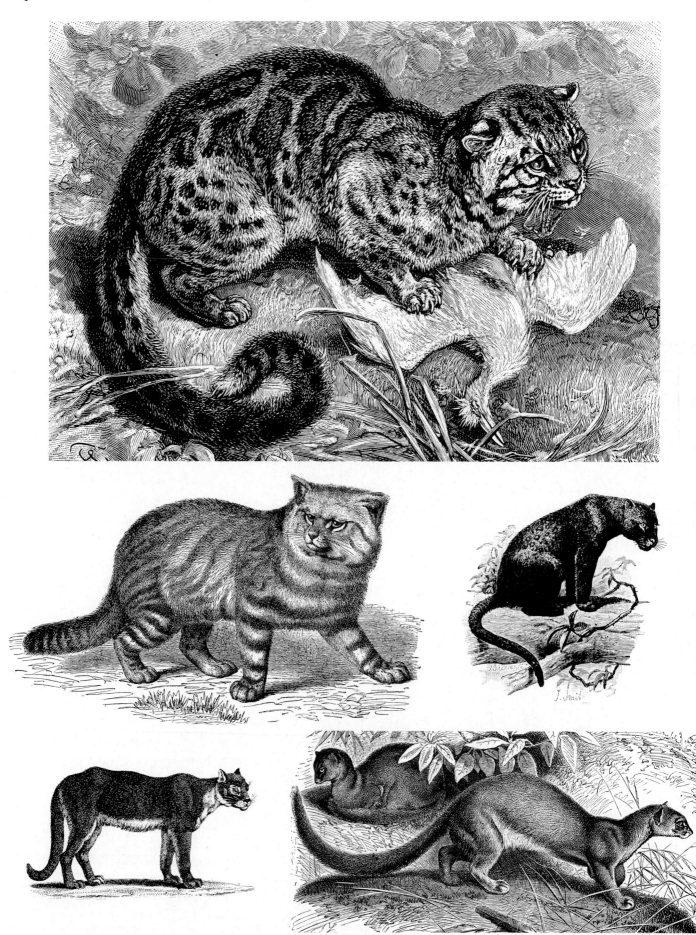

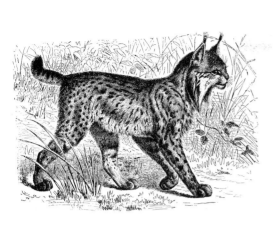

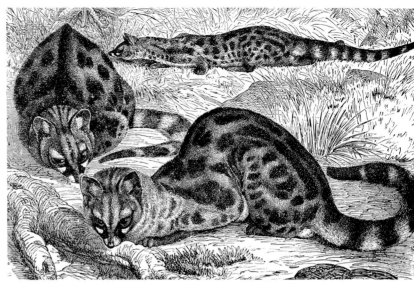

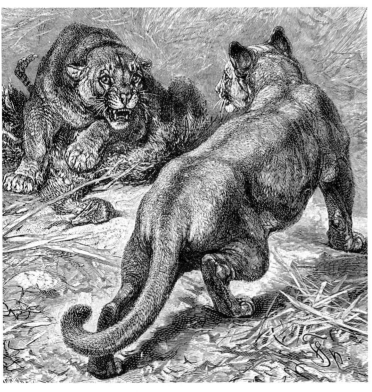

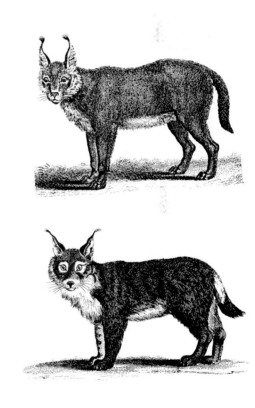

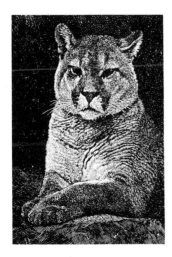

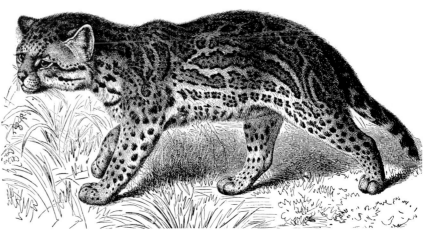

QUADRUPEDS (continued)

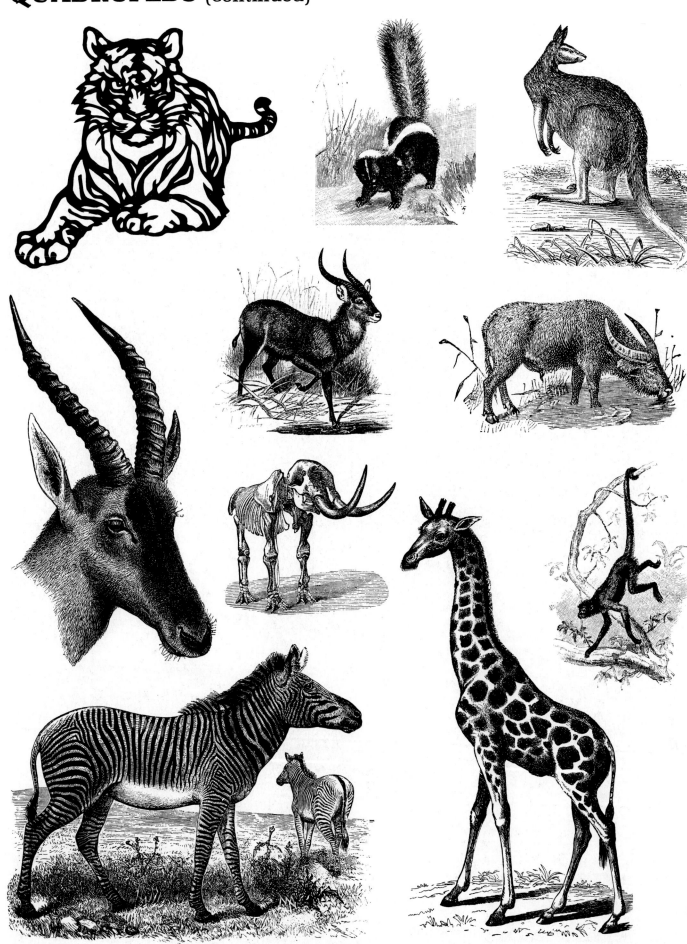

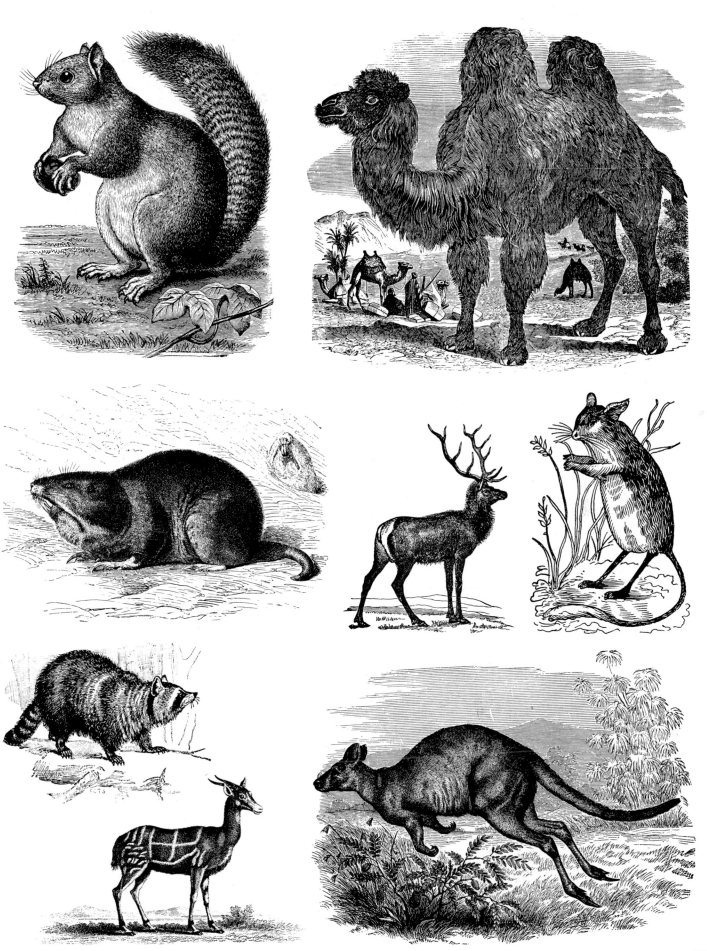

RABBITS & HARES

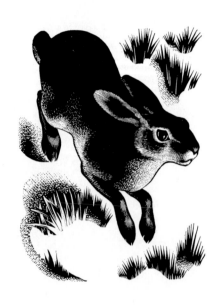

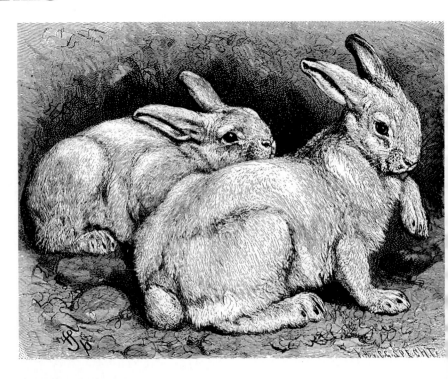

RAIN

RAIN (continued)

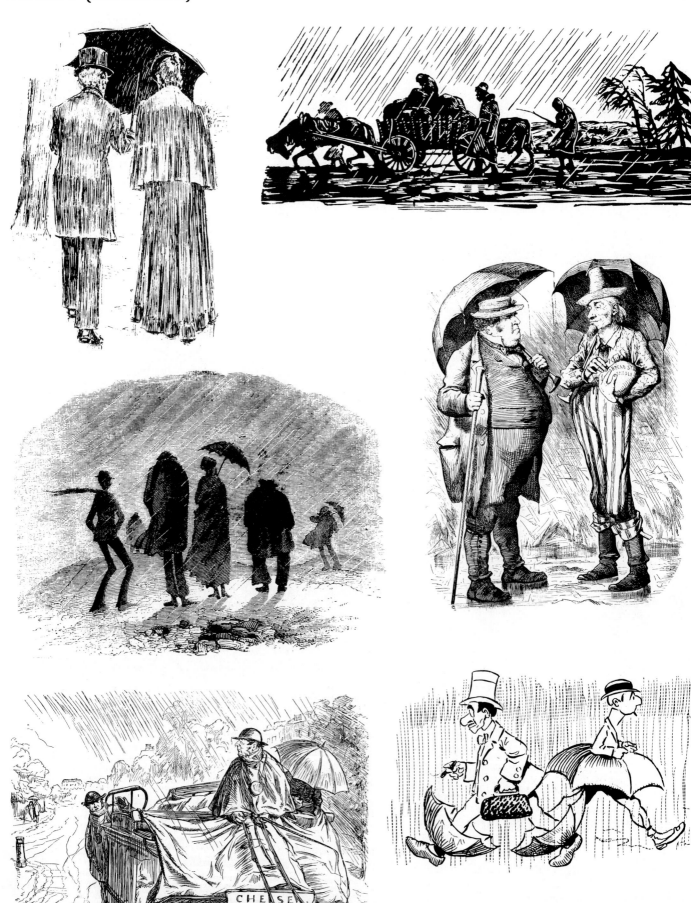

READING & WRITING

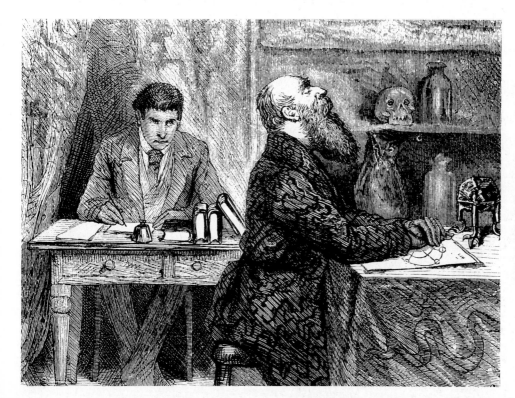

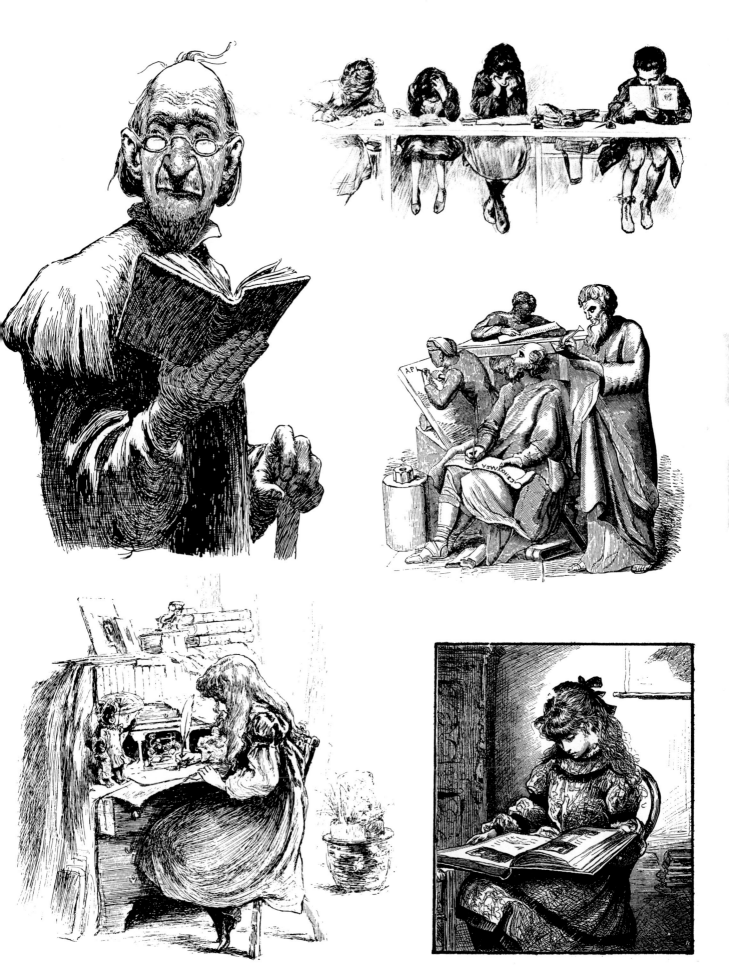

REPTILES

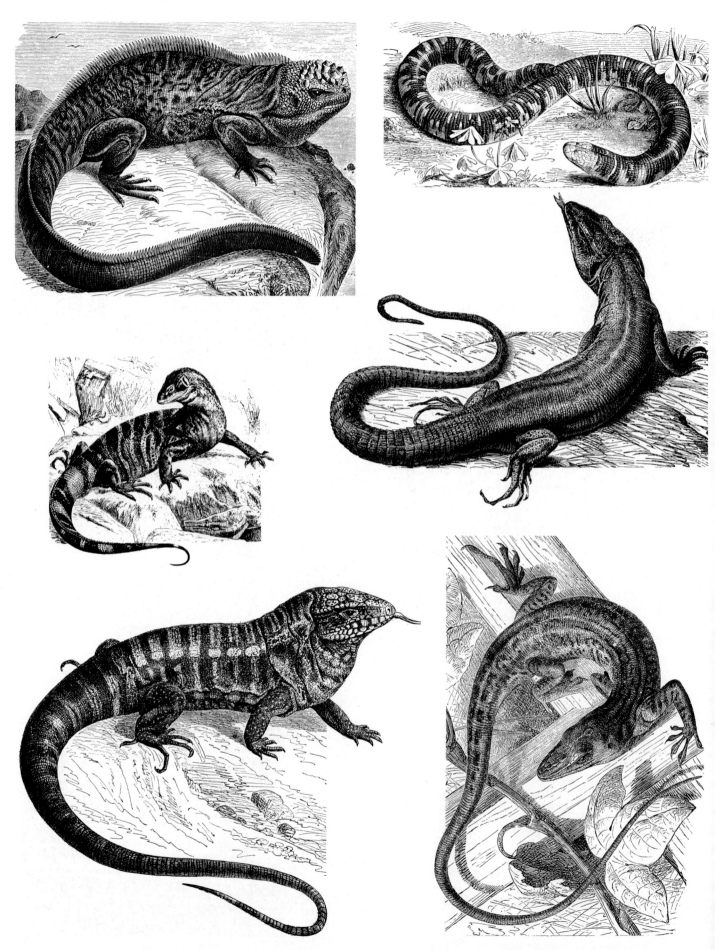

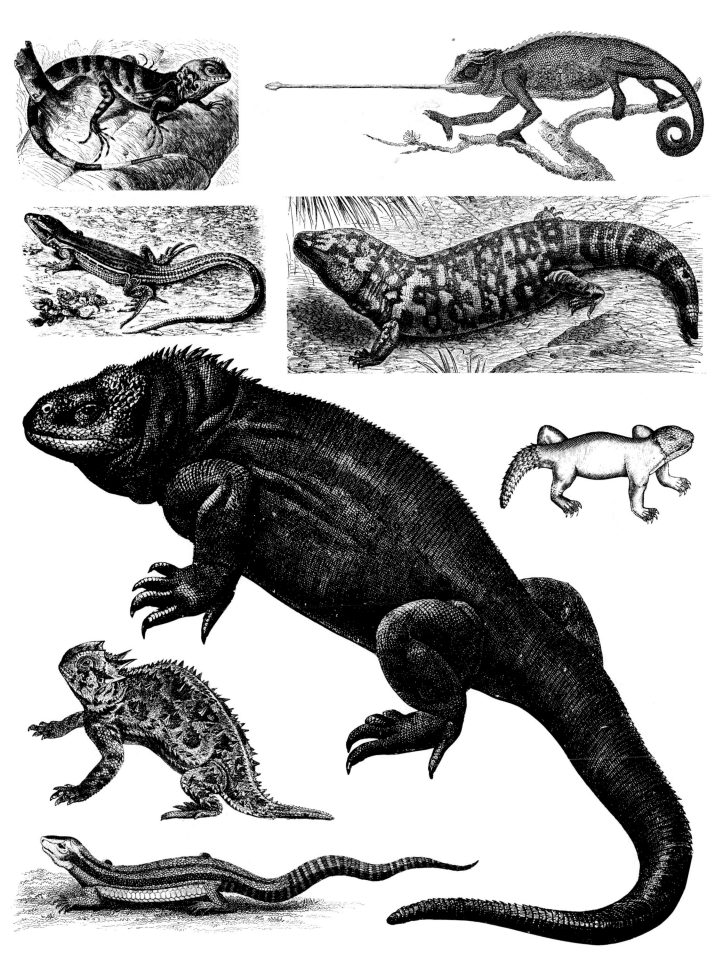

RINGS

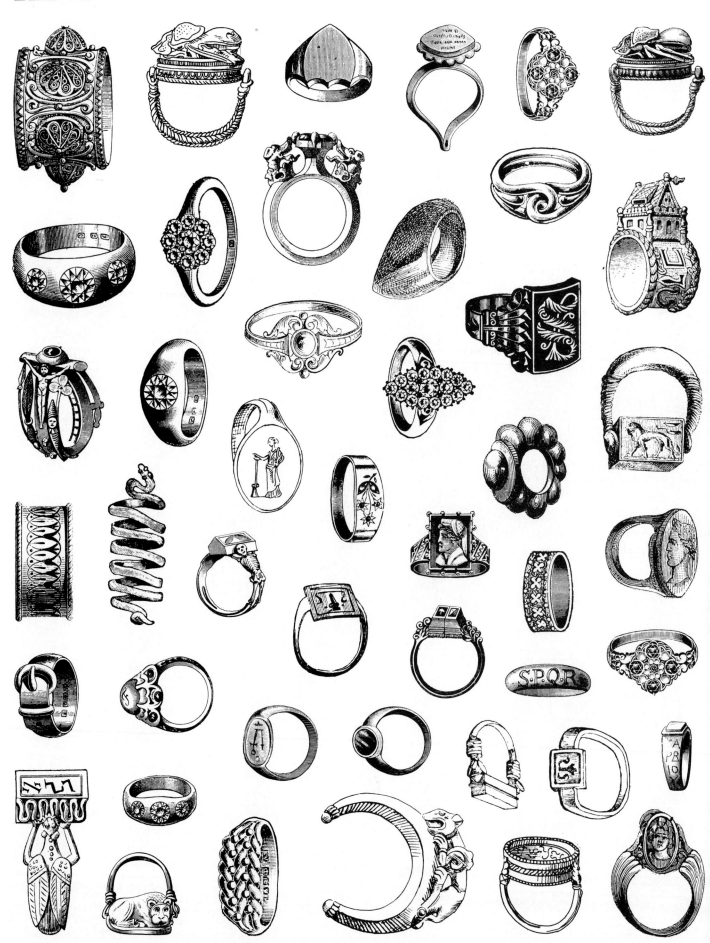

RODENTS

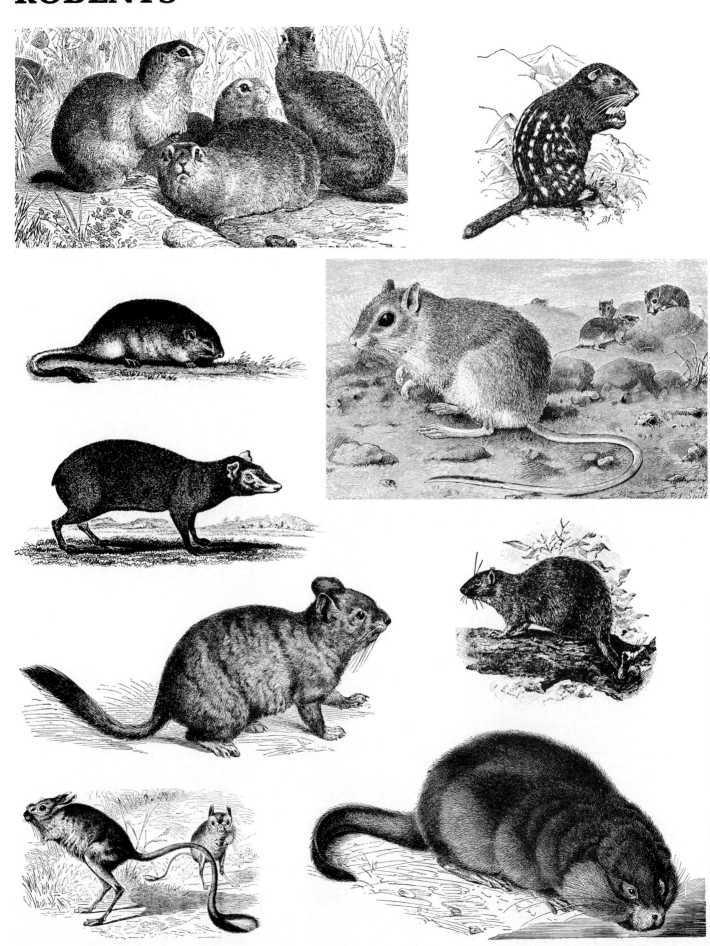

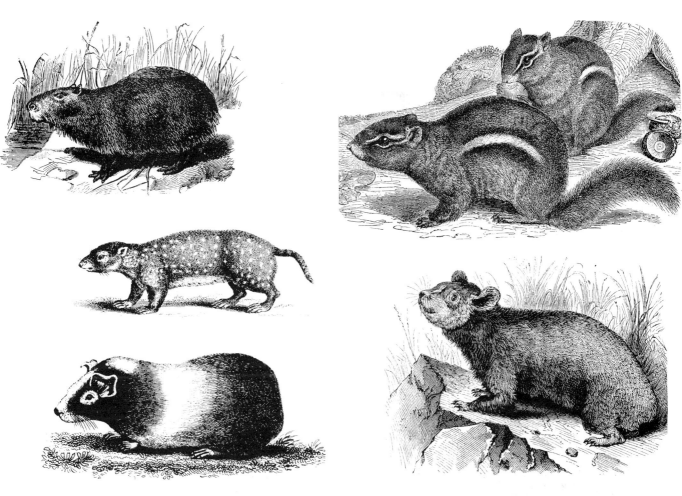

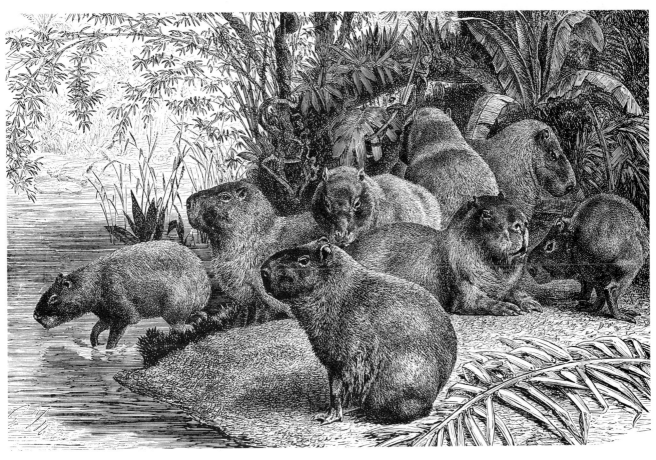

SAILORS

SEA BIRDS

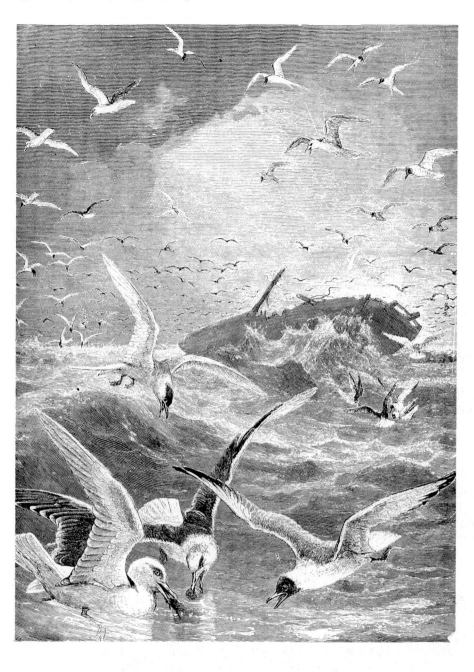

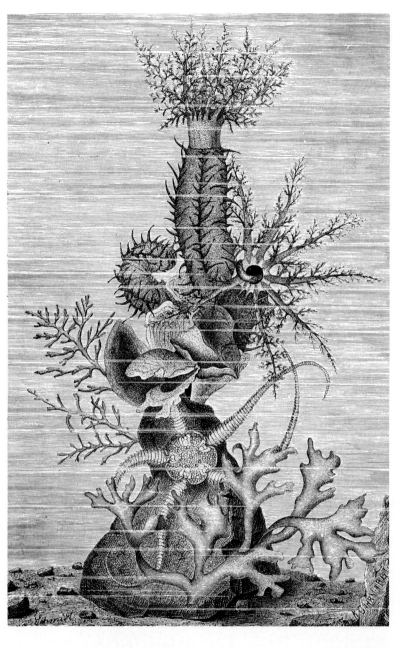

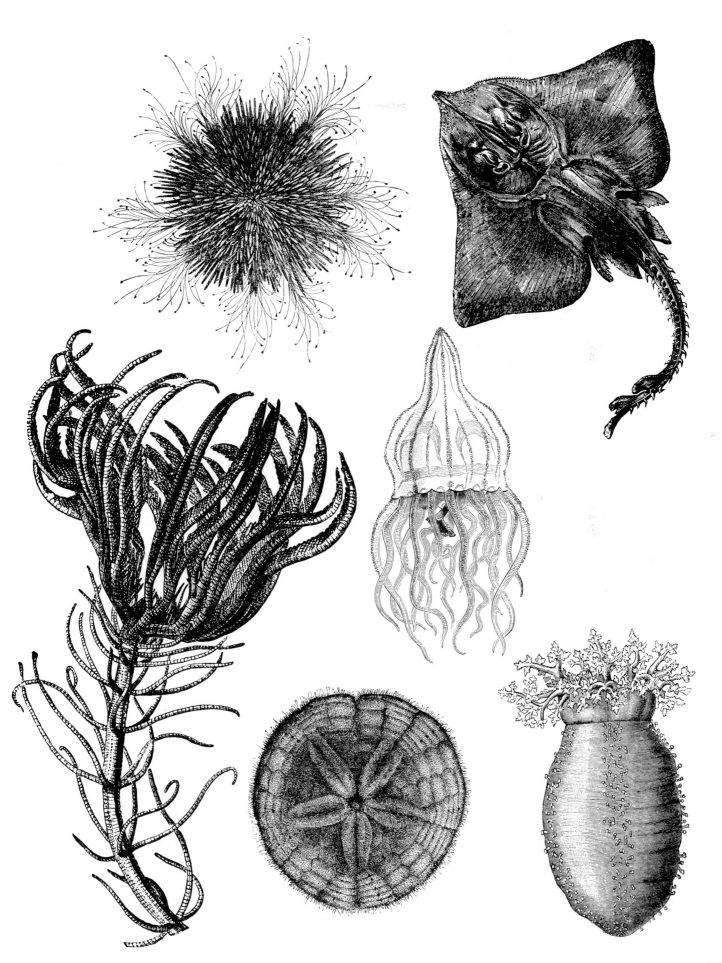

SERVANTS

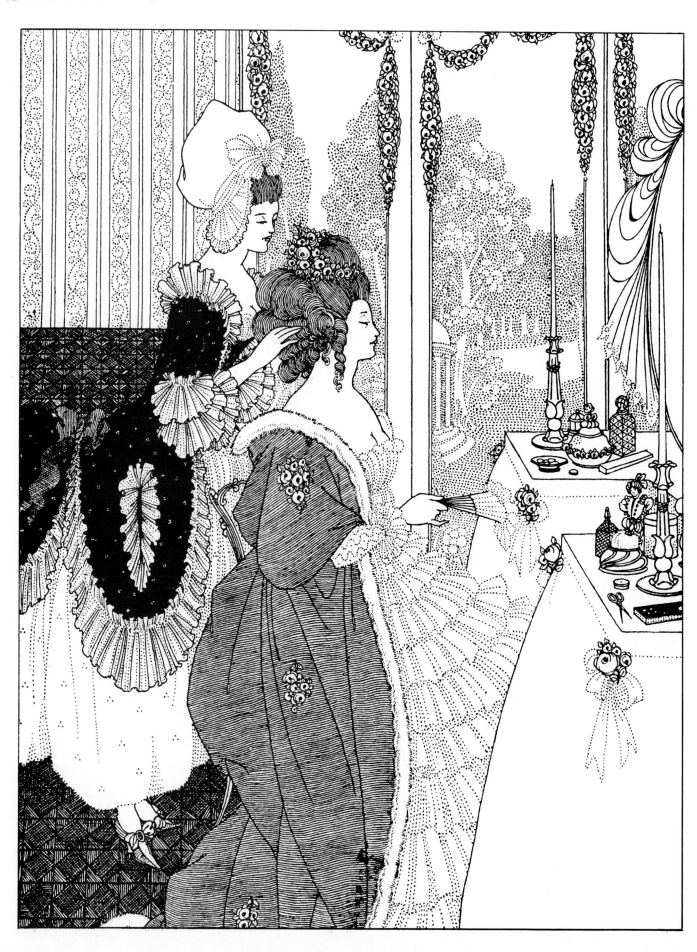

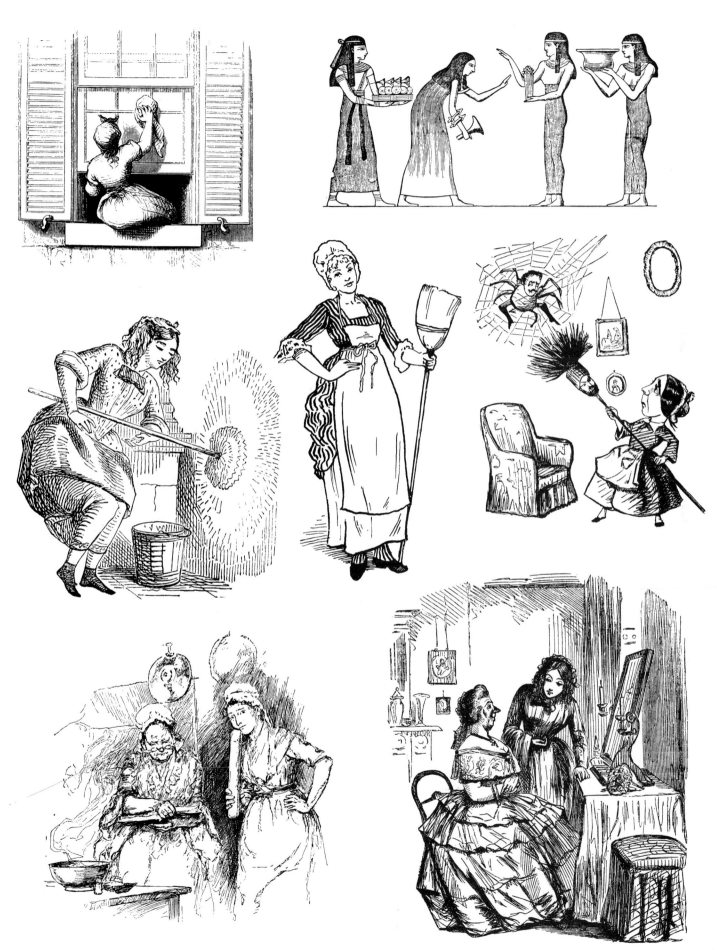

SHEEP

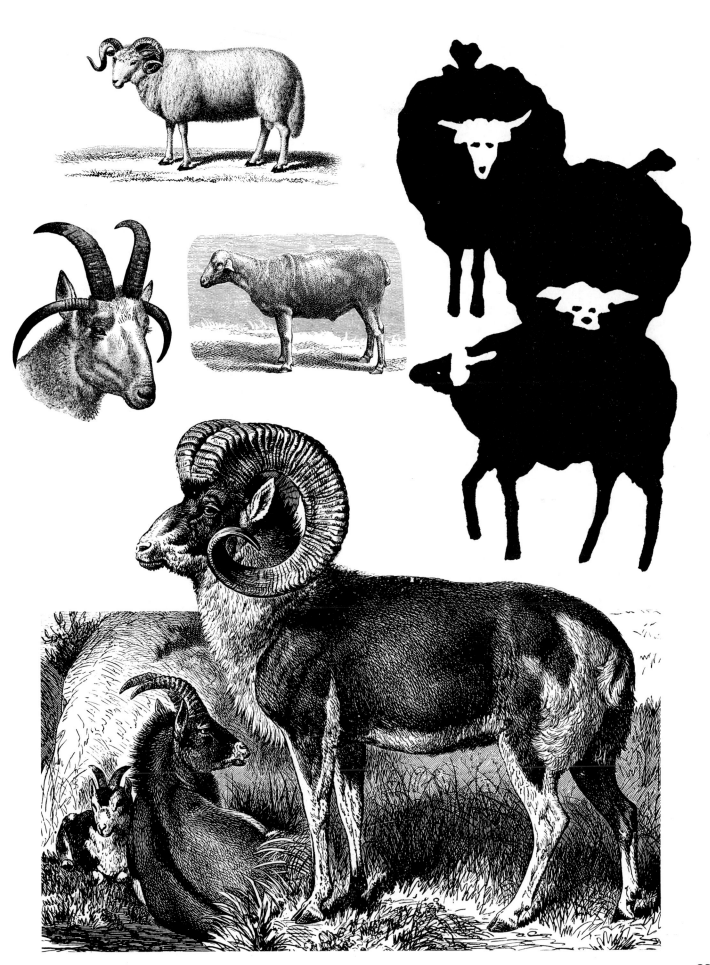

SHELLFISH

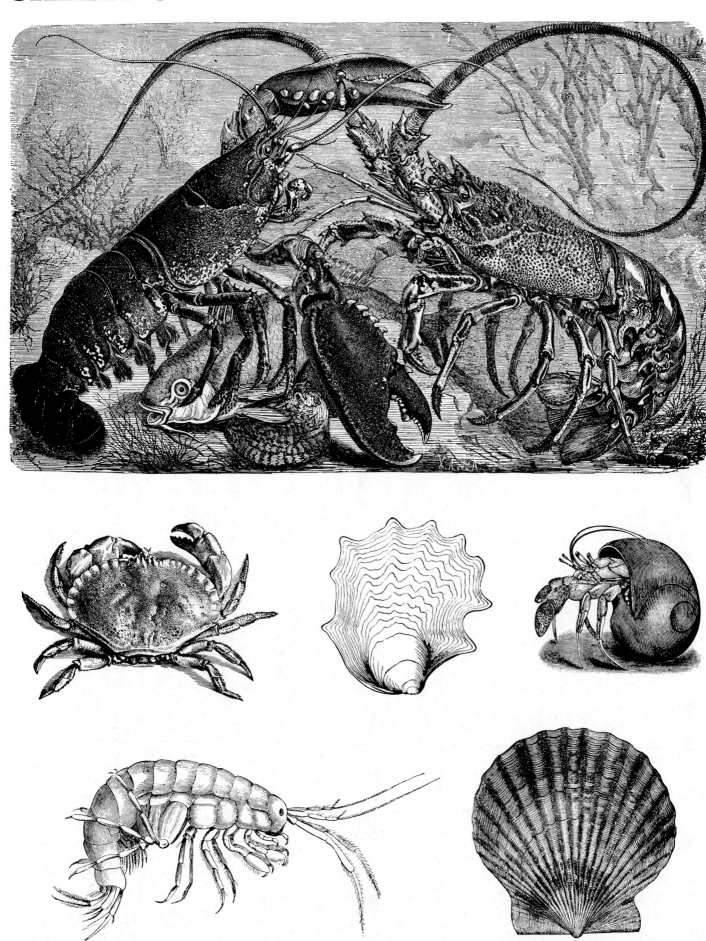

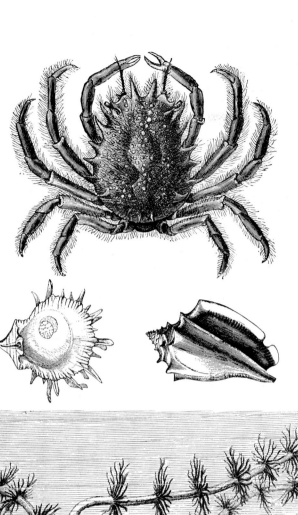

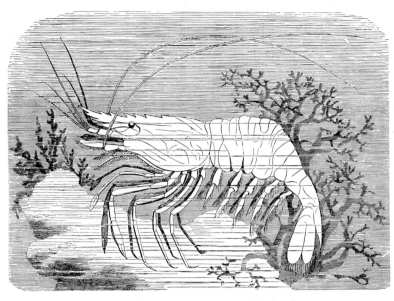

SHIPS & BOATS

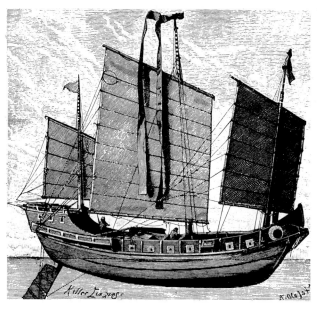

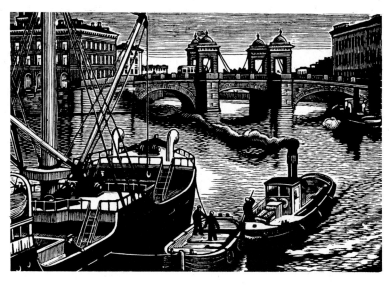

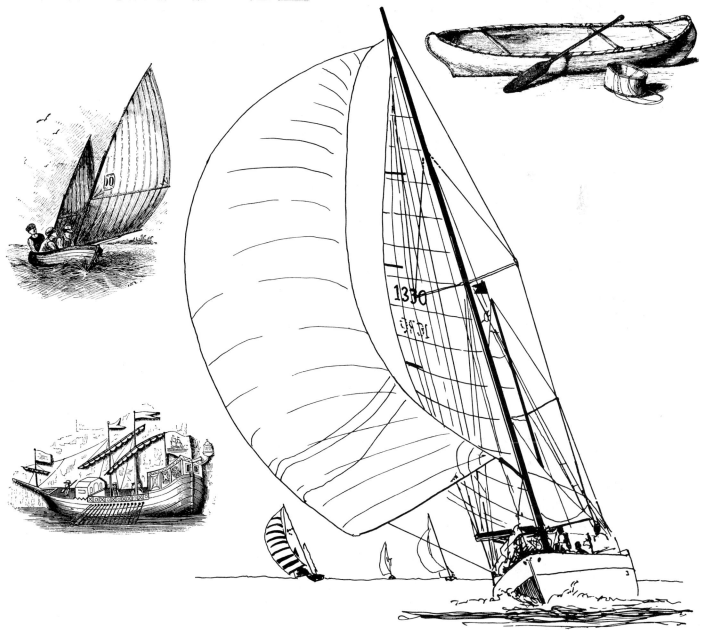

SHOES & BOOTS

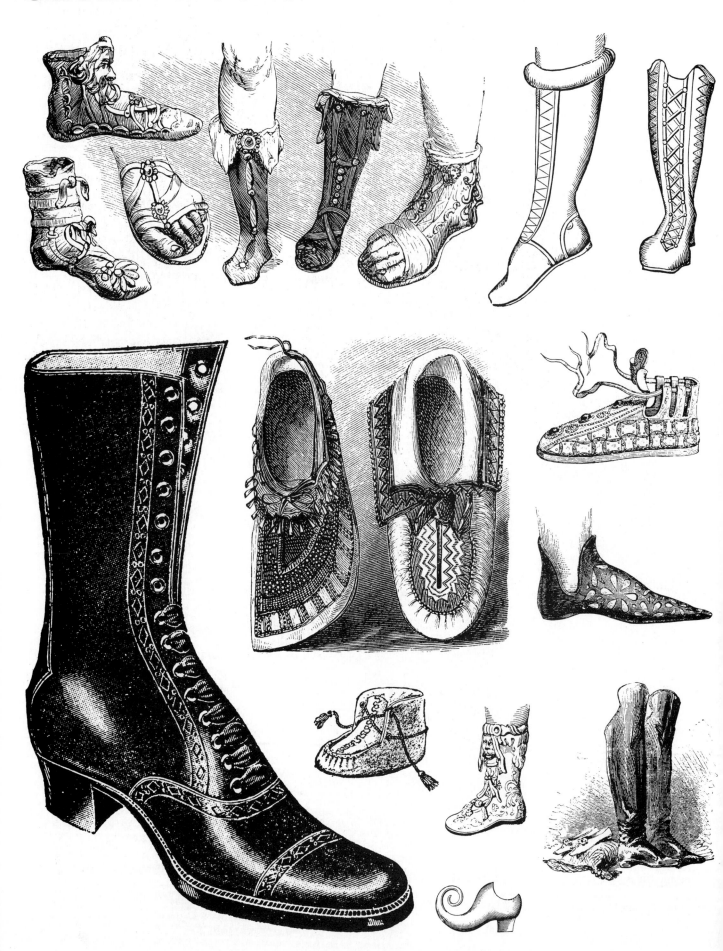

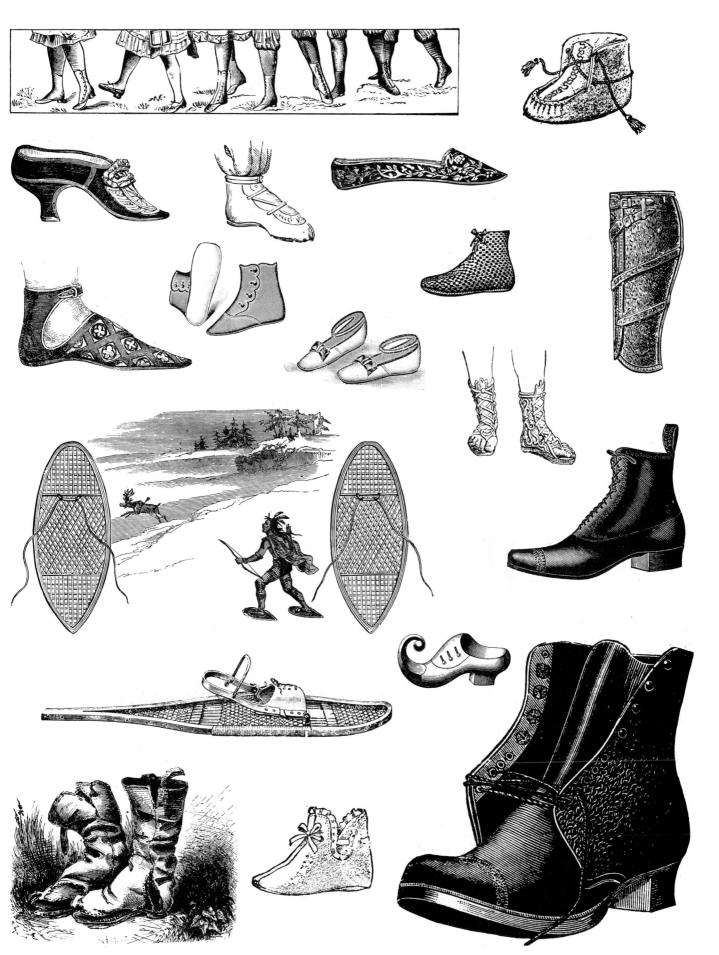

SHOPKEEPERS

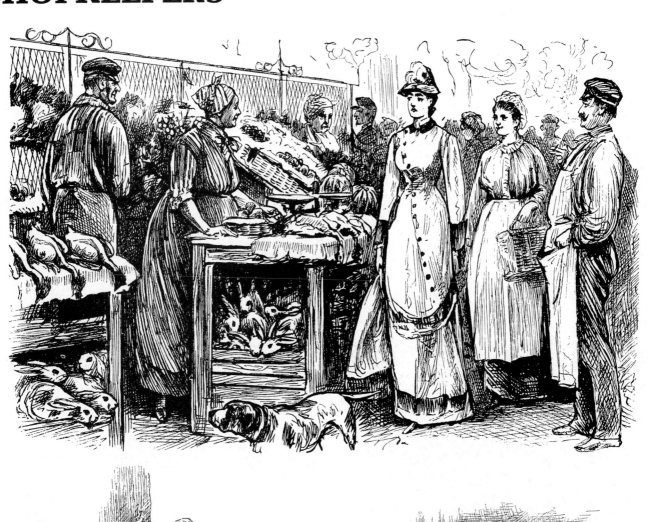

SIGNS & SYMBOLS

SILHOUETTES & SHADOWS

SLEEP & REPOSE

SMOKING

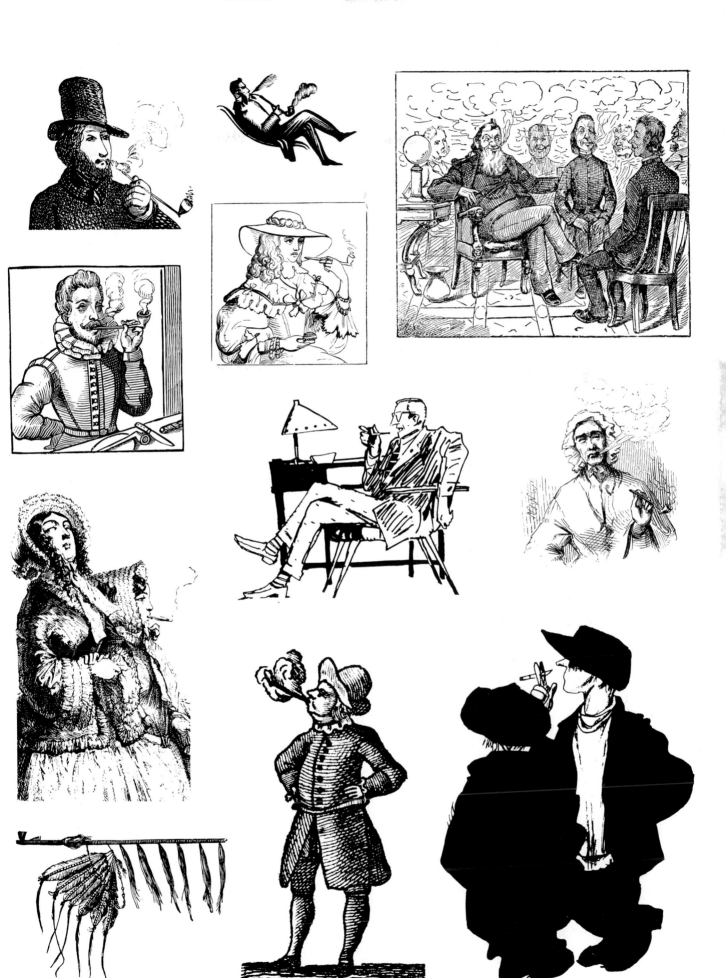

SNAKES

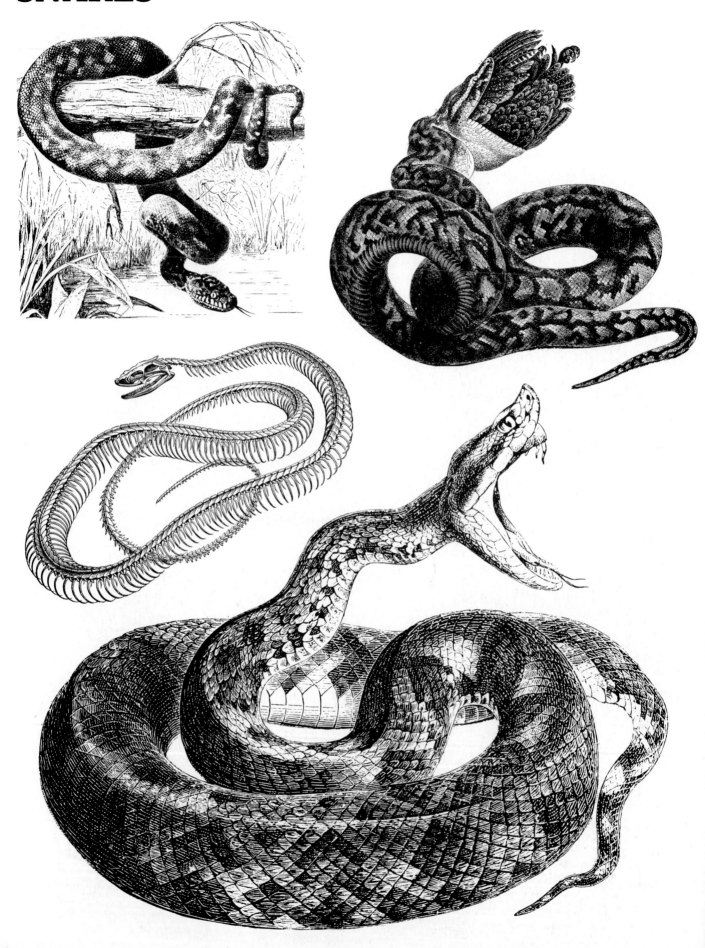

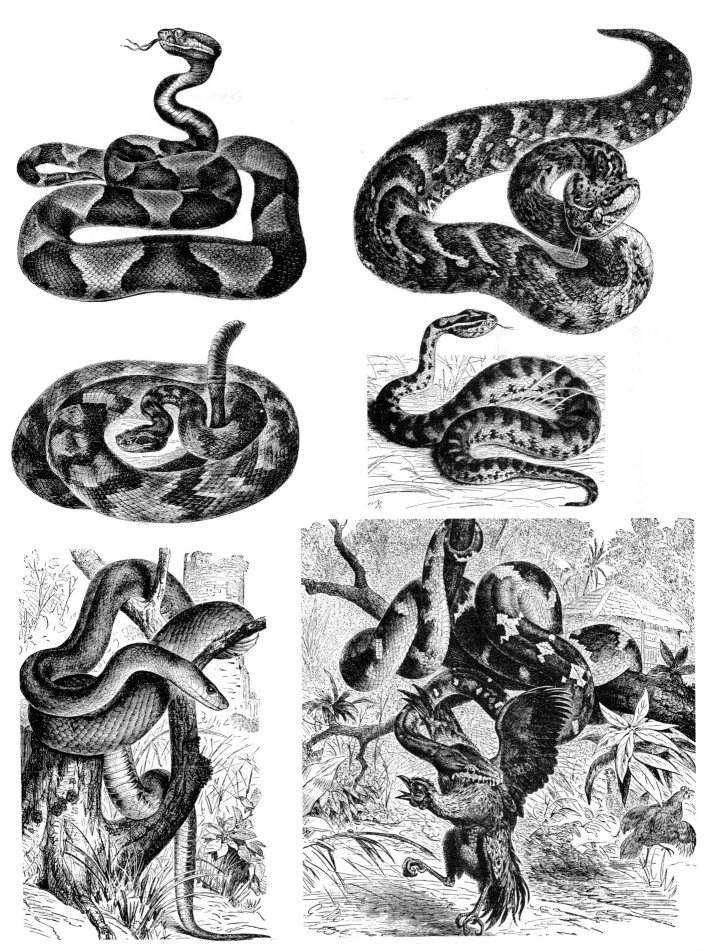

SNOW

SOCIETY SWELLS

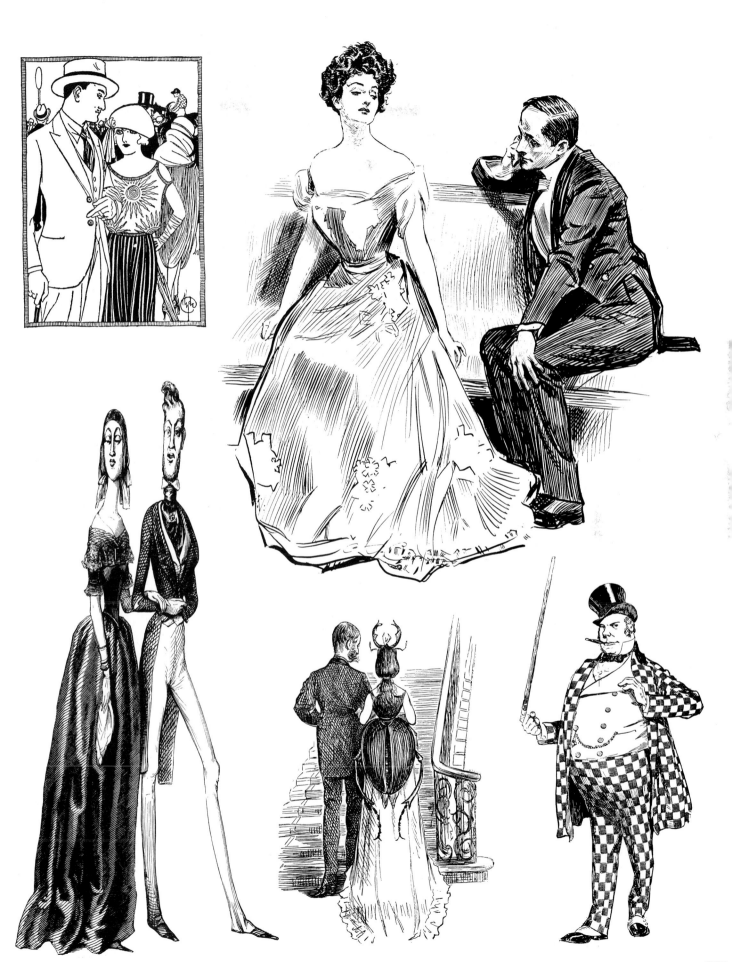

SPIDERS

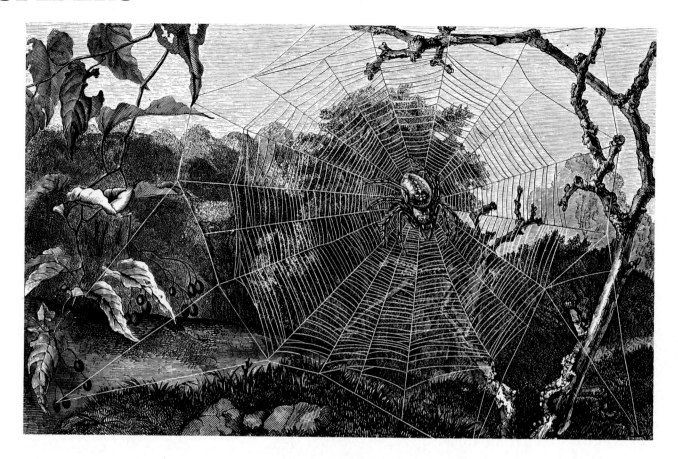

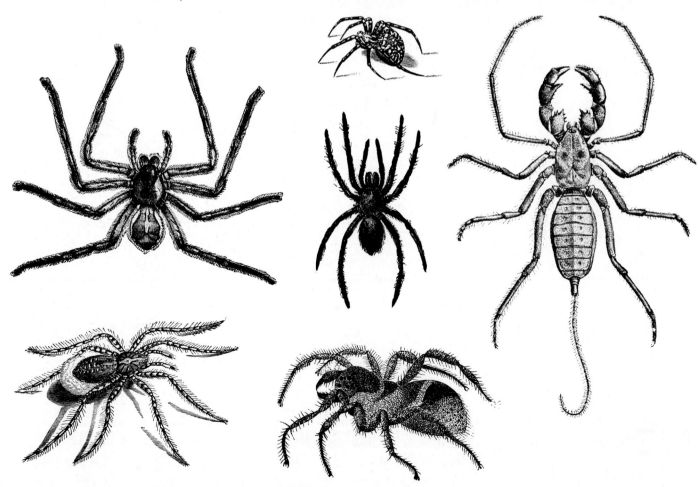

SPORTING GOODS

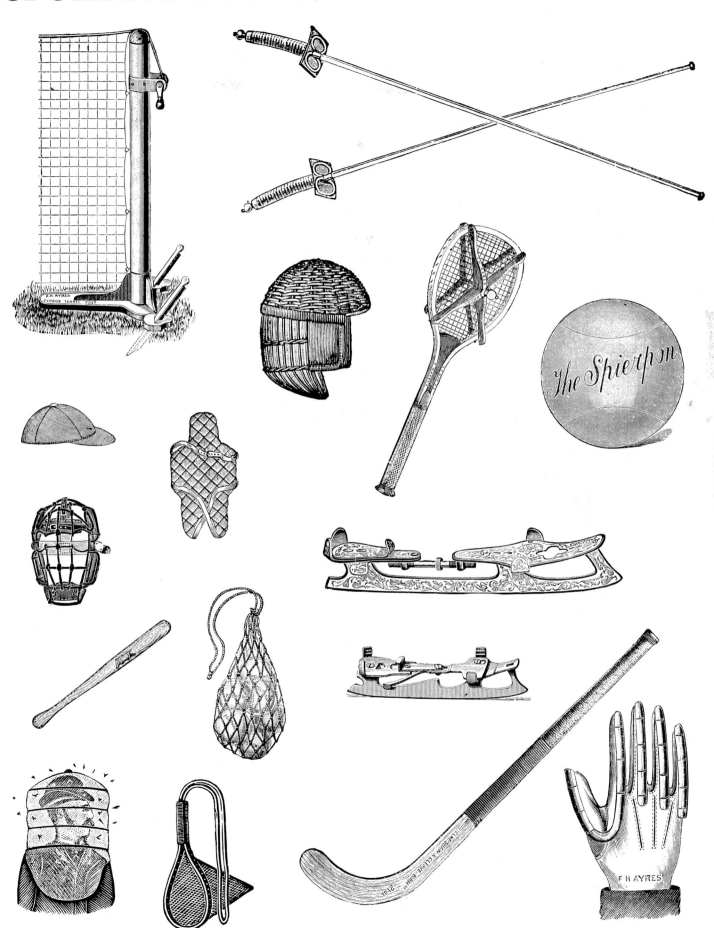

SPORTING GOODS (continued)

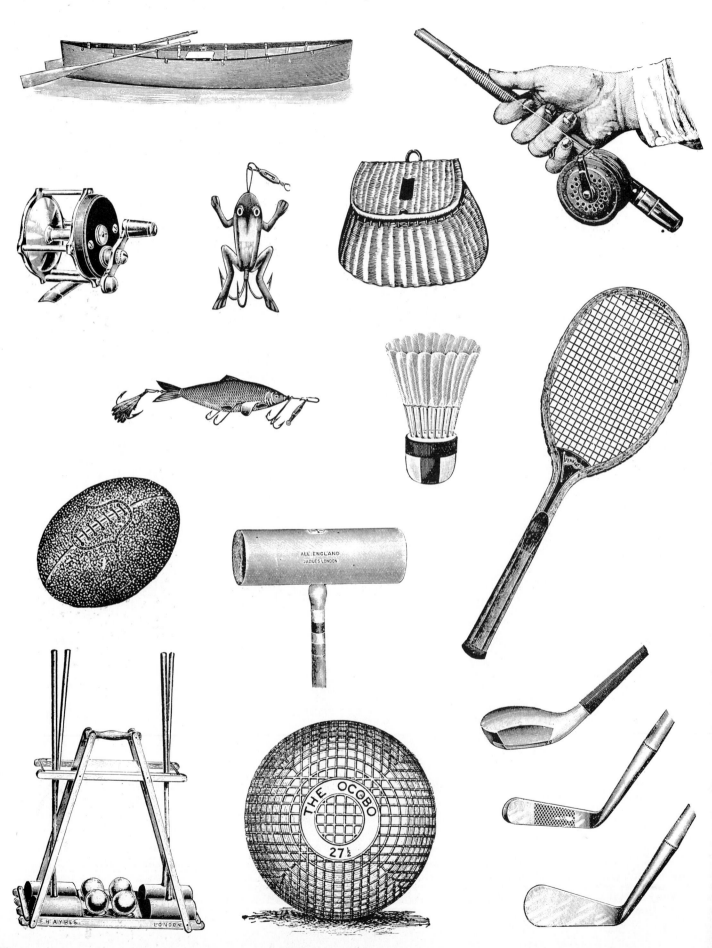

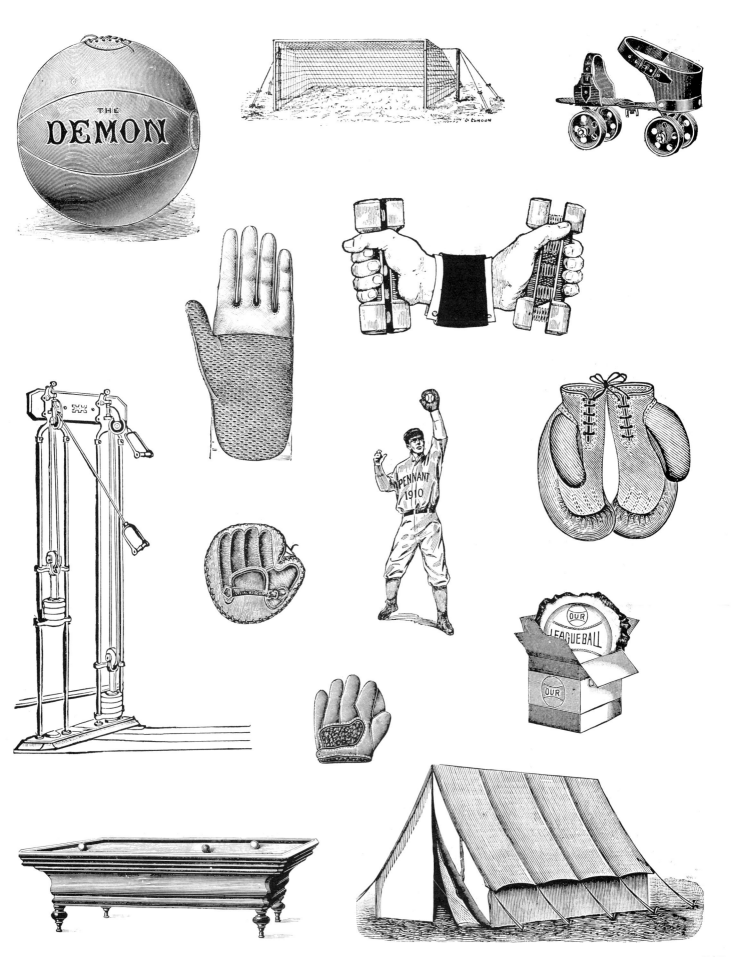

SPORTS

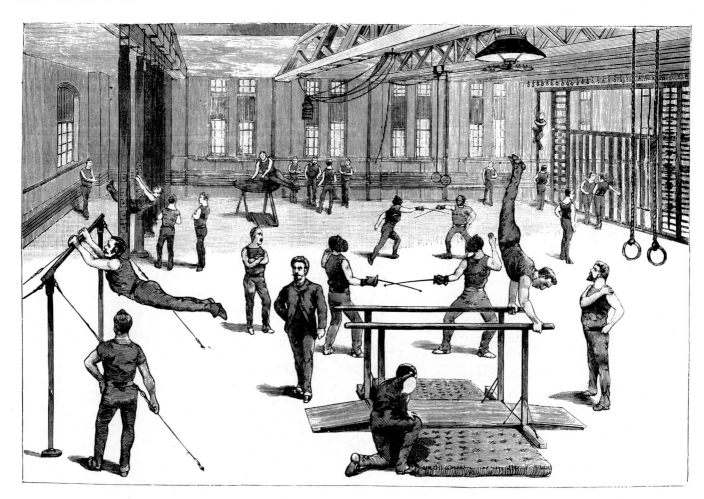

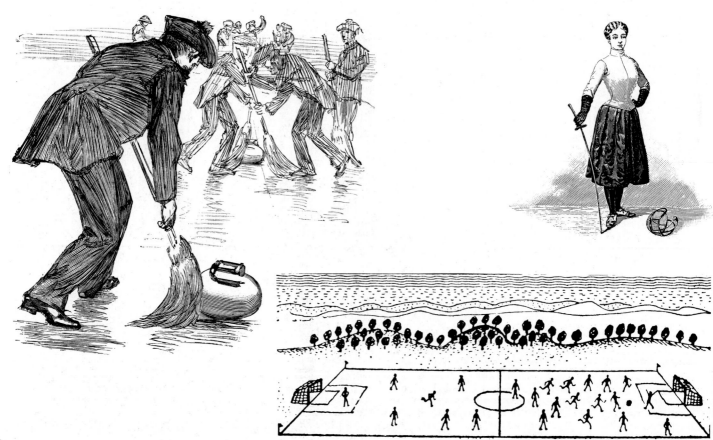

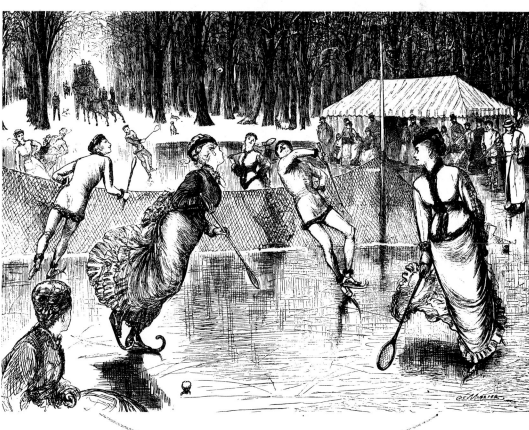

SPORTS (continued)

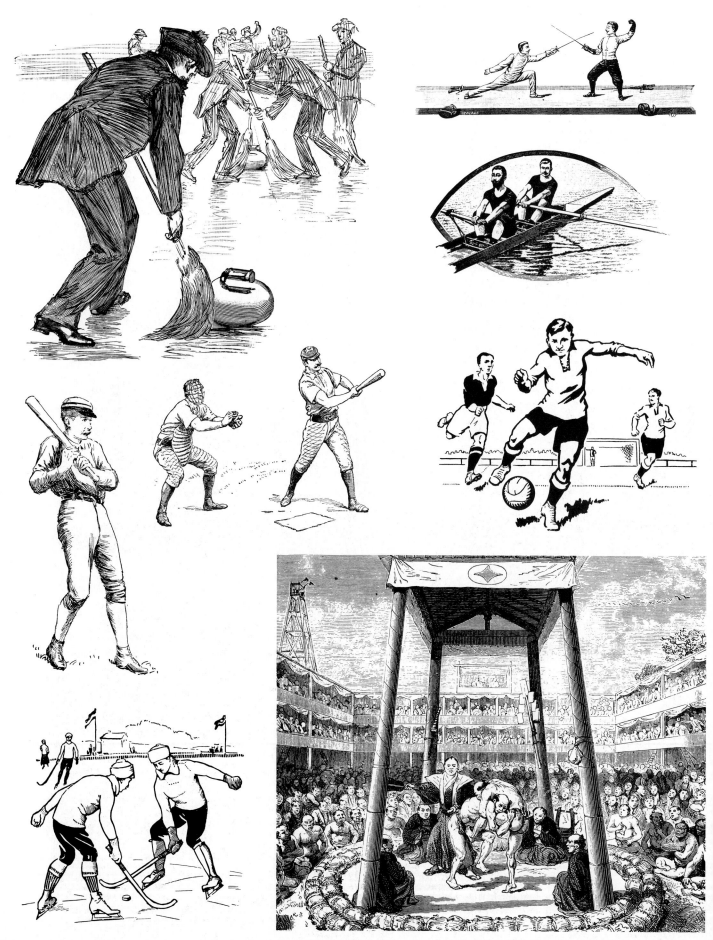

SQUIRRELS

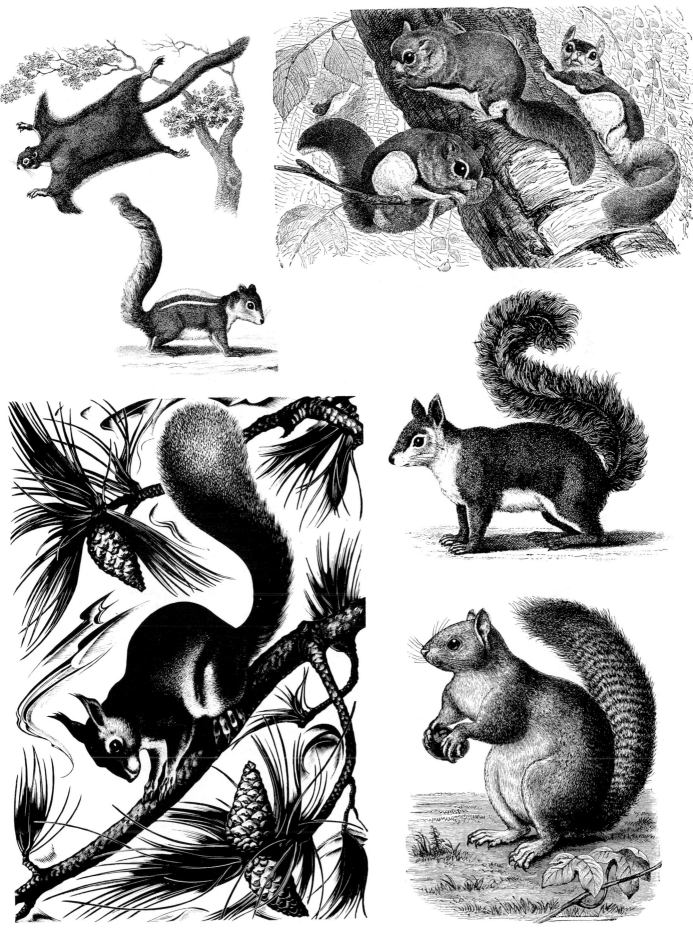

STATUES

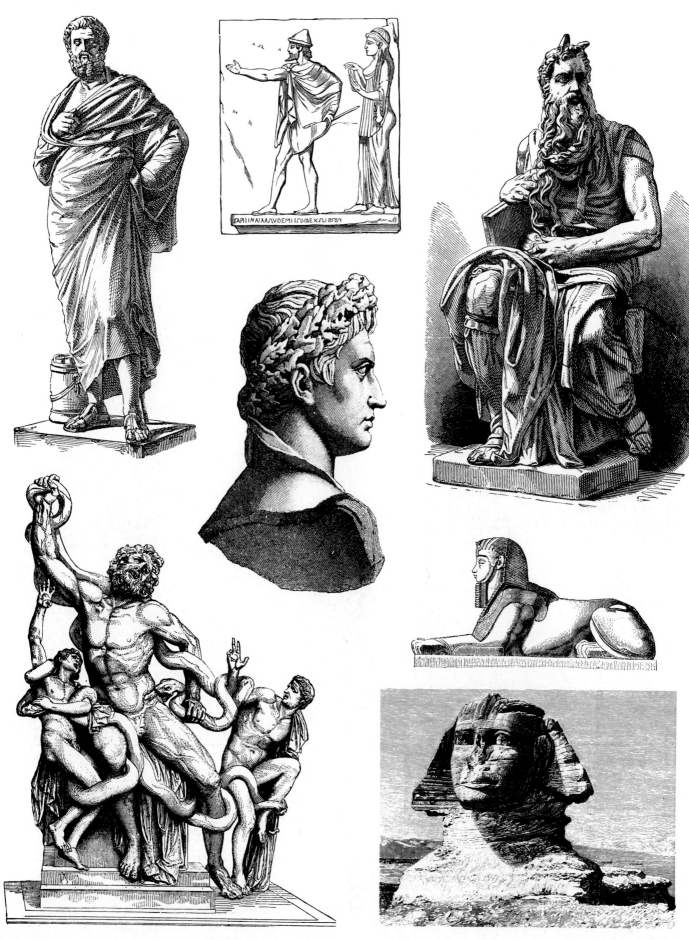

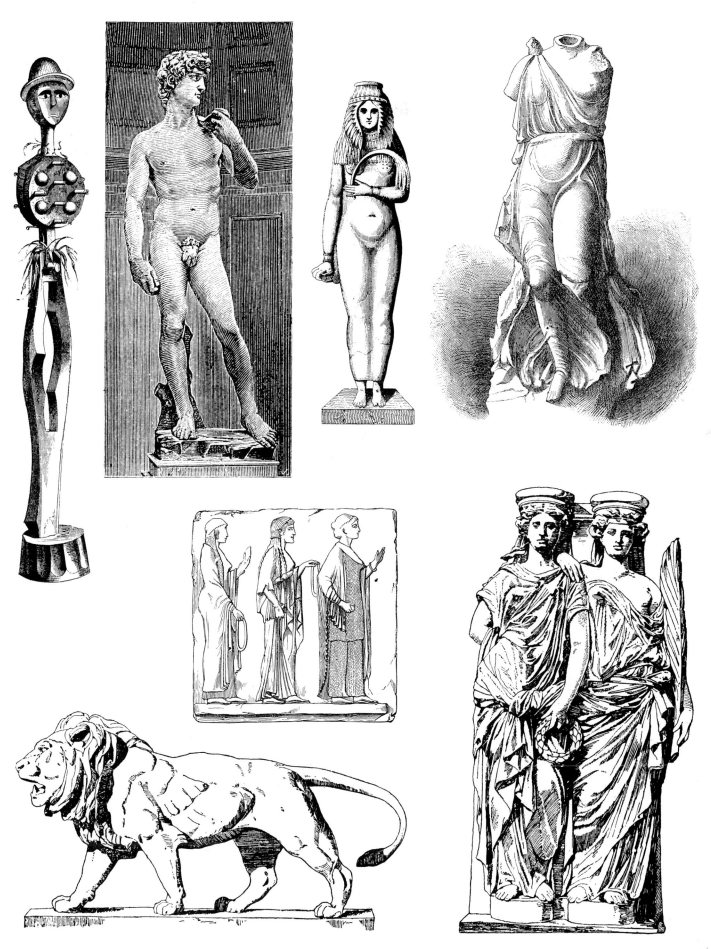

319

SUNBURSTS

SWINE

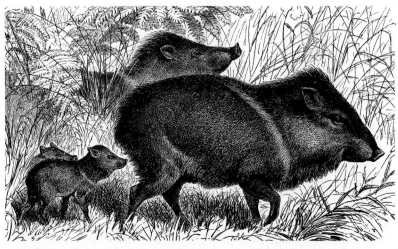

TAILORS

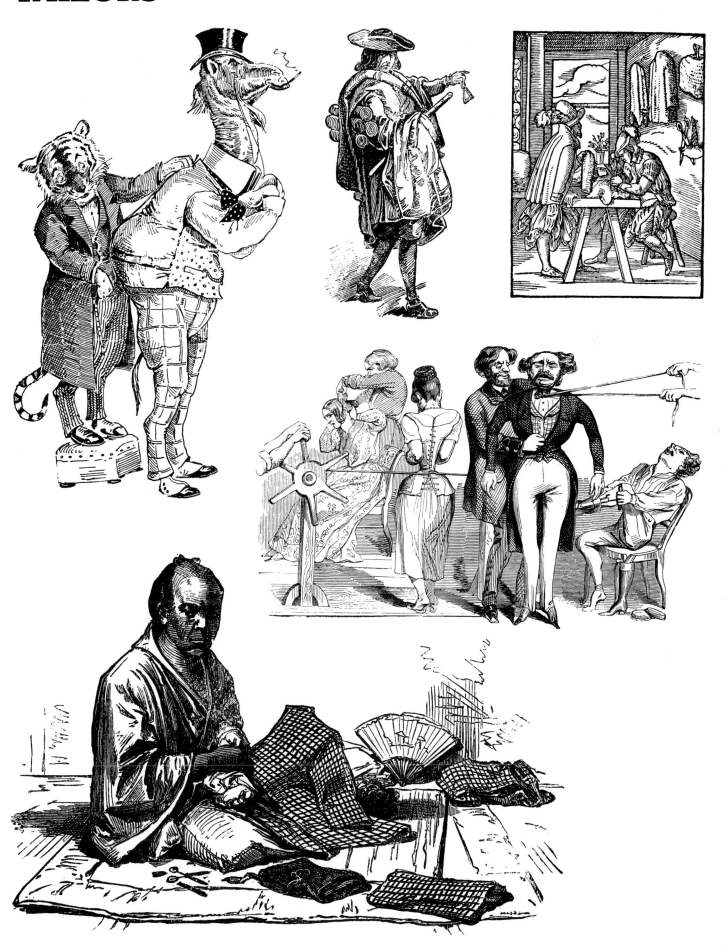

TABLEWARE

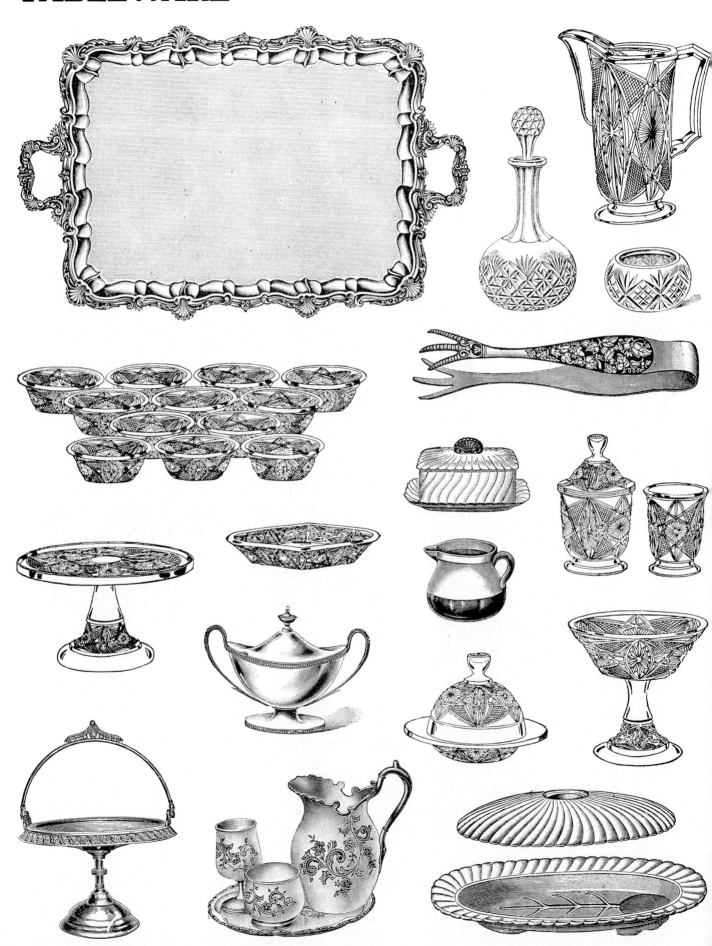

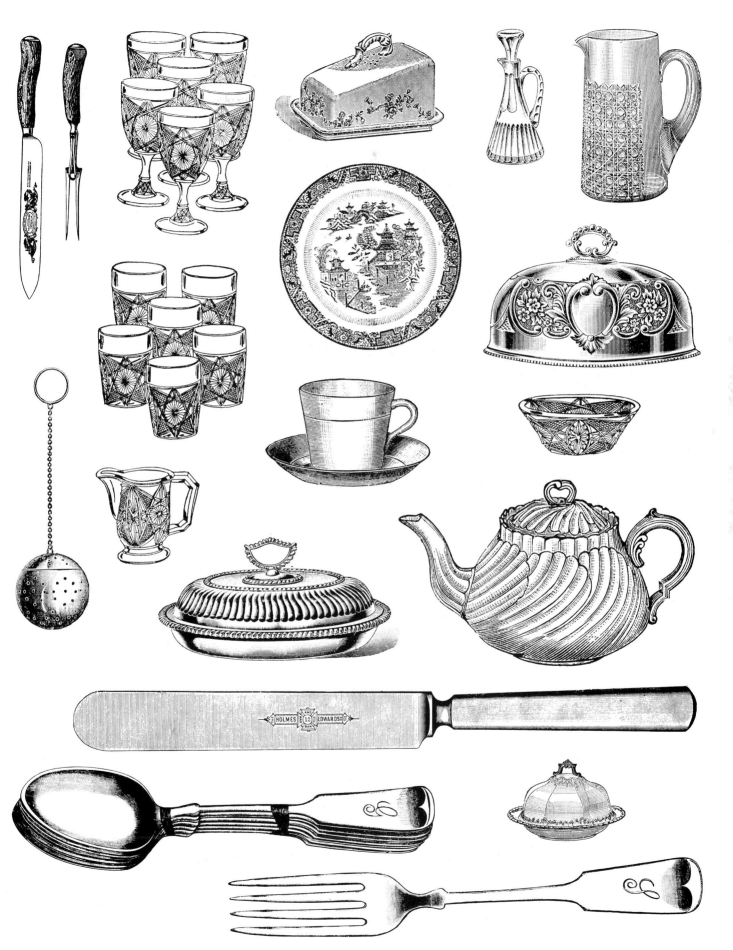

TOILETRIES

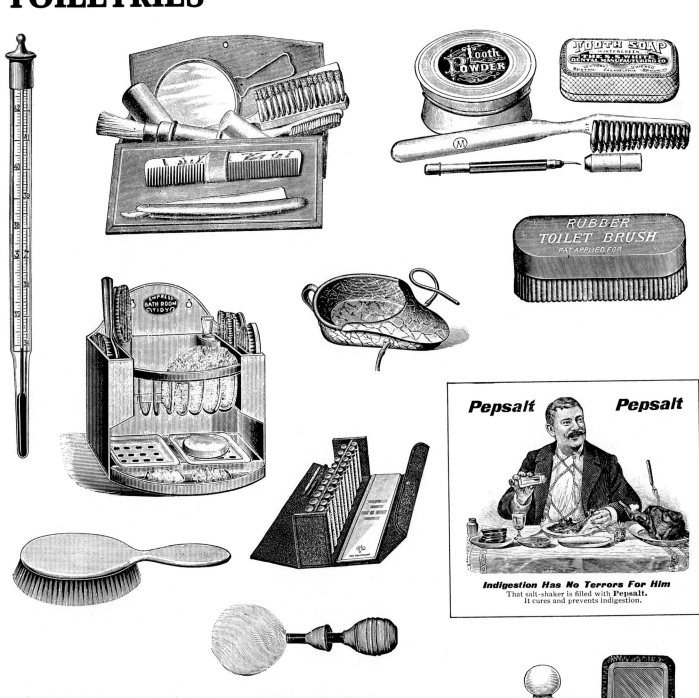

Tooth Powder

TOOTH SOAP
WINTERGREEN
KNIES WHITE DENTAL MANUFACTURING CO.
BOSTON · NEW YORK · CHICAGO
PHILADELPHIA · BROOKLYN N.Y.

RUBBER
TOILET BRUSH
PAT APPLIED FOR

EMPRESS
BATH ROOM
TIDY

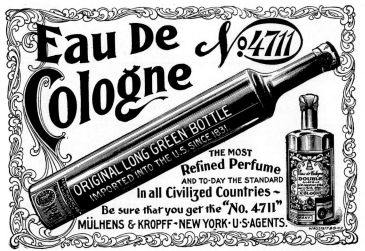

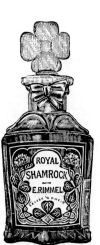

ROYAL
SHAMROCK
E. RIMMEL

Rhine
Violets
N⁰ 4711
FERD. MÜLHENS, CO.
U.S. AGENTS, MÜLHENS & KROPFF, N.Y.

BARRY'S TRICOPHEROUS

FOR THE HAIR.

COE'S ECZEMA CURE

A SPECIFIC FOR ECZEMA (SALT RHEUM) HERPES HIVES ITCHING PILES AND ALL SKIN DISEASES.

PRICE TRADE MARK C.C.C. REGISTERED. $1.00

RUB CURE THOROUGHLY ONE OR MORE TIMES DAILY ON PARTS AFFECTED. ITCHING IMMEDIATELY RELIEVED. 2 TO 10 APPLICATIONS USUALLY EXTERMINATE DISEASE.

Coe Chemical Co. Cleveland.

Rexall Orderlies

EPSOM SALTS

MONTGOMERY WARD&Co CHICAGO

'TABLOID' BLAUD PILL COMPRESSED

P.T.R. Co. COLORADO

PURE SANITARY PAPER PERFORATED.

COLORADO TOILET ROLL.

COD LIVER OIL EMULSION WITH HYPOPHOSPRITES

A GOOD FOR INFANTS AND INVALIDS

SPIERS & POND LTD

QUAKER COLD CREAM

TYRIAN

IVORY SOAP IVORY 99 $\frac{44}{100}$ % PURE

IT FLOATS

J.R.TORREY CO US

BAYER

J.R.TORREY WORCESTER MASS. COMBINATION HONE AND CUSHION BELT STROP DIRECTIONS FINISH ON PLAIN LEATHER. No. 230

327

TEACHERS

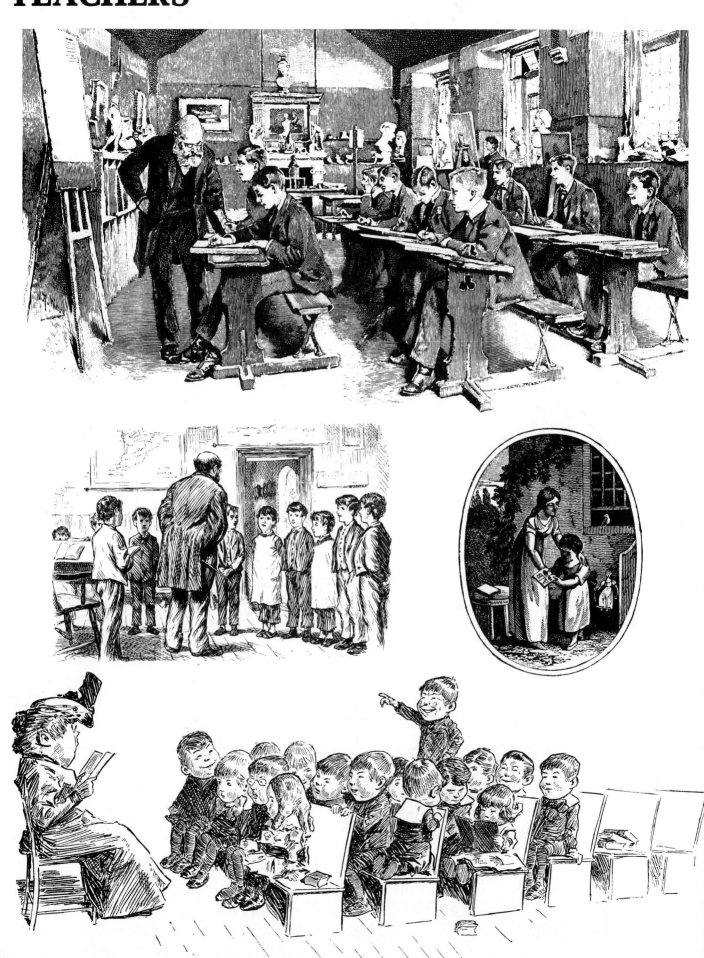

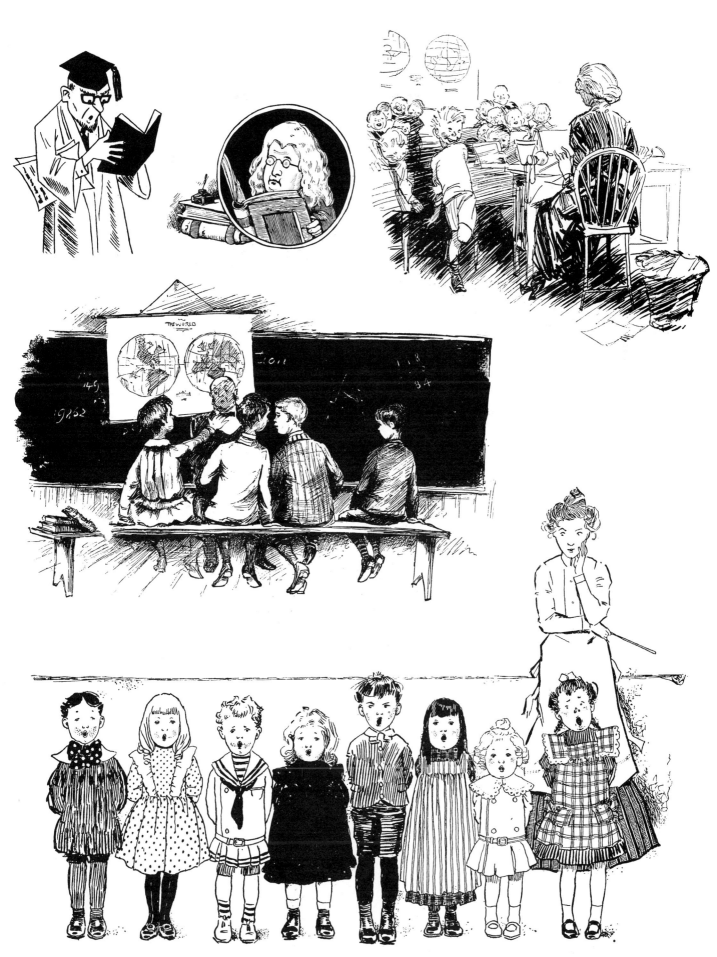

TOOLS

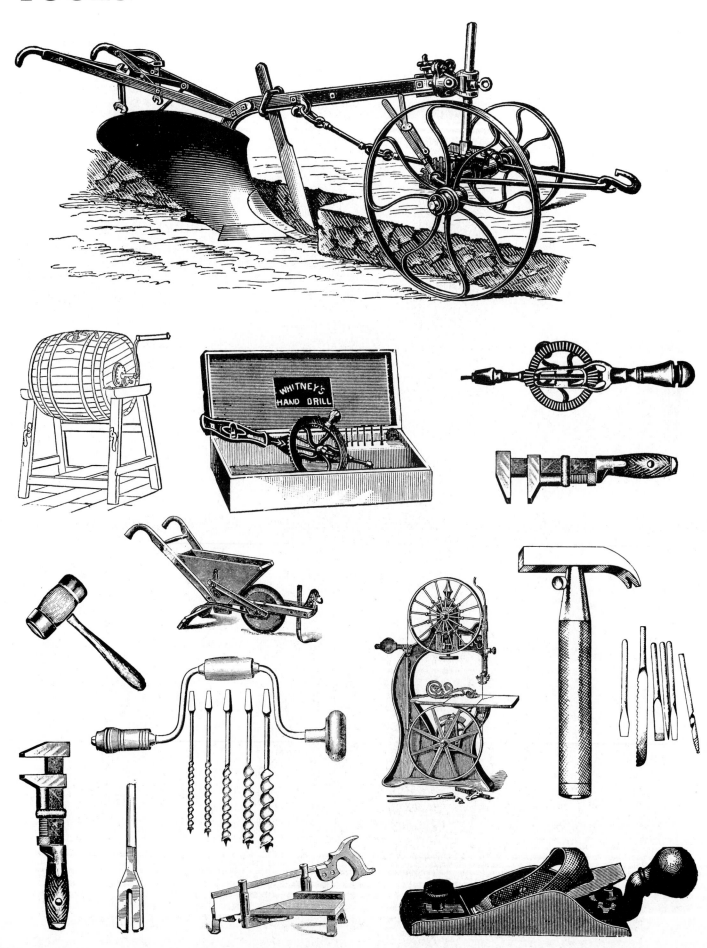

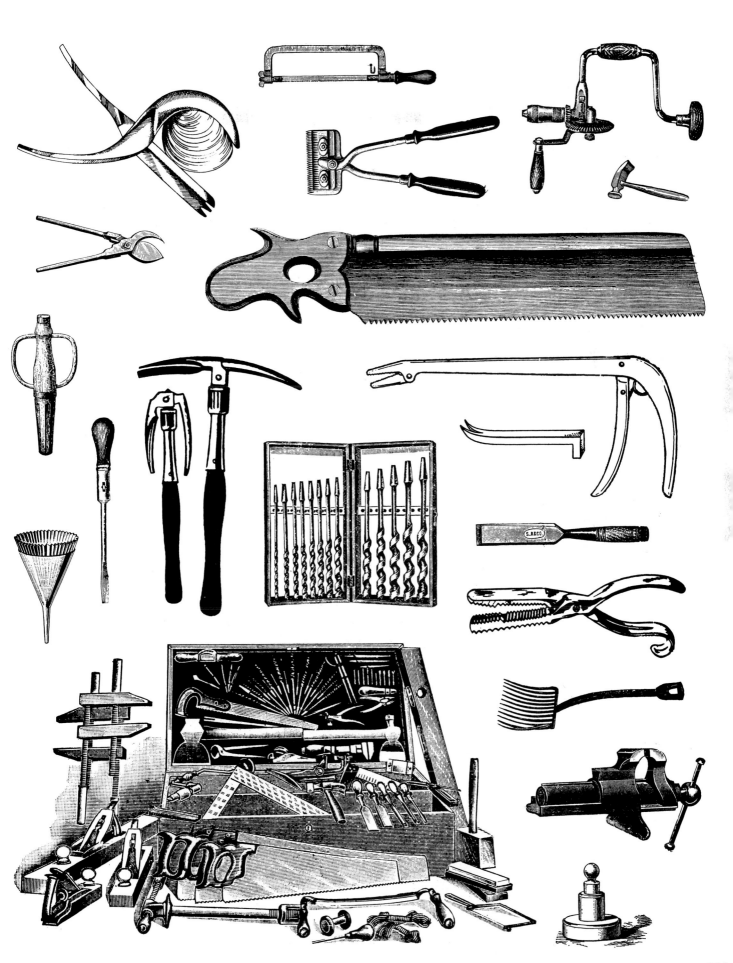

TORNADOES & WATERSPOUTS

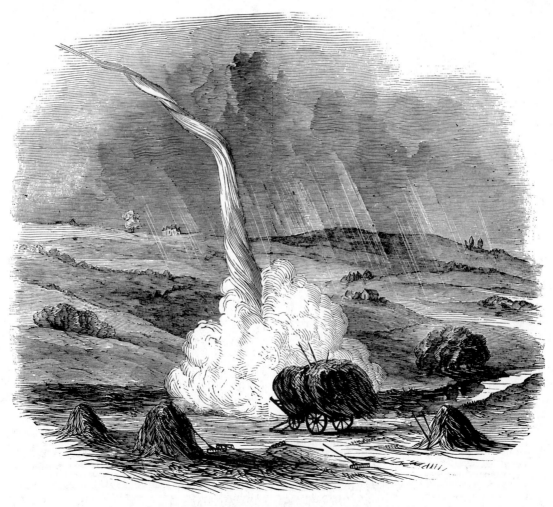

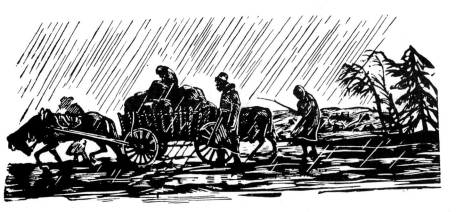

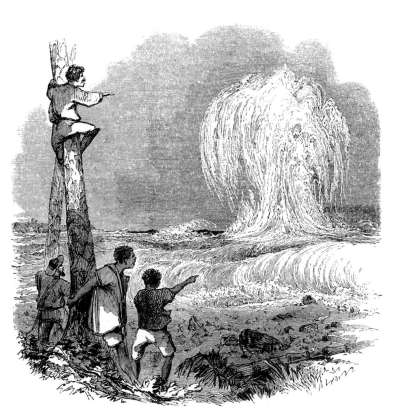

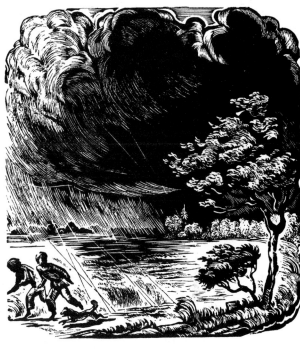

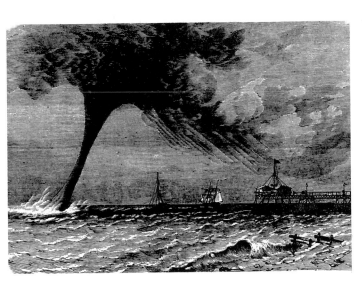

TOYS & GAMES

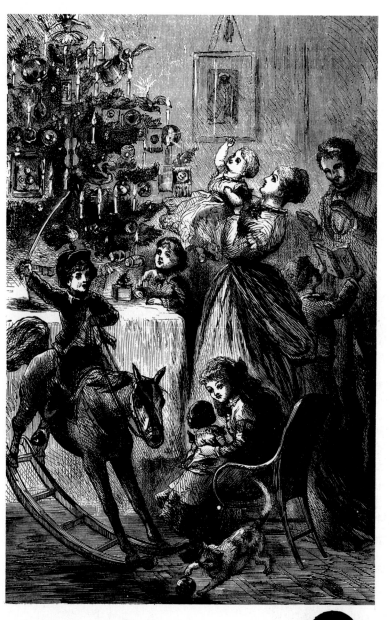

TURTLES & TORTOISES

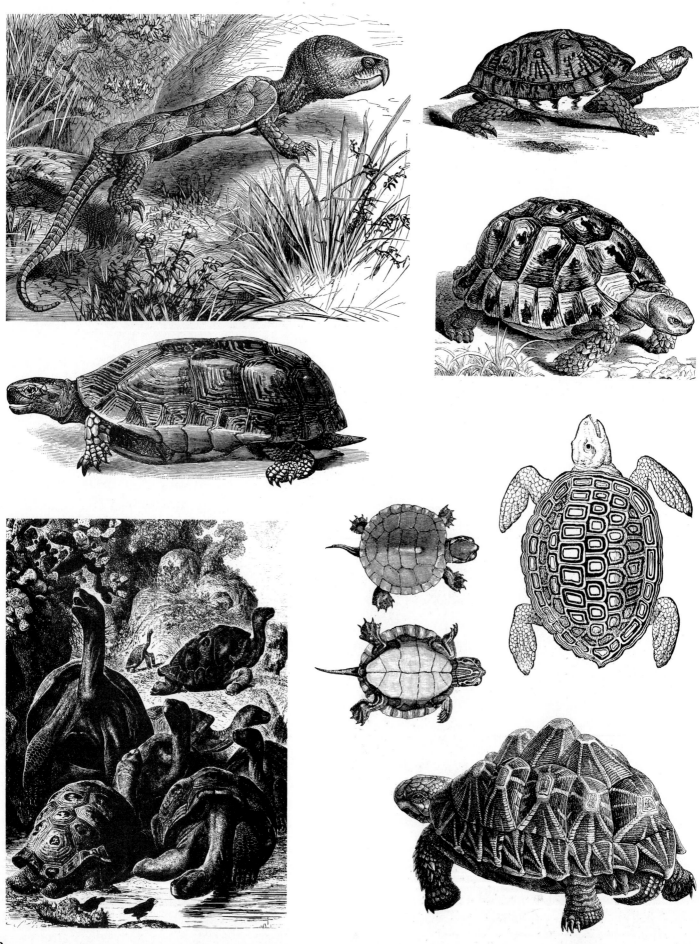

VALENTINES

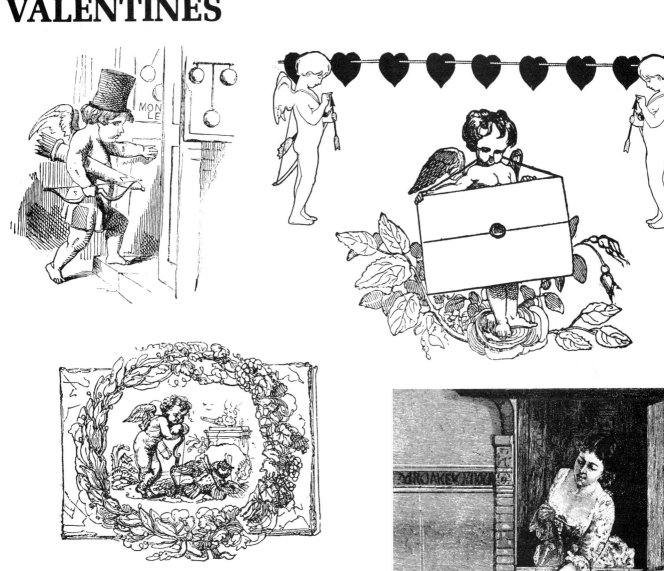

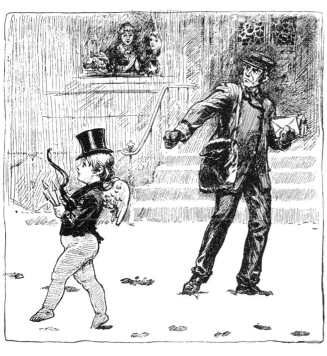

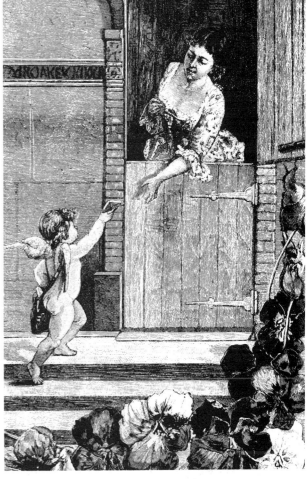

VEGETABLES

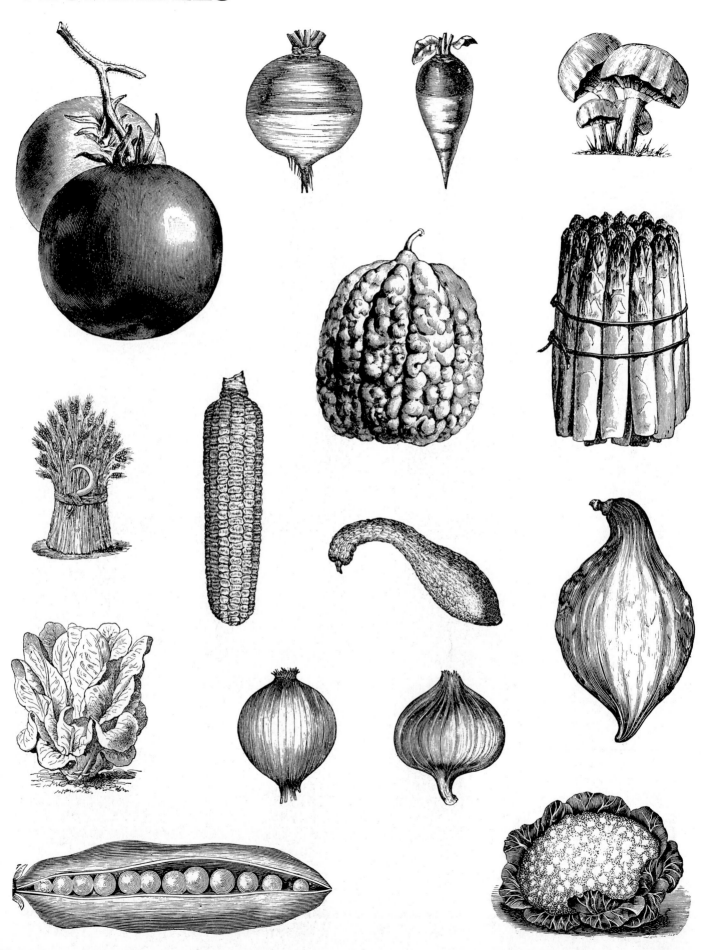

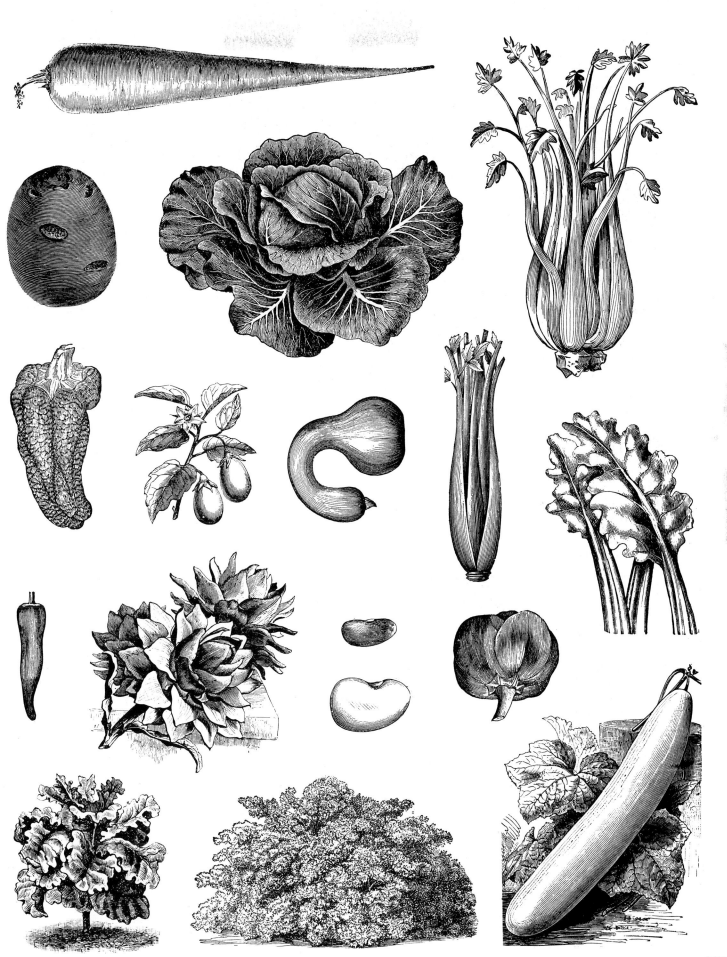

VEHICLES

VILLAGE SCENES

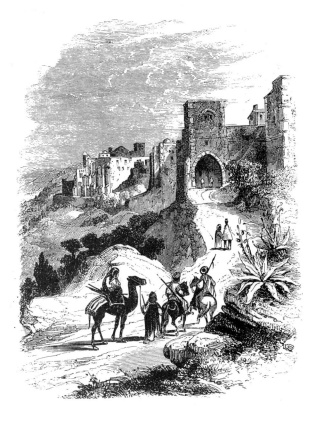

WADING BIRDS

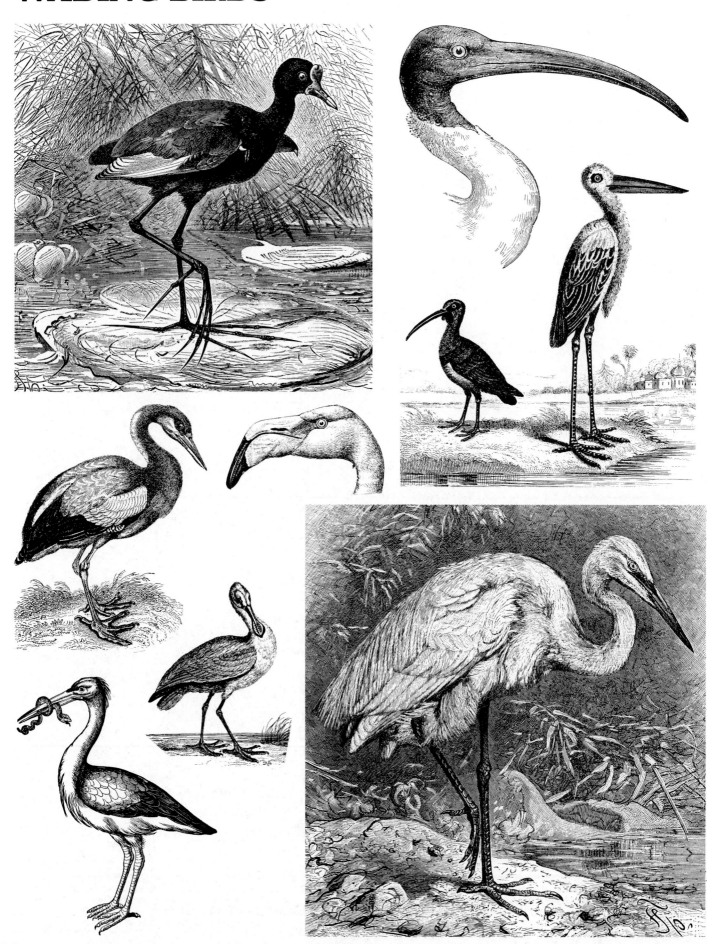

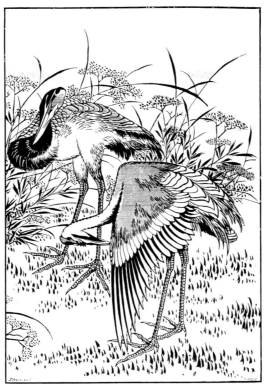

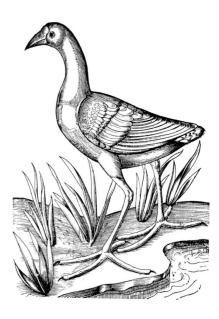

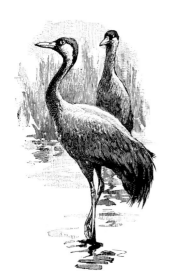

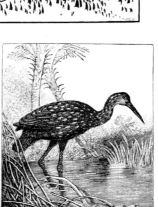

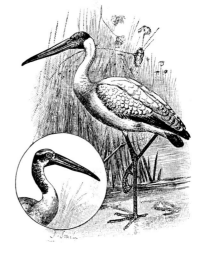

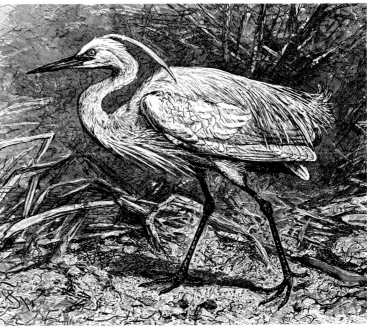

WAITERS & BARTENDERS

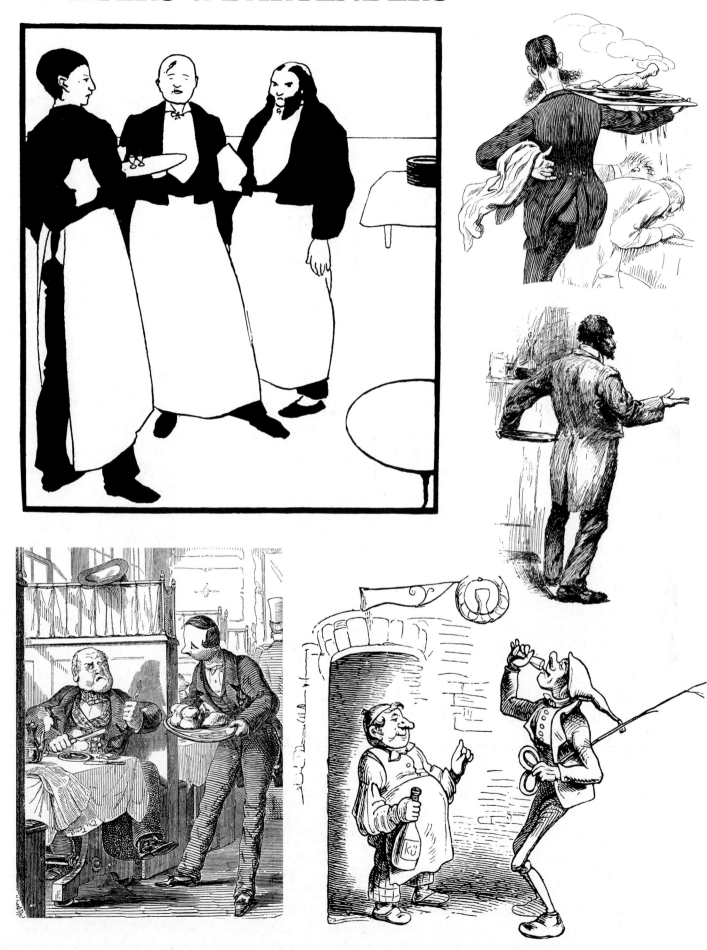

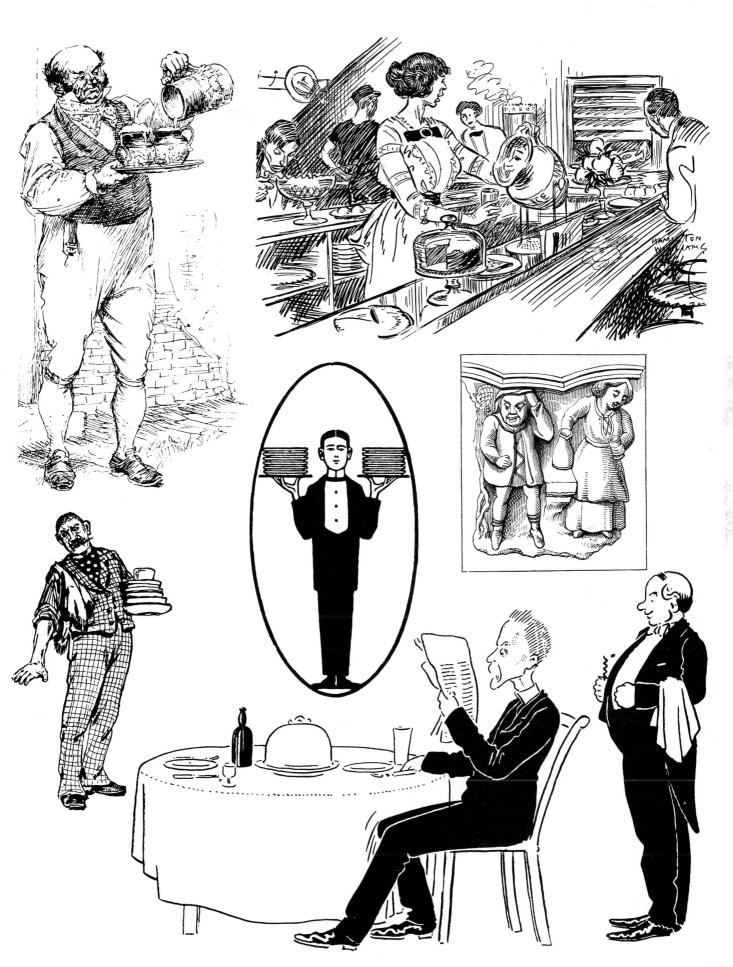

WAR & WARRIORS

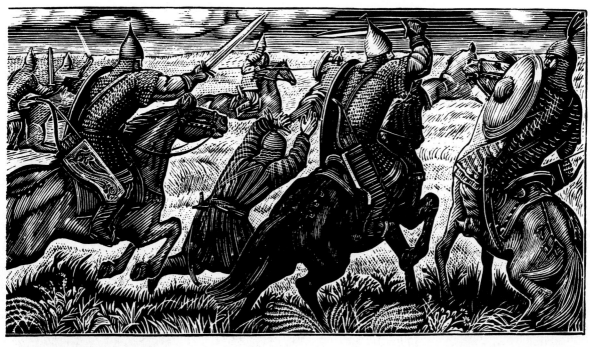

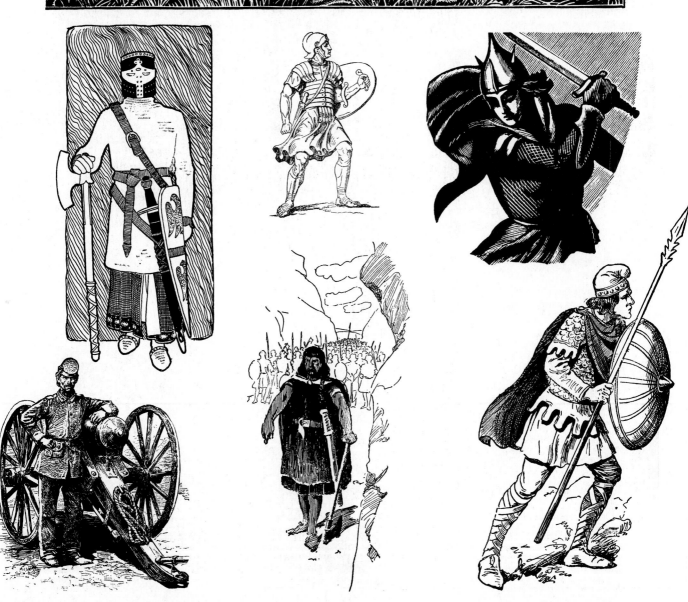

WATCHES

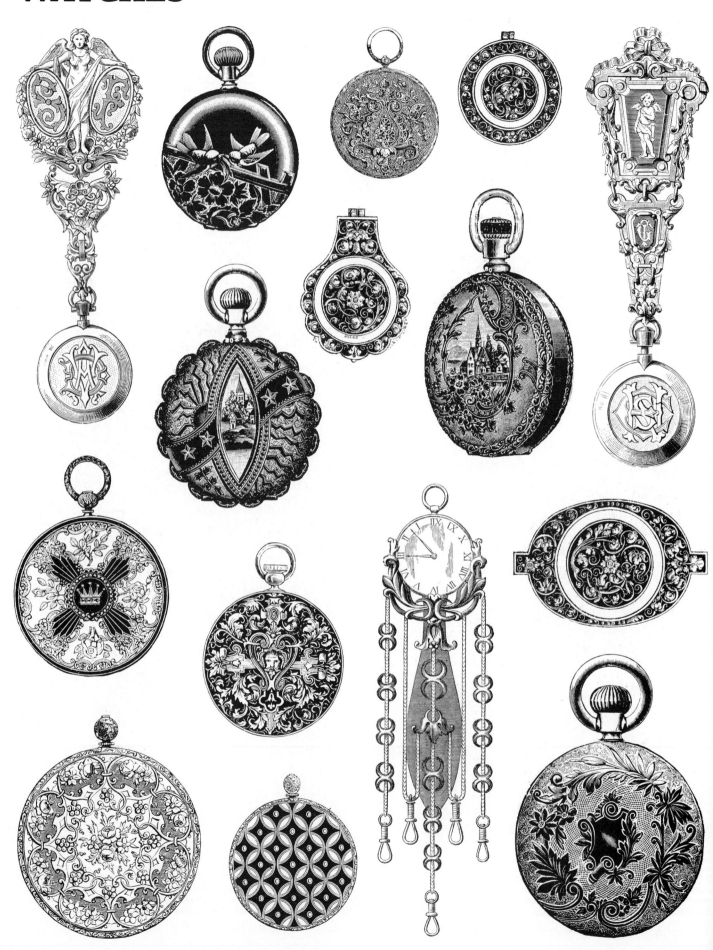

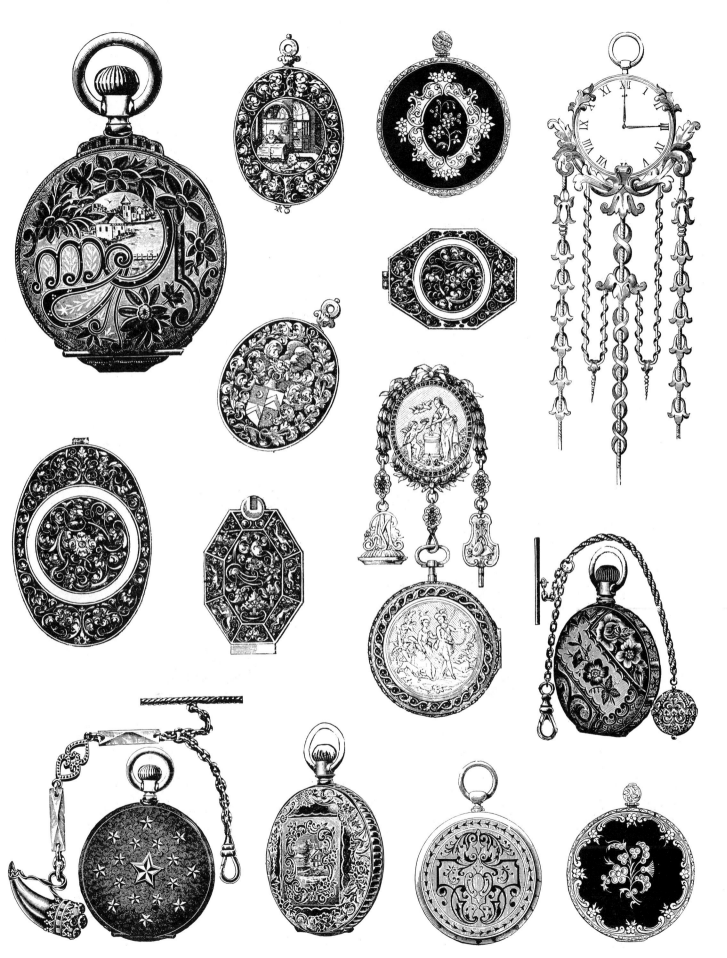

WATER CARRIERS

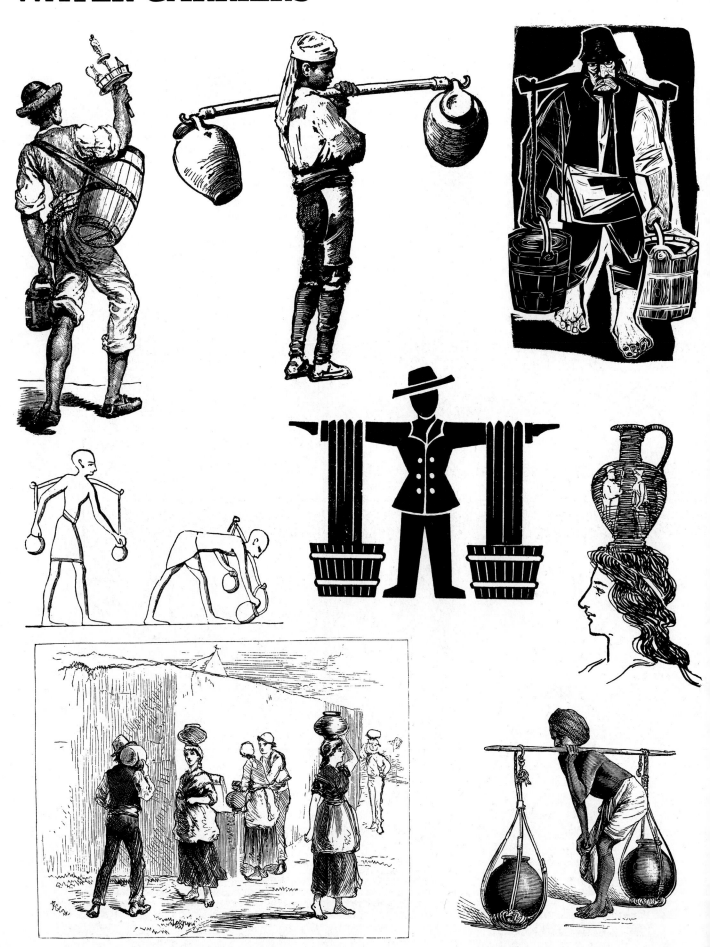

WATERFOWL

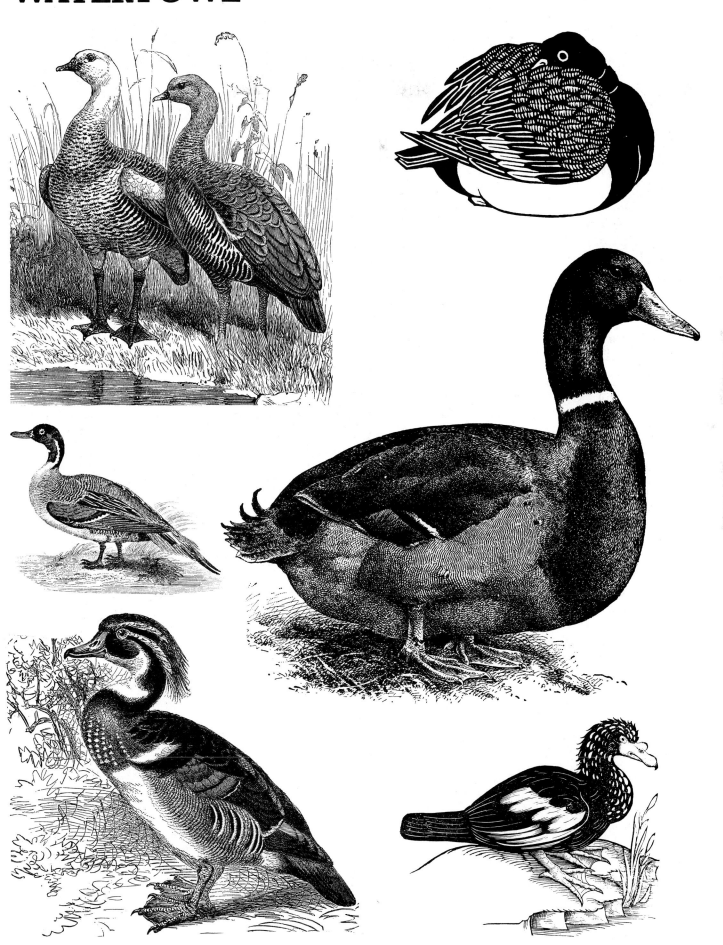

WEASELS

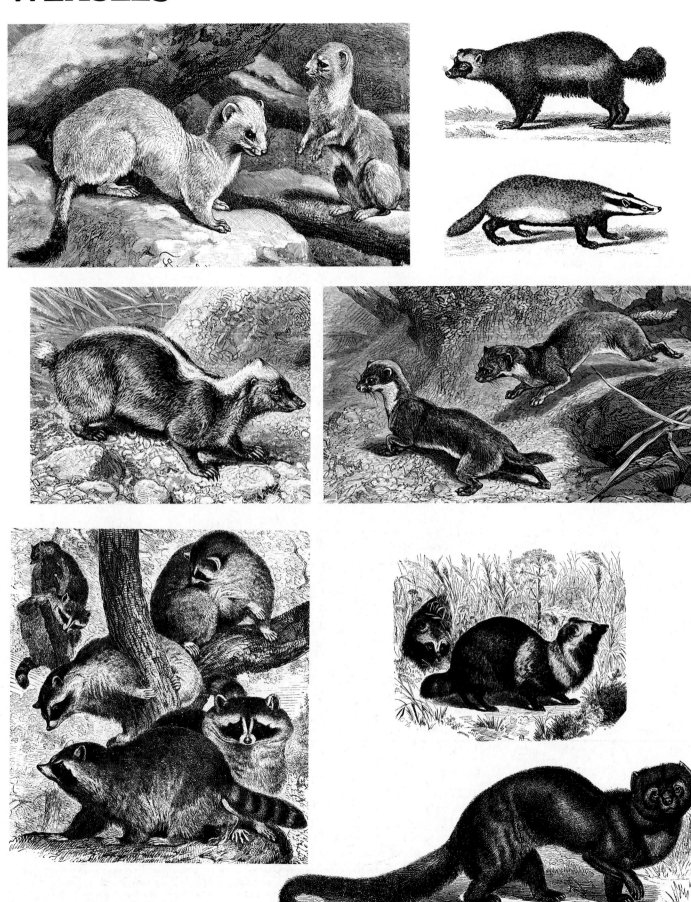

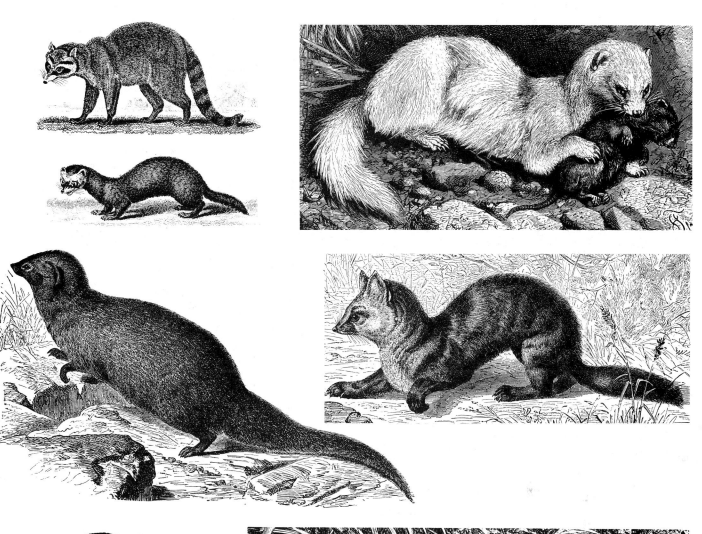

WHALES & NARWHALS

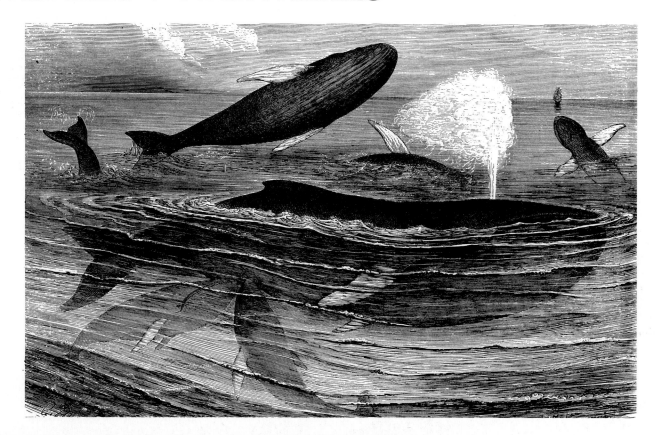

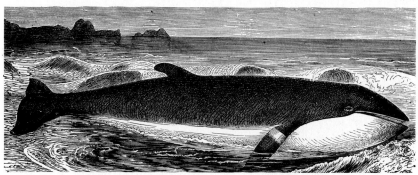

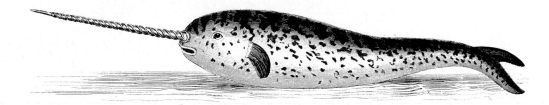

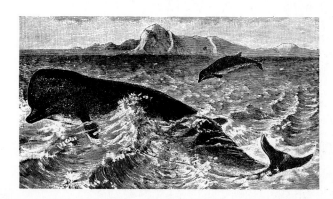

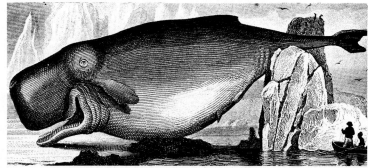

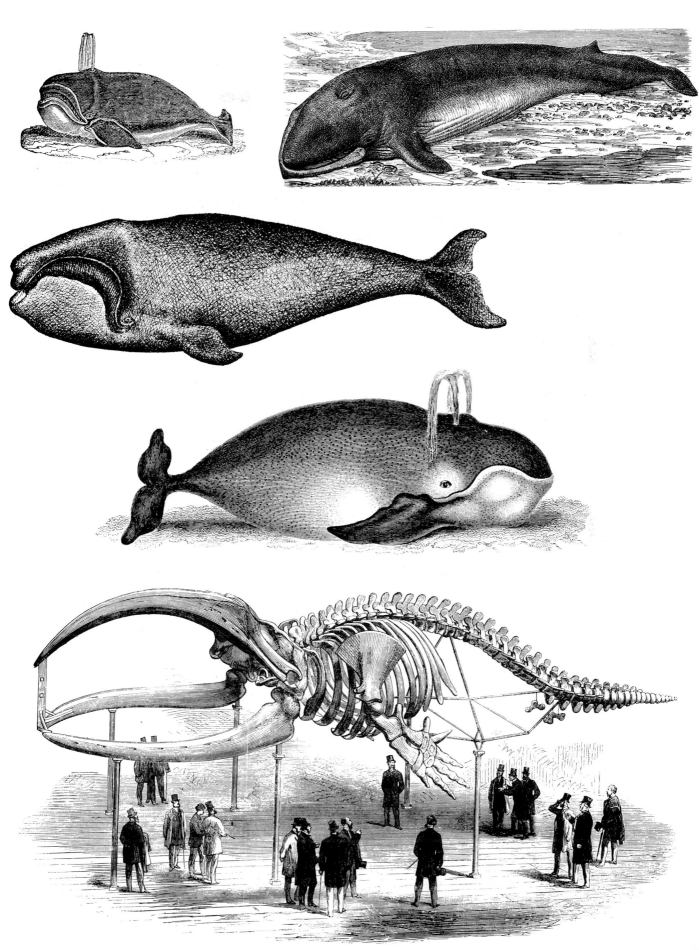

WIND

WOMEN'S CLOTHING

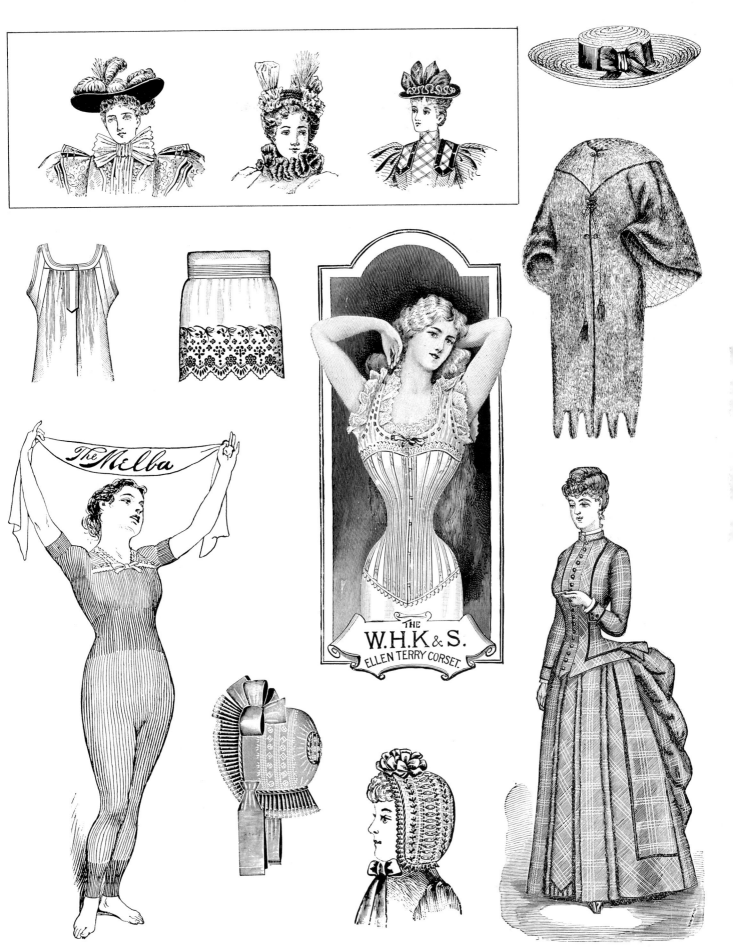

The Melba

THE
W.H.K & S.
ELLEN TERRY CORSET.

WORMS

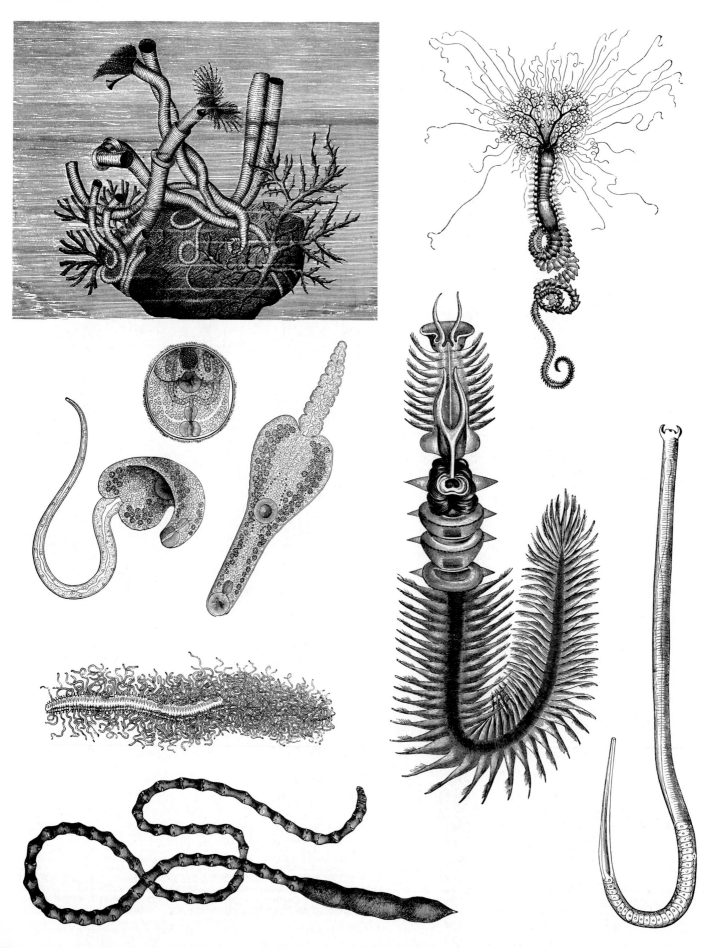

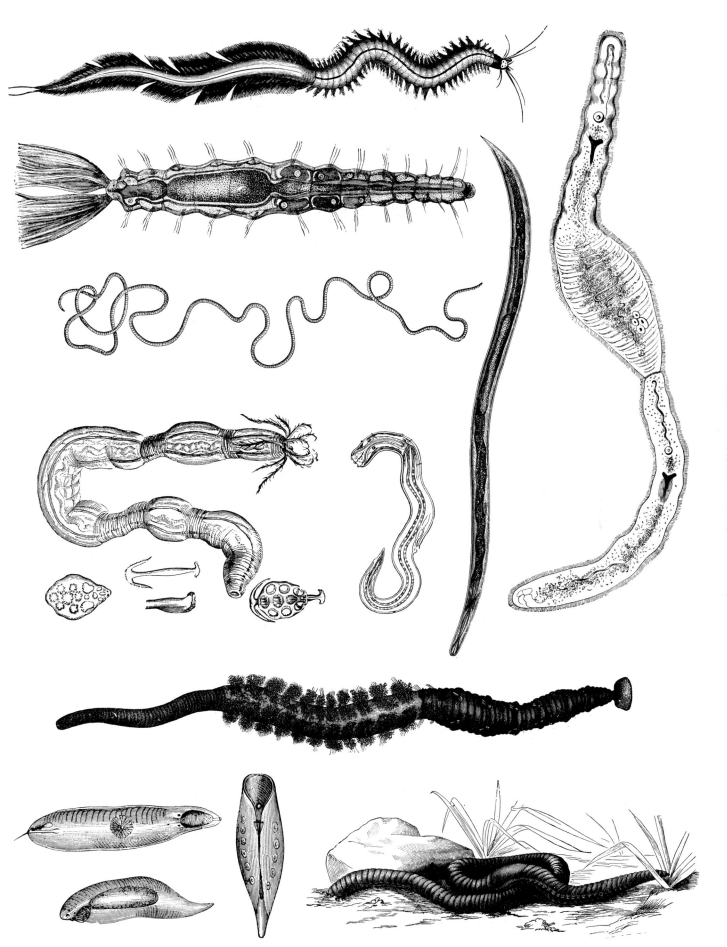

THE HART
PICTURE ARCHIVES

If you like THE GREAT GIANT SWIPE FILE and require pictures for your graphic work, you will most certainly be interested in THE HART PICTURE ARCHIVES.

You can order these books through your bookstore or directly from Hart Publishing Company, Inc, 12 East 12th Street, New York, N.Y. 10003. Send check or money order. Books will be shipped to you post-paid. Your satisfaction is guaranteed.

HART PICTURE ARCHIVES

A tremendous resource for art directors, HART PICTURE ARCHIVES offers a vast pictorial encyclopedia.

This unique series of books contains thousands and thousands of pictures gathered from all corners of the earth.

All pictures are in the public domain. This incredible collection of art can be used without fee, and without permission.

All pictures are of superior quality. Many have never been printed before in the United States. Each picture can be easily reduced or enlarged by photostat.

Each volume stands on its own, and each is indexed. All books are 9½ x 12⅜ and are printed on 80-lb. glossy stock.

All books have complete data about the sources from which the pictures derive.

Pictures have been culled from hundreds of books and world-famous magazines. From Britain, there are pictures from *Punch*, from *The Connoisseur*, etc.: from American magazines, pictures have been taken from *Harper's, Scribner's, Century, Leslie's,* and a host of others; from Germany, pictures from the world-famous *Lustige Blatter;* from Paris, from the equally famous *La Vie Parisienne;* in the field of natural history, pictures from the renowned *Buffon's Natural History,* from *Lydekker,* and from scores of other volumes.

How is it that these pictures can be used without fee? Well, for one thing, most of the pictures were printed before 1904, when copyright came into force, and are therefore in the public domain. Second, some of the pictures come from foreign countries, such as Russia and China, before they had copyright agreements with the United States. Then there are pictures from books and magazines where

the second term of copyright was never renewed. And lastly, there is a wide accumulation of pictures original to Hart Publishing which are now being released to the public.

WHAT THE REVIEWERS SAY:

Visual gold mines that prove again that pictures are worth a thousand words. Neat organized, easy to look at, printed on good, coated stock, the detailed black-and-white line drawings and engravings (with a scattering of halftones) are in the public domain and can be reproduced with fidelity and ease.

Each collection covers a wide range; there are captions to the illustrations, and a list of "Sources." For instance, THE ANIMAL KINGDOM, with more than 2200 reproductions, ranges from birds, reptiles, and fish to extinct species. The volume on chairs is a virtual history, from Renaissance to Early American, to modern, with a section of "Unusual Chairs."

The originals come from such divergent sources as early magazines (Harper's, Illustrated London News) and the work of hundreds of artists and illustrators over the decades.

To advertising agencies, graphic designers, antique dealers, decorators, teachers, just about anyone who makes use of visual material, the value of these collections is inestimable.
LIBRARY JOURNAL

Well-indexed, well-organized. Excellent sources. The drawings and graphics go Baroque, calligraphic, and from Aubrey Beardsley to Grandville, and beyond that to the art of modern European advertising and Russian posters and bookplates. If your publications uses graphics, scrounge no more; this usable collection has just about everything.
CHRISTIAN CENTURY

We find HART PICTURE ARCHIVES especially valuable.
SYOSSET CENTRAL SCHOOL DISTRICT

A useful compilation which will be of value to advertising agencies, printers, publishers, artists, and schools.
ARBA

This series will receive heavy use in libraries where graphic artists and others are always asking, "Can you find me a picture showing...]"
WILSON LIBRARY BULLETIN

The illustrations are generally well-reproduced with good margins; the book lies flat for easy copying.
AMERICAN LIBRARY ASSOC., BOOK LIST

THE ANIMAL KINGDOM . . . a book of tremendous potential value to libraries serving artists and one certainly worth considering for addition to general reference collections.
AMERICAN LIBRARY ASSOC., BOOK LIST

HART PICTURE ARCHIVES justifies its existence through multiple improvements over its predecessors. These include linear reproductions, easily photocopied. The advantages of this source over traditional files created and maintained by a library staff are basic: Time and space are better utilized, while loss and damage to individual reproductions are eliminated.
RQ, REFERENCE AND ADULT SERVICES DIV.

COMPENDIUM . . . an encyclopedia of pictures, a gold mine for artists, agencies, book, magazines, or newpaper publishers . . . A master swipe file.
GRAPHICS TODAY

AMERICAN DESIGNS

Taking the broadest possible view of American design, this book contains illustrations as diverse as ancient Aztec pottery and modern Op Art. There are sections covering Native American design, Mexican design, Colonial design in the United States, Pennsylvania Dutch design and others. It is the first book of its kind to provide a compendium of American design with a multicultural outlook.

96 pages.
(ISBN No. 08055-1269-1) Hardcover **$17.95**
(ISBN No. 08055-0332-3) Paperback **$5.95**

THE ANIMAL KINGDOM

This fabulous collection of more than 2,000 pictures covers a wide variety of subjects—quadrupeds, crustaceans, birds, fish, and reptiles.

There are pictures from *The Illustrated Natural History*, J.G. Wood; *Magner's Standard Horse & Stock Book*; *Riverside Natural History of 1885*; *New Natural History*, Lydekker; among others.

400 pages.

(ISBN No. 08055-1161-X) *Hardcover* **$44.50**
(ISBN No. 08055-0269-6) *Paperback* **$14.95**

ATTENTION GETTERS

Compiled by ROBERT SIETSEMA

You don't have to stand on your head or wiggle your ears to make people notice. Try one of the sure-fire attention getters in this book. Whether it's an ad, a promotional piece, a letter, a flyer, an announcement, or a greeting card that needs sprucing up, you'll find something appropriate in this volume to grace it with. If you want to be amusing, or decorative, or elegant, or bizarre, or pompous, or dignified, or eccentric, there is art here to fit your choice.

Over 300 designs drawn from a wide variety of sources —all in the public domain—may be reproduced without fee or permission. A treasure trove for graphic artists.

Hart Picture Archives
Printed on heavy glossy stock. Size: 9⅜ × 12¼. 80 pages.
(ISBN No. 08055-0377-3) Paperback **$5.95**

BORDERS & FRAMES

A collection of over 500 borders, simple and ornate, including just about every kind of style imaginable. There are two-sided borders, three-sided borders, oval and rectangular frames, and simple line ornaments which can be extended endlessly to fill out a design of your invention.

Also included are animal borders and landscape borders, as well as borders by famous artists such as Aubrey Beardsley and Albrecht Durer.

224 pages.

(ISBN No. 08055-1251-9) Hardcover **$26.95**
(ISBN No. 08055-0353-6) Paperback **$8.95**

COMPENDIUM

This volume is the flagship of the Hart Picture Archives fleet. Its enormous popularity can be attributed to its wide range of subject matter, and the high quality and variety of its illustrations. Over 2200 pictures are divided into 96 sections for easy retrieval, and the book is carefully indexed. *Compendium* includes sections on Ships & Boats, Shoes & Boots, Signs, Seals, & Signets, Silverware, Sleep & Repose, Smoking & Tippling, Society Swells, Sport, Statues & Monuments, and Surprise. There are landscapes and cityscapes, pictures of famous faces, strange animals and familiar animals, and people undergoing strong emotions. Here is a book that makes hunting for the right picture a pleasure.

400 pages.

(ISBN No. 08055-1160-1) *Hardcover* **$44.50**

(ISBN No. 08055-0318-8) *Paperback* **$14.95**

DESIGNS OF THE ANCIENT WORLD

Including Egyptian tomb paintings, Grecian ceramics, and Roman draperies, this book documents the richness of ancient design.

The volume contains over 250 illustrations.

80 pages.
(ISBN No. 08055-1271-3) *Hardcover* **$12.95**
(ISBN No. 08055-0335-8) *Paperback* **$4.95**

EUROPEAN DESIGNS

A comprehensive collection of the best in European design. Containing 400 illustrations, this compilation embraces all major styles of design, medieval to modern.

The designs are grouped according to nationality and each collection runs the gamut from the simplest of folk motifs to the most ornate pieces of art.

128 pages.
(ISBN No. 08055-1268-3) Hardcover **$17.95**
(ISBN No. 08055-0331-5) Paperback **$5.95**

GOODS & MERCHANDISE

Every art director knows that sometimes the most difficult pictures to obtain are those of simple, common things—a zipper, a pocket knife, a light bulb, an umbrella. *Goods & Merchandise* fills that need with a profusion of illustrations of everyday objects.

This book contains over 1500 pictures divided into twenty-five sections for easy reference. There are sections covering hardware, vehicles, sporting goods, firearms, furniture, comestibles, apparel, and appliances.

An exhaustive index simplifies the process of retrieving exactly the right picture for your needs.

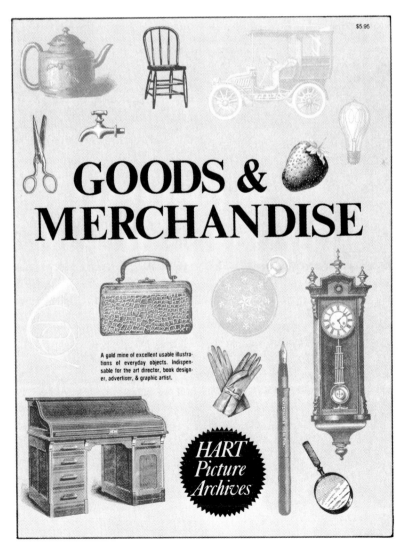

128 pages.

(ISBN No. 08055-1264-0) Hardcover **$17.95**
(ISBN No. 08055-0326-9) Paperback **$5.95**

HOLIDAYS

Need an illustration for a greeting card, a motif for a fabric design, or a topical border to brighten up a party announcement? This book has illustrations—including the obvious as well as the unusual—for every holiday.

Holidays contains over 300 illustrations of all the holidays, including Christmas, New Year's, Chanukah, St. Patrick's Day, Easter, Thanksgiving, and the Fourth of July.

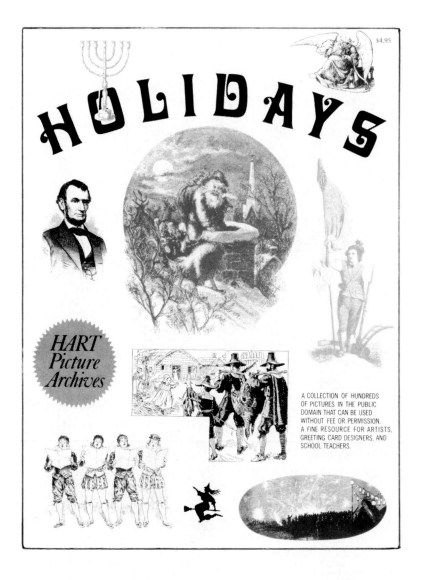

64 pages.

(ISBN No. 08055-1252-7) Hardcover **$12.95**

(ISBN No. 08055-0354-4) Paperback **$4.95**

JEWELRY (Revised Edition)

Text by NANCY GOLDBERG

The making of jewelry has engaged amateur craftsmen from one end of the world to the other. Few have models to work with.

This revised edition encompasses a broad range of pictures and provides over 1,000 classic designs from all periods of history and all corners of the earth.

A text on the history of jewelry accompanies the pictures.

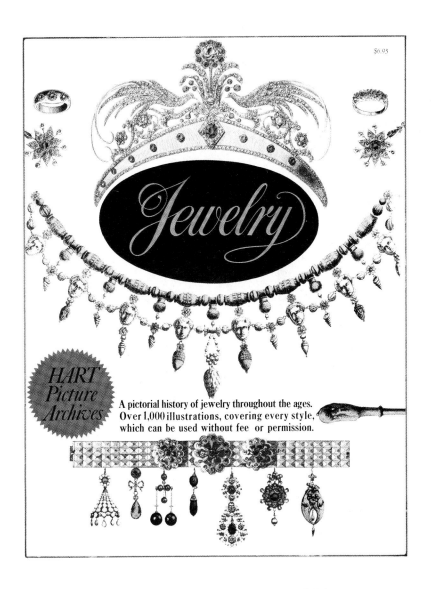

144 pages.

(ISBN No. 08055-1210-1) Hardcover **$17.95**
(ISBN No. 08055-0303-X) Paperback **$5.95**

ORIENTAL DESIGNS

Oriental Designs is a resource of extraordinary usefulness for anyone who needs ideas for fabrics, wallpaper, embroidery, greeting cards, etc. Included are fine illustrations of carpets and textiles, ink drawings by celebrated masters, bronze folk motifs, miniature paintings, and delicate papercuts. The book contains over 250 illustrations, and encompasses all the important styles of Oriental design, ancient and modern: Persian, Chinese, Japanese, and Indian.

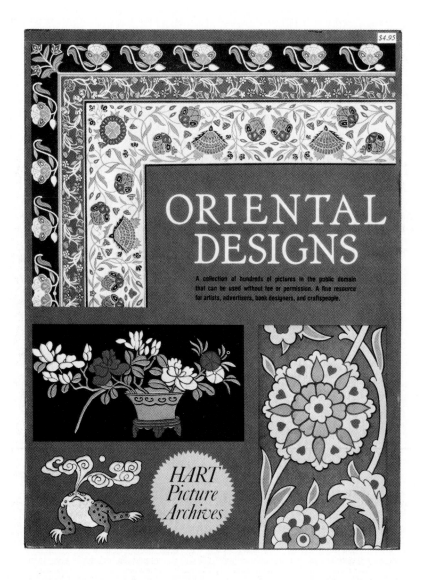

80 pages.

(ISBN No. 08055-1267-5) Hardcover **$12.95**

(ISBN No. 08055-0330-7) Paperback **$4.95**

TRADES & PROFESSIONS

Here is a presentation of over 2,000 pictures of professionals, such as doctors, dentists, musicians, priests, dancers, accountants, and lawyers, along with bee keepers, carpenters, blacksmiths, construction workers, etc. Among scores of industries, there are sections on mining, cotton picking, orcharding, and smelting.

416 pages.

(ISBN No. 08055-1214-4) Hardcover **$44.50**
(ISBN No. 08055-0307-2) Paperback **$14.95**

WEAPONS & ARMOR

A pictorial history of the development of the engines of warfare from ancient to modern times. The unique and often beautiful implements with which man has defended himself are represented by illustrations culled from a wide range of sources.

This volume is divided into two sections. The section on armor contains excellent, detailed illustrations of cuirasses, helmets, gauntlets, coats of mail, as well as complete suits of armor from many different countries and periods of history.

The section covering weaponry includes the full range of defensive gear from primitive war clubs to sophisticated automatic guns.

192 pages.

(ISBN No. 08055-1253-5) Hardcover **$23.95**
(ISBN No. 08055-0363-3) Paperback **$7.95**